2004 ANNUAL

tips, inspiration and instruction in all mediums

How did you paint that?

100 ways to paint
STILL LIFE & FLORALS

international
artist

NORTH INDIAN RIVER COUNTY LIBRARY

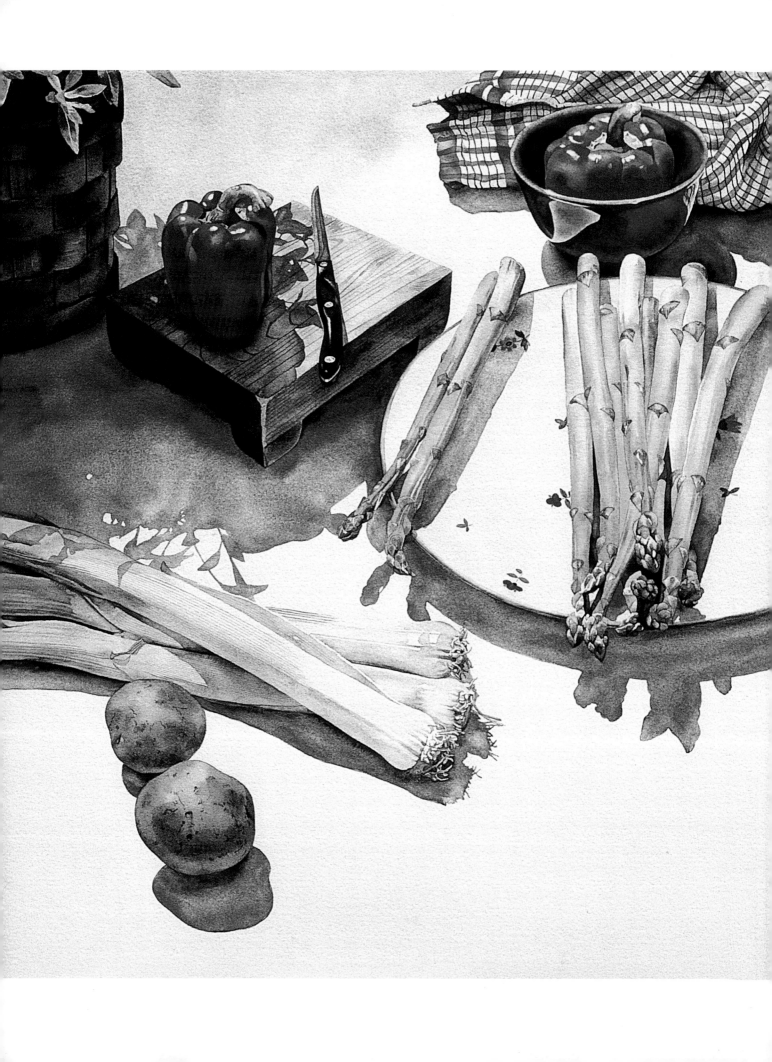

2004 ANNUAL

tips, inspiration and instruction in all mediums

How did you paint that?

100 ways to paint

STILL LIFE & FLORALS

international
artist

International Artist Publishing, Inc
2775 Old Highway 40
P.O. Box 1450
Verdi, Nevada 89439

Website: www.intenationalartist.com

© International Artist 2004

Edited by Terri Dodd and Jennifer King
Designed by Vincent Miller
Typeset by Ilse Holloway, Lisa Rowsell
and Cara Herald
Editorial Assistance by Dianne Miller

ISBN 1-929834-39-X

Printed in Hong Kong
First printed in 2004
08 07 06 05 04 6 5 4 3 2 1

Distributed to the trade and art markets
in North America by:
North Light Books,
an imprint of F&W Publications, Inc
4700 East Galbraith Road
Cincinnati, OH 45236
(800) 289-0963

Acknowledgments

International Artist Publishing Inc. would like to
thank the master artists whose generosity of spirit
made this book possible.

Susan Abbott
Anne Abgott
Kathryn Aiken
Jorge Alberto
Elizabeth Allen
Kathy Anderson
Mary Aries
Juliette Aristides
Robert Armetta
Joe Anna Arnett
John Atkinson
Eric Bader
Barbara Benedetti Newton
Brian Blood
Marci Boone
Ginger Bowen
Gwynneth Boyce
Mary Alice Braukman
Daniel Brient
Bonnita Budysz
Pat Camillo
Frank Canning
W D Carney
Jacob Chang
Ismael Checo
Xue Wen Chen
Chen Chong'En
Christine Chown
TK Daniel Chuang
Marjorie Collins
Rainie Crawford
Anita Daab
Randolf Dimalanta
Henry W Dixon
Raenell Doyle
Joseph John Dudding
Kathy Dunham
Cathy Edgar
Annie L Ferder
Cathy Fink
Beth Flor
Douglas Flynt
George A Gonzalez
Gerald Hannibal
Julia Hargreaves
Grace Haverty
Carolyn Hayes
Richard William Haynes
Susan Fleming Hotard
Shirley Howells

Nancy Howie
William Jaeger
Bill James
Marvin Johnson
Hilde Jones
Laurie Kersey
Roger Lewis
Catherine Lidden
Isabel M Lorca Godoy
Yvonne Lucas
Martin Lutz
Barbara Maiser
Tricia May
Isabel McCauley
Laurin McCracken
Angus McEwan
Judith McNea
Hedi Moran
Andrew Morris
Renato Muccillo
Wilda Northrop
Anita J Nugent
Elaine O'Donnell
Laura Ospanik
Monika Pate
Virginia Peake
Marietta Petrini
Frank Radcliffe
Kelly Reaves
Hope Reis
Roberta Remy
Katerina Ring
Mary Rodgers
Patricia A Rohrbacher
William A Schneider
Donald Sinclair
Paul Smith
Pornparn Sridhanabutr
Allayn Stevens
Terence Storey
Michele Suchland
Wei Tai
Vivian Thierfelder
Dorothy Tilburn
Wu Ting-Hsuan
Tim Tyler
Mary Ulm Mayhew
Charles van der Merwe
Sam Vokey
William C Wright

Message from the Publisher

We have taken the "learn by observing" approach six huge steps further.

Welcome to the first in our innovative 6-Annual series, **How Did You Paint That? 100 Ways to Paint Still Life and Florals**, which contains 100 different interpretations of the subject by some outstanding artists working in the world today — in all mediums.

In store for you in 2004 are five more Annuals, each tackling a popular subject. Upcoming titles to look forward to are:

100 Ways to paint People & Figures

100 Ways to paint Landscapes

100 Ways to paint Flowers & Gardens

100 ways to paint Seascapes, Rivers & Lakes

100 ways to paint Favorite Subjects

Studying the work of other artists is one of the best ways to learn, but in this series of Annuals the artists give much more information about a favorite painting. Here's what you can expect from each of the Annuals in the series.

- 100 different artists give 100 different interpretations of the subject category.
- Each one gives tips, instruction and insight.
- The range of paintings shows the variety of effects possible in every medium.
- A list of colors, supports used, brushes and other tools accompanies each picture.
- The artists reveal what they wanted to say when they painted the picture — the meaning behind the painting and its message.

- Each artist explains their inspiration, motivation and the working methodology for their painting.
- Artists say what they think is so special about their painting, telling how and why they arrived at the design, color and techniques in their composition.
- The artists describe the main challenges in painting their picture, and how they solved problems along the way.
- They offer suggestions and exercises that you can try yourself.
- They give their best advice on painting each subject based on their experience.
- Others explain why they work with their chosen medium and why they choose the supports and tools they do.
- The main learning point of each painting is identified in the headline.

Each of the explanations shown in **100 Ways to Paint Still Life & Florals** was generously provided by artists who want you to share their joy of painting. Take the time to read each description fully, because you never know which piece of advice will be the turning point in your own career.

Vincent Miller

Vincent Miller
Publisher

You would not be holding this book in your hands if you weren't fiercely curious about how so many accomplished artists manage to achieve the results they do.

For some of us, this need to know "how" simply must be addressed. Of course, whenever we see a painting that takes our fancy we make our own (sometimes wrong) assumptions about it. We recognize certain techniques, and often we make wild guesses about the artist's master plan. Occasionally, we can identify the tonal and color strategy — we can sometimes work out the big picture. But wouldn't it be nice to know exactly what the artist had in mind when they painted an exceptional work. Sometimes, all it takes is just one little titbit of information, something you are not doing now but could adopt, that will turn your art around and steer you in a more productive and personally rewarding direction. That is why this book is so valuable — it gives you the opportunity to find out what works!

pretend you are a sponge

In this book you will see various means of expression thrown open to you. And "open" is the operative word. Possibly the most important piece of advice we can offer you is to retain an open mind when you study the paintings in this book and read carefully what the artists have to say. Do not bring your own experience, habits, idiosyncrasies, color preferences or even preferred medium into the exercise. This is where you make like a sponge, and just soak up all the valuable information presented to you by these 100 generous artists. Whenever you read something and hear yourself saying, "Yes, but I would…" give yourself a metaphorical slap on the wrist, and continue reading what the artist has to say. Absorb the information, let it sit in your consciousness, because the next time you paint a still life and encounter a problem your marvelous creative mind, that files away countless bytes of inspirational data, could access a relevant solution from something spied in this book, and your painting will flow again.

work at it

Perhaps C. W. Mundy, one of America's finest artists, said it best when he said, "There is a huge difference between being a painter and being an artist. Stage one is painter. Stage two is the artist. A painter paints with five per cent soul and ninety-five per cent mind, while an artist paints with ninety-five per cent soul and five per cent mind."

Unfortunately, there is no short-cut to experience. In order to reach the level of "artist" you must be prepared to paint as often as you can. Like any other muscle, your "art muscle" works best if you give it a workout. Practice until you become comfortable with brushes, paints and color mixing. Know which colors are opaque and which ones are translucent. Understand about glazes. Find out how mediums can help you with your oil painting and how pigment strength can help you with your watercolor. Practice your brushwork and experiment to find out the idiosyncrasies of the various weights of paper. Be prepared to experiment.

This is a wonderful journey you are undertaking. It is full of surprises and rewards. Treat each painting as a learning experience and try not to be disappointed if you sometimes mess it up — it is simply part of the pathway to becoming an artist.

what are these artists telling you?

When you appreciate the paintings and then read the accompanying text you'll keep encountering words like: design, tone, shape, shadows, lights, balance, repetition, contrast, movement, focal point, eye level, color strategy, complementary color, color temperature, and so on.

These words tell you that there is a system in art. There are tools you can use to help you put across your message — as the artists in this book so ably demonstrate.

It is vital to know the design principles, to understand the importance of tone (the degree of lightness and darkness) how color works to suggest depth and distance

and how shape can unify a painting. These tools are essential to the success of your work. Knowing and using these tools will lift your work from looking amateurish to looking professional.

You will be able to see the results of this knowledge in the paintings featured in this book, and it will give you some grounding in these important tools. However, we suggest you make it your business to learn more about the essential building blocks of art. Ask your bookseller to show you more *International Artist* titles that cover these subjects.

For your information, at the back of the book is also a list of explanations of some art terms and jargon you should know.

claim your rightful place in the world of art

One of the wonderful things to realize is that you can make your own individual contribution to the world of art. There's plenty of room for the art that you bring to the table. All the great paintings haven't been done already, just as all the great books haven't been written and all the great music hasn't been composed yet. What an inspiring thought that is. You may only be a short way into your artistic journey, but just think what can happen if you persevere. All you have to do to "get it" is to "work at it". We believe that the explanations in this book will play their part in your overall progress.

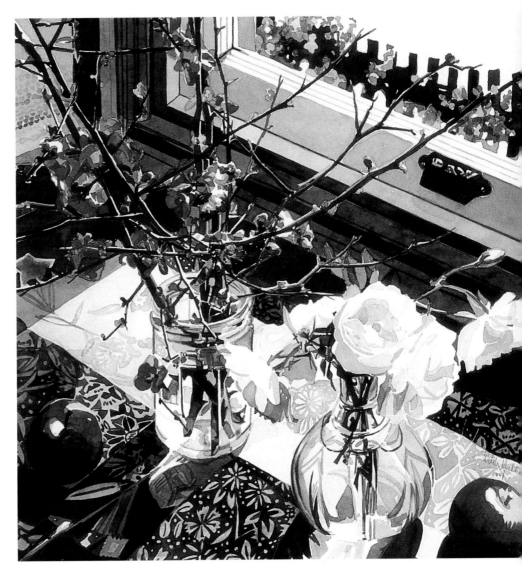

Still Life in the Window, watercolor, 20 x 20" (51 x 51cm) by Wilda Northrop

acrylic paint

Fast drying, waterproof, long lasting acrylic is an elastic paint that flexes and resists cracking.

Use it straight from the tube for intense color, dilute with water for transparent washes, or mix with an assortment of mediums to create texture. Available in tubes or jars, liquid or impasto, matte or gloss finish.

Binder: Acrylic resin emulsified with water.

Support: Flexible and inflexible, primed or unprimed.

alkyd

Looks similar to oil paints and can be mixed with them. Alkyds resist yellowing and they dry faster than oils.

Support: Prime flexible or inflexible surfaces first with oil or acrylic primer.

Binder: Alcohol and acid oil modified resin.

casein

This old medium, bound with skim milk curds, has mostly been overtaken by acrylic paints. However, casein is still available and many artists swear by it. The medium dries quickly to a velvety matte finish and is water-resistant when dry. It does become brittle, and if you apply too much, it can crack. Like acrylic paint, casein is versatile and can be applied as a thin wash or as an underpainting for oils and oil glazes. When it is varnished it looks like oil paint.

Support: Because casein does not flex like acrylics it is not suitable for canvas. Use watercolor paper or rigid surfaces, primed or unprimed.

egg tempera

This product uses egg yolk in oil emulsion as its binder. It dries quickly, doesn't yellow and can be used just as it is or diluted with water. Egg tempera will crack on canvas so only use rigid supports. Use as underpainting for oils and oil glazes.

gouache

This medium is opaque and can be rewetted and reworked. It comes in vivid colors.

Binder: gum arabic

Support: paper and paper boards. Dilute with water or use neat. Don't apply too thickly or it will crack.

acrylic gouache

This gouache uses water-soluble acrylic resin as the binder. Use it just like gouache, but notice that because it is water-resistant you can layer to intensify color.

oil

The classic painting medium. You can achieve everything from luminous glazes to opaque impasto. As the paintings from the Old Masters show, oil paintings can crack, yellow and darken with age. Oil paint dries slowly on its own, or the

bud or soft brush. Hard pastels enable finer detail to be added as the work progresses or as a primary drawing medium for planning sketches and outdoor studies. Pastel pencils can be used for drawing and for extra fine detail on your pastel painting.

You can combine pastel with acrylic, gouache and watercolor. As long as the surface upon which you are working has a "tooth" (a textured surface that provides grip), then it is suitable for pastel.

Support: There is a variety of papers available in different grades and textures. Some have a different texture on each side. These days you can buy sandpaper type surfaces either already colored or you can prime them yourself with a colored pastel primer. Some artists prepaint watercolor paper with a wash and apply pastel over that.

water-thinned oil

A recent development. Looks like oil paint but cleans up in water instead of solvent. Dries like traditional oil. Use straight or modify with traditional oils and oil painting medium. Transparent or impasto.

Support: Flexible and inflexible canvas or wood.

watercolor

Ancient medium. Pigments are very finely ground so that when the watercolor paint is mixed with water the paint goes on evenly. Some pigments do retain a grainy appearance, but this can be used to advantage. Provided you let previous washes dry, you can applying other washes (glazes) on top without disturbing the color beneath. Know that watercolor dries lighter than it looks.

Watercolor is diluted with different ratios of pigment to water to achieve thin, transparent glazes or rich, pigment filled accents of color. Watercolor pigments can be divided into transparent, semi-transparent and opaque. It is important to know which colors are opaque, because it is difficult to regain transparency once it is lost. Watercolor can be lifted out with a sponge, a damp brush or tissue.

Support: There are many different grade watercolor papers available from very rough, dimply surfaces to smooth and shiny. Different effects are achieved with each. Although many traditional watercolorists allow the white of the paper to show through, there are also colored watercolor papers available.

process can be accelerated using drying medium. There are many mediums that facilitate oil painting, including low odor types. Turps is widely used to thin oil paint in the early layers. Oils can be applied transparently in glazes or as thick impasto. You can blend totally or take advantage of brush marks, depending on your intention. Oil can be used on both flexible and inflexible surfaces. Prime these first with oil or acrylic primers. Many artists underpaint using flexible acrylic paint and then apply oil paint in layers. You can work oils all in one go (the alla prima method), or allow previous layers to dry before overpainting. Once the painting is finished allow as much time as possible before varnishing.

Binder: linseed, poppy, safflower, sunflower oil.
Support: Flexible and inflexible canvas or wood.

oil stick

This relatively new medium is artist quality oil paint in stick form. Dries faster than tube oils. Oil sticks allow calligraphic effects and they can be mixed with traditional oils and oil medium. Oil stick work can be varnished.

pastel

Use soft pastels to cover large areas of a painting. Use the side of the pastel to rapidly cover an area, either thickly or in a thin restrained manner. You can blend pastel with a finger, cotton

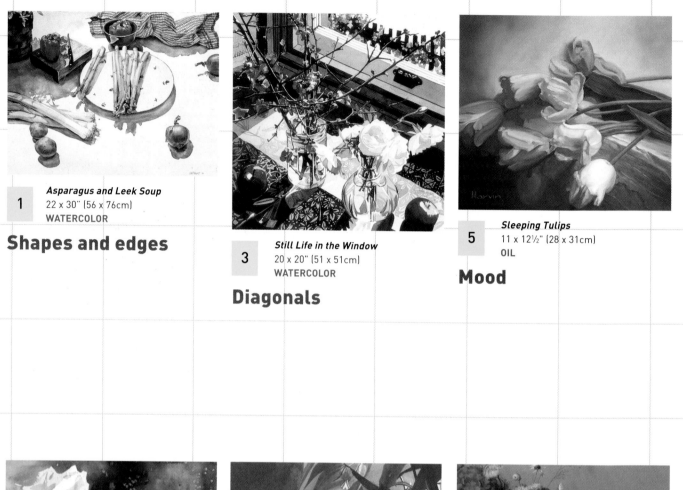

1
Asparagus and Leek Soup
22 x 30" (56 x 76cm)
WATERCOLOR

Shapes and edges

3
Still Life in the Window
20 x 20" (51 x 51cm)
WATERCOLOR

Diagonals

5
Sleeping Tulips
11 x 12½" (28 x 31cm)
OIL

Mood

2
Light of Roses
14 x 11" (36 x 28cm)
WATERCOLOR

Dramatic tone

4
Lily Shadows
19½ x 14½" (50 x 36cm)
WATERCOLOR/PENCIL

Shadows and half-light

6
Summer Lunch
32 x 29" (81 x 74cm)
OIL

Overlapped shapes

You'll find all the information you want about how each painting was created by turning to the tab number indicated, in sequence from 1 to 100

↓

7 *Sharpening My Skills*
16 x 20" (41 x 51cm)
OIL

Eye path design

Offerings From the Orient
9 22 x 18" (56 x 46cm)
OIL

Classic, dramatic lighting

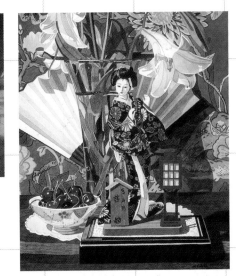

Still Life with Roses
11 28 x 20" (71 x 51cm)
WATERCOLOR

Delicate translucency

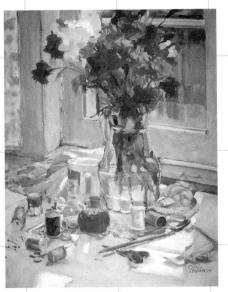

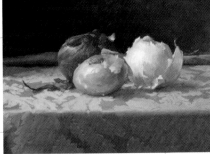

Onions
10 9 x 12" (23 x 31cm)
OIL

Surface form and texture

Japanese Still Life
12 28 x 20½" (71 x 52cm)
WATERCOLOR

Building a theme

Carnations and Threads
8 20 x 16" (51 x 41cm)
OIL

Meaning

Find it Faster directory
Color coded numbers let you quickly find the paintings you like,
all the methods and materials used and how each artist painted them

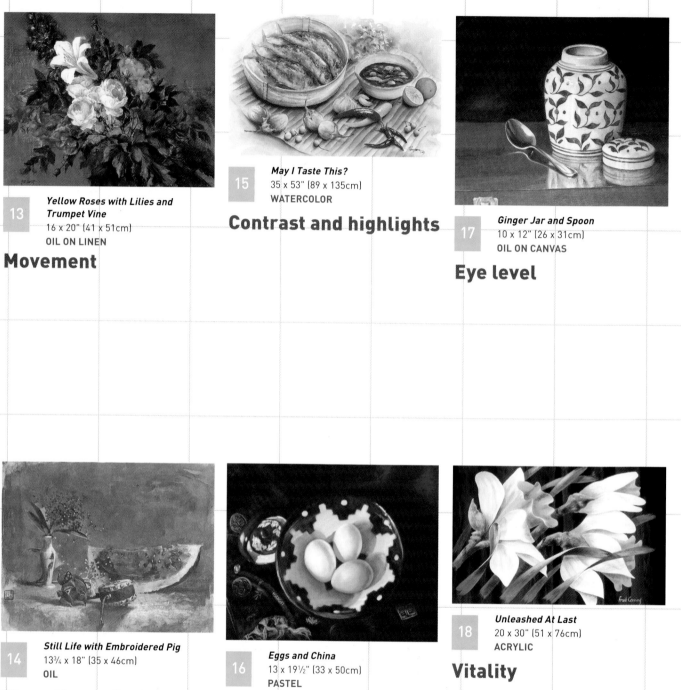

13 *Yellow Roses with Lilies and Trumpet Vine*
16 x 20" (41 x 51cm)
OIL ON LINEN
Movement

15 *May I Taste This?*
35 x 53" (89 x 135cm)
WATERCOLOR
Contrast and highlights

17 *Ginger Jar and Spoon*
10 x 12" (26 x 31cm)
OIL ON CANVAS
Eye level

14 *Still Life with Embroidered Pig*
13¾ x 18" (35 x 46cm)
OIL
Show through

16 *Eggs and China*
13 x 19½" (33 x 50cm)
PASTEL
Black paper

18 *Unleashed At Last*
20 x 30" (51 x 76cm)
ACRYLIC
Vitality

You'll find all the information you want about how each painting was created by turning to the tab number indicated, in sequence from 1 to 100

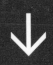

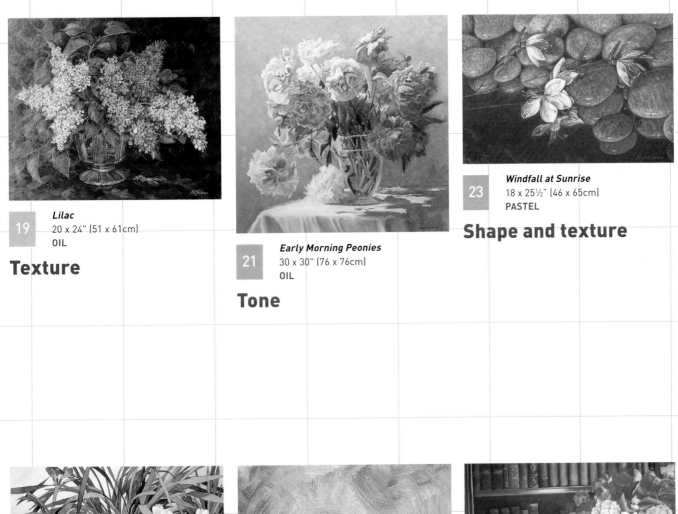

19
Lilac
20 x 24" (51 x 61cm)
OIL

Texture

21
Early Morning Peonies
30 x 30" (76 x 76cm)
OIL

Tone

23
Windfall at Sunrise
18 x 25½" (46 x 65cm)
PASTEL

Shape and texture

20
Still Life with Tulips and Teapot
12 x 17" (31 x 44cm)
WATERCOLOR

Patterns

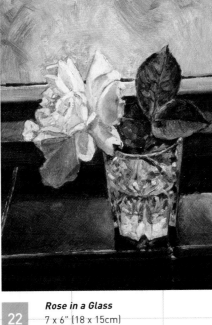

22
Rose in a Glass
7 x 6" (18 x 15cm)
OIL

Expression

24
Something Old, Something New
18 x 24" (46 x 61cm)
PASTEL

Harmony

25
Spuds — Onions
15 x 28" (38 x 71cm)
WATERCOLOR

Saturated color

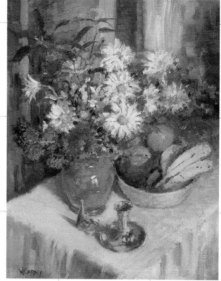

27
Flowers & Fruit
20 x 16" (51 x 41cm)
OIL

Design

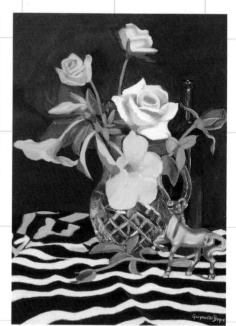

29
Still Life with Brass
13 x 18" (33 x 46cm)
PASTEL

Shape and color

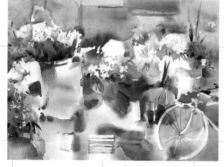

26
Flowermarket
22½ x 29½" (57 x 75cm)
WATERCOLOR

Enhanced white

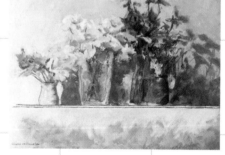

28
Blooms in Cycle
17 x 21" (44 x 54cm)
PASTEL

Storytelling

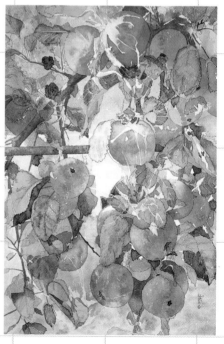

30
Recolte de Provence
18 x 12" (46 x 31cm)
WATERCOLOR

Strategic color

You'll find all the information you want about how each painting was created by turning to the tab number indicated, in sequence from 1 to 100

31 Tulips & Celestial Clock
22 x 30" (56 x 76cm)
WATERCOLOR

Color and rhythm

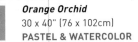

33 Orange Orchid
30 x 40" (76 x 102cm)
PASTEL & WATERCOLOR

Pastel over watercolor

35 Green Glass & Pansies
16 x 15" (41 x 38cm)
OIL

The Brown Method

32 Dutchmen with Cutting Garden
15 x 22" (38 x 56cm)
WATERCOLOR

Feeling

34 Roses and Crabapples
12 x 16" (31 x 41cm)
OIL

Concentration

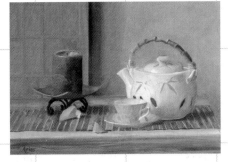

36 Chinese Teapot
14 x 20" (36 x 51cm)
OIL

Mystery

Find it Faster directory
Color coded numbers let you quickly find the paintings you like,
all the methods and materials used and how each artist painted them

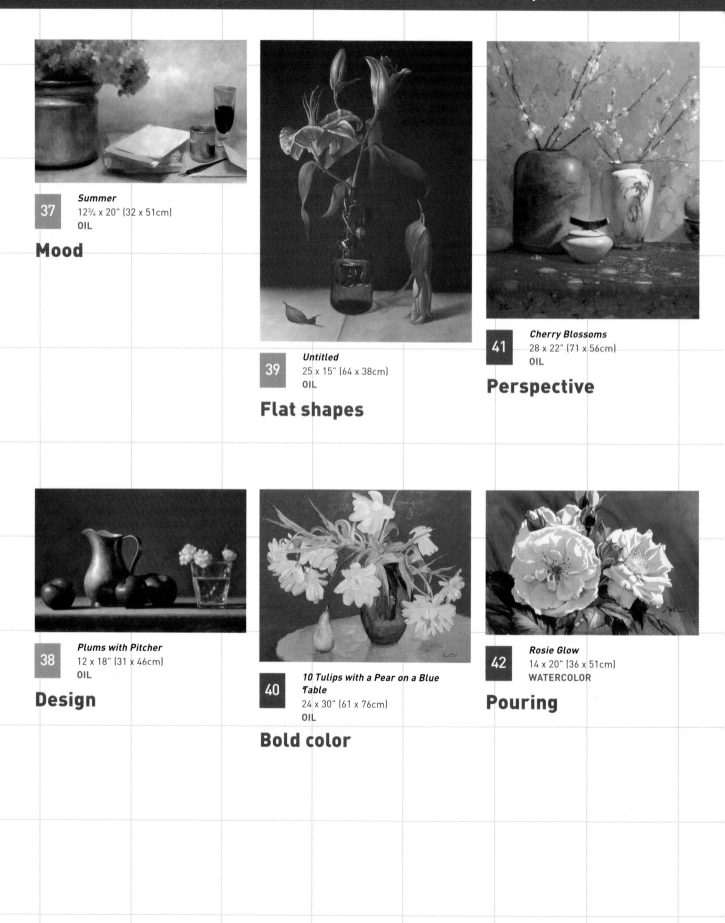

37
Summer
12¾ x 20" (32 x 51cm)
OIL

Mood

39
Untitled
25 x 15" (64 x 38cm)
OIL

Flat shapes

41
Cherry Blossoms
28 x 22" (71 x 56cm)
OIL

Perspective

38
Plums with Pitcher
12 x 18" (31 x 46cm)
OIL

Design

40
10 Tulips with a Pear on a Blue Table
24 x 30" (61 x 76cm)
OIL

Bold color

42
Rosie Glow
14 x 20" (36 x 51cm)
WATERCOLOR

Pouring

You'll find all the information you want about how each painting was created by turning to the tab number indicated, in sequence from 1 to 100

43 *Bird of Paradise*
25 x 39" (64 x 99cm)
FLUID ACRYLICS

Pouring

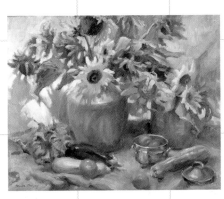

45 *Sunshine Harvest*
24 x 30" (61 x 76cm)
OIL

Cropping

47 *Crane*
20 x 16" (51 x 41cm)
OIL

Texture

44 *Le Plateau de Prunes et Gloires du Matin*
20 x 16" (51 x 4cm)
OIL

Movement

46 *In the Morning*
29 x 38" (74 x 97cm)
WATERCOLOR

Depth and height

48 *Vegetables*
24 x 24" (61 x 61cm)
ACRYLIC

Design

Find it Faster directory

Color coded numbers let you quickly find the paintings you like,
all the methods and materials used and how each artist painted them

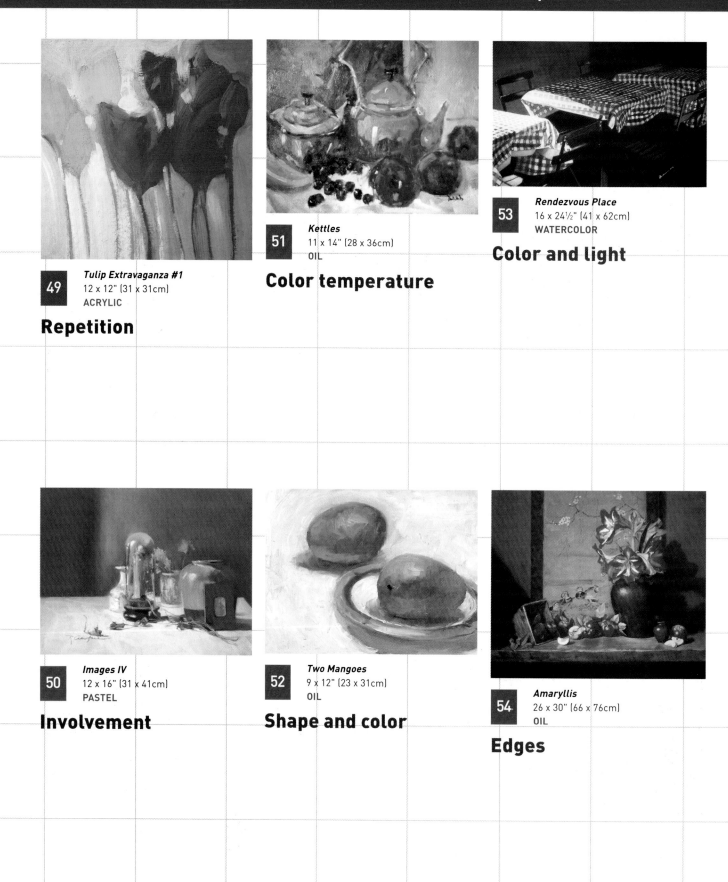

49
Tulip Extravaganza #1
12 x 12" (31 x 31cm)
ACRYLIC

Repetition

51
Kettles
11 x 14" (28 x 36cm)
OIL

Color temperature

53
Rendezvous Place
16 x 24½" (41 x 62cm)
WATERCOLOR

Color and light

50
Images IV
12 x 16" (31 x 41cm)
PASTEL

Involvement

52
Two Mangoes
9 x 12" (23 x 31cm)
OIL

Shape and color

54
Amaryllis
26 x 30" (66 x 76cm)
OIL

Edges

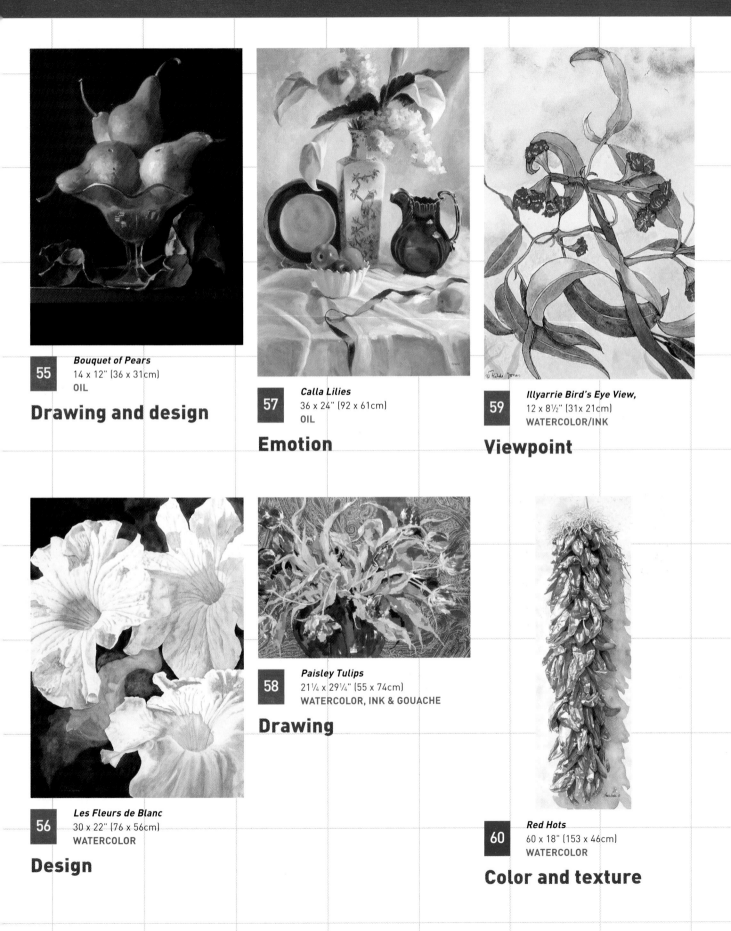

55 *Bouquet of Pears*
14 x 12" (36 x 31cm)
OIL

Drawing and design

57 *Calla Lilies*
36 x 24" (92 x 61cm)
OIL

Emotion

59 *Illyarrie Bird's Eye View,*
12 x 8½" (31x 21cm)
WATERCOLOR/INK

Viewpoint

56 *Les Fleurs de Blanc*
30 x 22" (76 x 56cm)
WATERCOLOR

Design

58 *Paisley Tulips*
21¼ x 29¼" (55 x 74cm)
WATERCOLOR, INK & GOUACHE

Drawing

60 *Red Hots*
60 x 18" (153 x 46cm)
WATERCOLOR

Color and texture

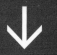

Find it Faster directory
Color coded numbers let you quickly find the paintings you like,
all the methods and materials used and how each artist painted them

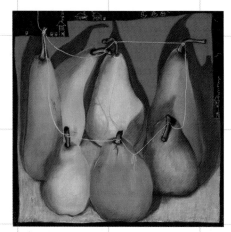

61 *Family (Tied to Life)*
22½ x 22¼" (57 x 56cm)
PASTEL & CHARCOAL

Communication

63 *Persimmons*
31½ x 47" (80 x 120cm)
OIL

Meaning

65 *Sweet Pea Posy*
16 x 16" (41 x 41cm)
WATERCOLOR

Color

62 *Morning Shadowplay*
22 x 18" (56 x 46cm)
OIL

Tone

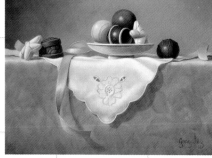

64 *Sweet Things*
9 x 12" (23 x 31cm)
OIL

Classic technique

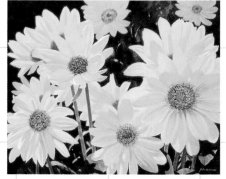

66 *I Got Sunshine*
16 x 20" (41 x 51cm)
ACRYLIC

Glazes

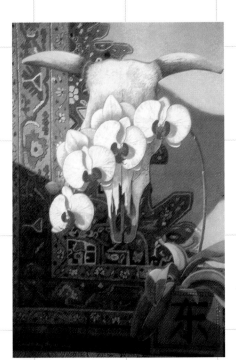

67
Sunlit Meditation
24 x 18" (61 x 46cm)
OPAQUE WATERCOLOR

Content

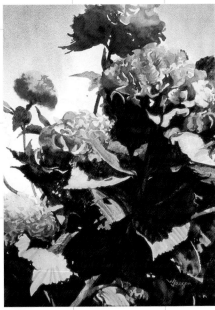

69
Sunstruck
15 x 11" (38 x 28cm)
WATERCOLOR

Cropping

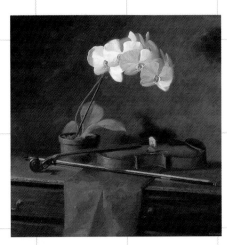

71
Intermission
30 x 30" (76 x 76cm)
OIL

Planes

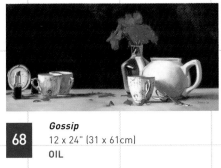

68
Gossip
12 x 24" (31 x 61cm)
OIL

Design

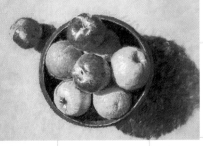

70
Apples and Oranges #2
18 x 28" (46 x 71cm)
PASTEL

Viewpoint

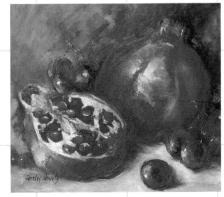

72
Pomegranates
23½ x 27½" (60 x 70cm)
OIL

Zoom in

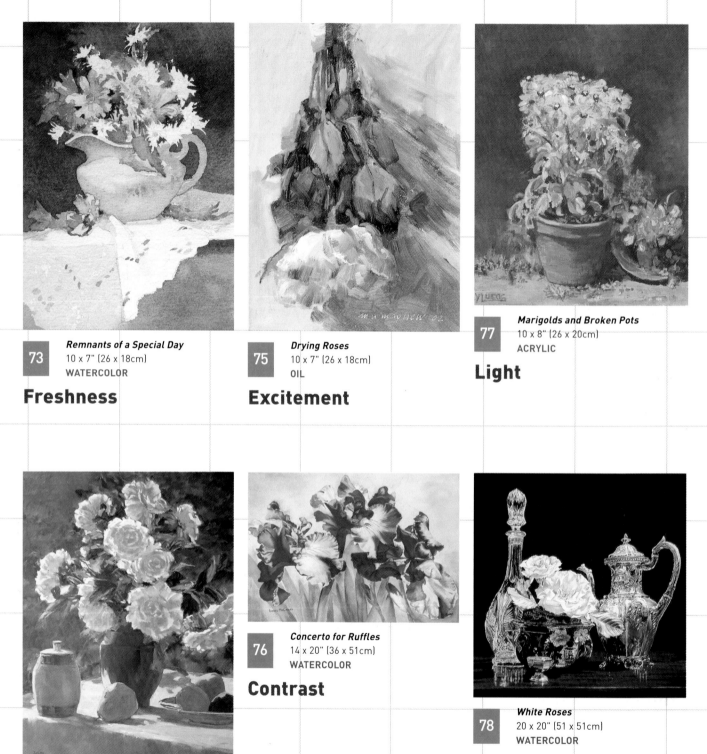

73
Remnants of a Special Day
10 x 7" (26 x 18cm)
WATERCOLOR
Freshness

75
Drying Roses
10 x 7" (26 x 18cm)
OIL
Excitement

77
Marigolds and Broken Pots
10 x 8" (26 x 20cm)
ACRYLIC
Light

74
Sunlit Floral
48 x 36" (122 x 92cm)
OIL
Passion

76
Concerto for Ruffles
14 x 20" (36 x 51cm)
WATERCOLOR
Contrast

78
White Roses
20 x 20" (51 x 51cm)
WATERCOLOR
Color and contrast

You'll find all the information you want about how each painting was created by turning to the tab number indicated, in sequence from 1 to 100

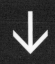

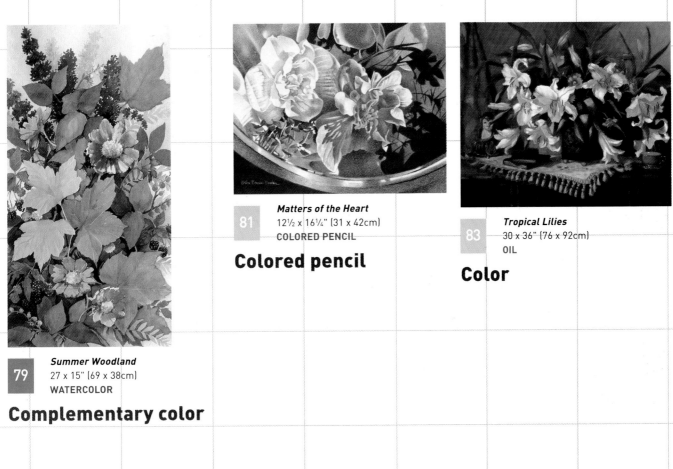

79 *Summer Woodland*
27 x 15" (69 x 38cm)
WATERCOLOR

Complementary color

81 *Matters of the Heart*
12½ x 16¼" (31 x 42cm)
COLORED PENCIL

Colored pencil

83 *Tropical Lilies*
30 x 36" (76 x 92cm)
OIL

Color

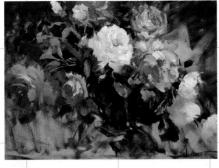

80 *Fragrance*
16 x 20" (41 x 51cm)
OIL

Pigment Quality

82 *Shadow Lights*
22 x 30" (56 x 76cm)
COLORED PENCIL

Light

84 *Melons*
14 x 19½" (36 x 50cm)
WATERCOLOR

Movement

Find it Faster directory
Color coded numbers let you quickly find the paintings you like, all the methods and materials used and how each artist painted them

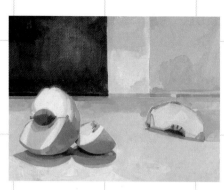

85
Peaches
16 x 20" (41 x 51cm)
OIL

Form

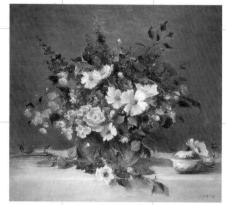

87
Frances' Flowers
14 x 16" (36 x 41cm)
OIL

Color

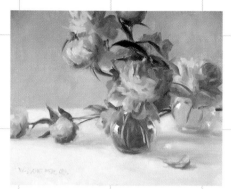

89
Peonies, Cool Light
16 x 20" (41 x 51cm)
OIL

Design

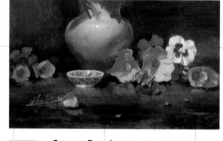

86
Orange Poppies
12 x 20" (31 x 51cm)
OIL

Composition

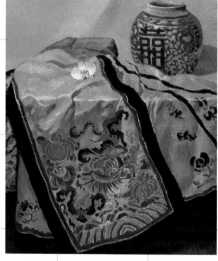

88
Endless Love
21 x 18" (54 x 46cm)
OIL

Harmony

90
Bolero
20 x 20" (51 x 51cm)
PASTEL

Impact

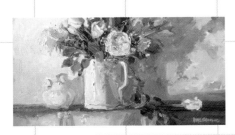

 91

White On White
12 x 24" (31 x 61cm)
OIL

Tone

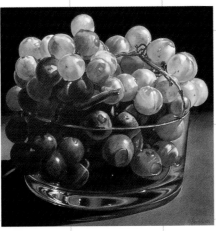

 93

Table Grapes
13 x 13" (33 x 33cm)
WATERCOLOR

Design

95

Cadmium Flowers
14 x 11" (36 x 28cm)
OIL

Impact

92

Silver & Iris
14 x 26½" (36 x 67cm)
GOUACHE

Color and shape

94

Key Lime
14 x 22" (36 x 56cm)
OIL

Light

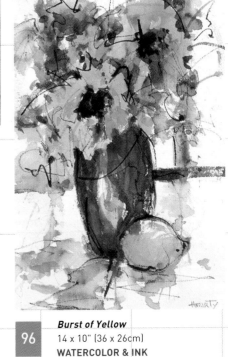

96

Burst of Yellow
14 x 10" (36 x 26cm)
WATERCOLOR & INK

Light

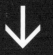

Find it Faster directory
Color coded numbers let you quickly find the paintings you like, all the methods and materials used and how each artist painted them

97
Anemone in Blue
26 x 29" (66 x 72cm)
WATERCOLOR

Impact

You'll find all the information you want about how each painting was created by turning to the tab number indicated, in sequence from 1 to 100

99
Iris
39 x 15½" (99 x 40cm)
OIL ON CANVAS

Content

98
Oranges & Pears
24½ x 14½" (62 x 36cm)
ACRYLIC

Viewpoint

100
Purple Glory
20 x 14" (51 x 36cm)
WATERCOLOR

Mood

My two-brush method helps me control shapes and edges.

Asparagus and Leek Soup, watercolor, 22 x 30" (56 x 76cm)

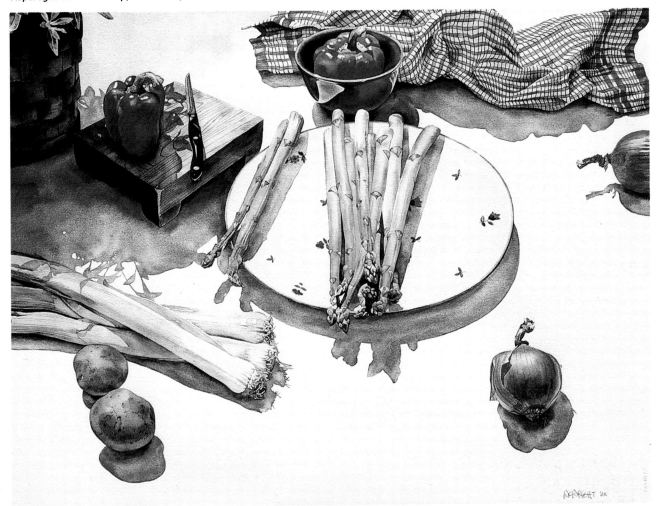

my inspiration

Last spring, I was particularly interested in the color of asparagus and leeks so I decided to use them in a set-up for my students. However, as I worked with the objects, they brought to mind several design ideas I've been considering, such as isolating objects and working with interesting cast shadows. So what began as a set-up for my students ultimately inspired a more complicated design for me to paint.

my design strategy

I always use backlighting to create strong cast shadows that are very organic and abstract in nature. Not only do they connect the objects and unify the composition, they also provide an abstract variable to a realistic painting.

I have several other criteria for my design as well. I love to see light blue shadows and crisp whites, and I'm always looking for high contrast in tonal value, hue, color temperature, form and shape.

my working process

• Working from both my photographs and my set-up, I took several weeks to do a detailed drawing to work out my design.

• I then traced the drawing, rubbed graphite pencil on the reverse of the tracing and traced the image onto my watercolor paper.

• I started with the light values, working wet-into-wet to create soft edges. I did not use masking, but painted around the whites.

• Next, I proceeded to carefully layer watercolor paint in the traditional realistic method to develop the forms, subtle colors and shadows. I painted with two brushes simultaneously — one brush loaded with paint, the other clean water. I wet the surface first, then laid in the paint. The water brush was used to immediately soften edges and push paint around. I stopped frequently to let the painting dry.

• I saved the darkest colors and values for last. At this point,

I realized I needed a stronger note of color, so I set up the red dishtowel and painted from life.

try these tactics yourself

• Work out your design carefully in a separate drawing. Drawing is the key to good painting.

• Study other artists, especially their design and subject matter.

• Use dishes or palettes with deep wells for mixing large amounts of paint so you can keep several shades and temperatures of a color ready for use.

what the artist used

support
300lb cold pressed watercolor paper

brushes
Sable brushes, generally small

watercolors
A palette of 15 colors

William C Wright can be contacted at PO Box 21, Stevenson MD 21153 USA

Dramatic, dark, rich tones at the top and light tones at the bottom set my flowers off.

Light of Roses, watercolor, 14 x 11" (36 x 28cm)

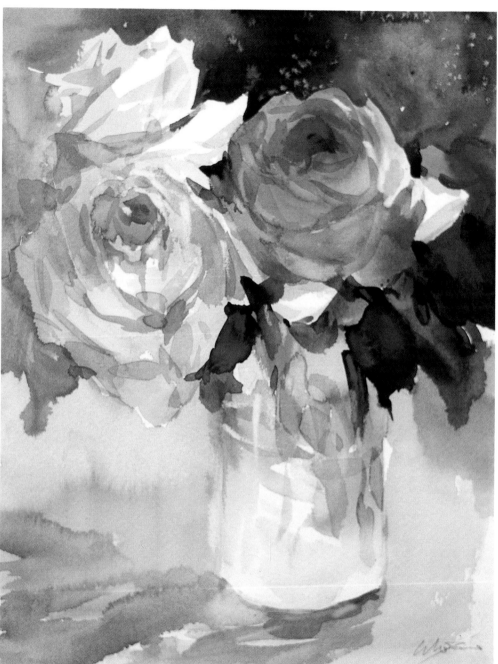

my inspiration

I like to paint roses, so one day I put a vase of roses near a sunny window. The light shone through the flowers and vase, and revealed dramatic color. The petals and the jade were beautifully wrought. The changes of color, the contrasting light, the transparent shade, the off-center position and the interplay of cool and warm tones all gave me inspiration. It was the dramatic light and color that I tried to interpret.

my working process

- I drew the image very lightly on my working surface, paying attention to the composition.
- I began by working wet-into-wet, letting the colors run into one another on the paper.
- In order to create a loose atmosphere in the background, I added a little salt to those washes. Notice how the dramatic contrast of the dark, rich tones at the top and the light tones at the bottom set my flowers off.
- Because I wanted to put the focus on the roses, I added a little more contrast and brighter color in that area, with some subtler contrast in the vase.
- Later, when the painting was done, I used a little bit of water-based crayon to accentuate the highlights.

the main challenge in painting this picture

Special regard was given to the way I handled the color under the shaded area. Keeping this color bright, yet with a subtle contrast, was a challenge.

something you could try

- Even in a shallow space such as a still life, allow the distant objects to have less definition and blend into the background. Put all the focus at the foreground.
- Consider using water-soluble watercolor crayons for highlights and extra definition at the end of the painting process.

Wei Tai lives in Phoenix, Arizona, USA → weitai@cox.net

what the artist used

support
140lb watercolor paper

brushes
Sable flats and rounds

watercolors

A strong diagonal light source and a dynamic composition always work for me.

Still Life in the Window, watercolor, 20 x 20" (51 x 51cm)

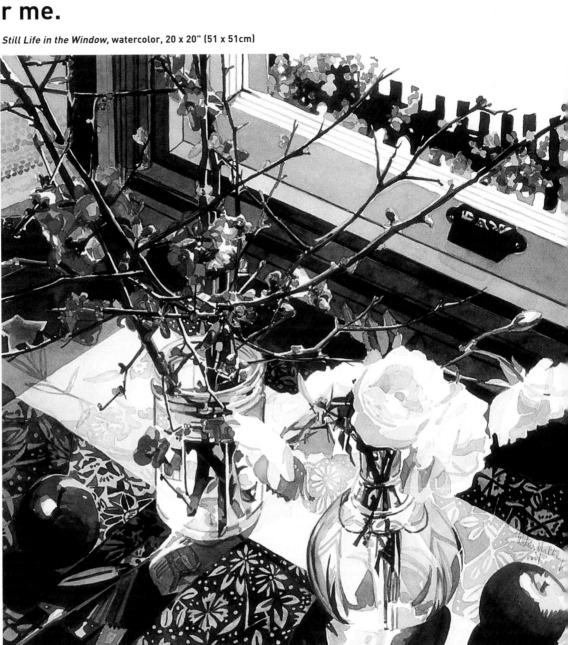

a few of my favorite things

The bright light shining through a window is always a good setting for my still lifes. It makes the glass sparkle, illuminates the flowers, gives me dark shadows that make the light seem more intense and dramatic. In this case, I particularly liked the way diagonal lines of light and shadow falling across the table were echoed in the fence outside the window. I set up my props to interact with and enhance this. An exciting design is a good tool for preventing my paintings from looking overly sweet or sentimental.

I arranged the set-up, using fresh flowers and objects from my ever-growing collection of old dishes, vases and textiles, and then photographed it from various angles and distances. I know I could get several paintings from this one set-up as I arranged and rearranged the props during the photographing.

my working process

- After selecting the photograph with the most interesting design, I projected it and drew a detailed layout on the watercolor paper, using a light touch and a soft lead pencil.

- I laid in the medium values first, mindful to save the whites of the paper. That is what will make the painting sparkle.

- As the painting progressed, I intensified the colors and darkened the darks so that I had some saturated colors to offset the highlights.

- When it looked as much like the photograph as possible and I couldn't stand to work on it anymore, I called it finished. Then I erased my pencil marks, leaving a crisp, bright painting.

the main challenges in painting this picture

The first challenge was retaining the brightness of the light showing through the glass. I wanted to keep the light on the branches of the flowering quince and to show the subtle changes in white in the rose petals. It was also important to me to show the fence outside the window and its diagonal rhythm without conflicting with the flowers and vases.

my advice to you

Don't be afraid or disdainful of working with photographs and projecting devices. They are wonderful tools that allow you to view your subject from more perspectives in less time.

what the artist used

support
Cold pressed paper

brushes
Synthetic watercolor brushes (fairly inexpensive, so I can throw them away when they lose their point)

watercolors
A huge palette of blues, reds, yellows, greens, earth colors, blacks and neutral tint

Shadows and half-light made this still life compelling.

Lily Shadows, watercolor/pencil, 19½ x 14½" (50 x 36cm)

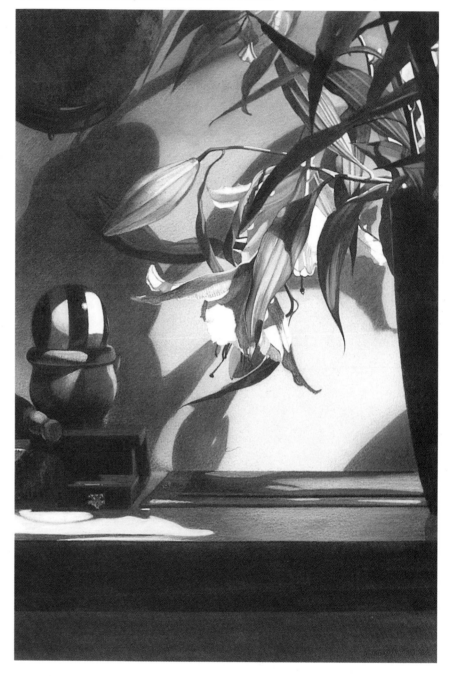

my inspiration

The shadows and complex shapes created by the flowers intrigued me, as did the color and tone, which were quite dramatic. The challenge was to recreate this in watercolor.

my design strategy

Working with both sketches and a digital camera, I explored different compositional and lighting solutions until I found something that felt right. I used small spotlights to make the objects appear to dissolve and emerge from the shadows. I liked the way the circular motion created by the leaves and shadows allows the eye to travel around the picture, always leading you back to the central flower and the onyx ball, which have the most contrast of value and color.

my working process

- Over a fairly precise drawing done with 2B and 4B pencils, I began with the palest washes, limiting the color to a very small range of pure colors.

- I proceeded to build the picture by effectively mixing my desired colors on the paper with a series of glazes and wet-in-wet washes.

- As the painting progressed, I used heavier, thicker paint. Once a layer went down, I never went over it again until it was dry as this would have lifted off the still-wet layer and resulted in a bare patch.

- Having allowed all areas to develop at the same time, I then stopped to assess what it needed. In this instance, I used watercolor pencils to add a slight orange to shadows and smooth a few transitions.

- Eventually, I added detail, tidied up edges, picked out highlights with Chinese White (I'm not a purist, I'm afraid) and viewed the picture from a distance to make sure it was reading as a whole and not as a jumble of parts with equal focal points jousting for attention.

the main challenge in painting this picture

The main challenge with this picture was to get the punchy quality produced from the shadows without allowing them to overwhelm the picture. I wanted them to sit quietly in the background, and not compete with the main object of focus (flowers). It is the simplicity of the shadows and half-light played off details, not the details themselves, that make this painting far more interesting and compelling.

what the artist used

support
140lb cold pressed watercolor paper, stretched before painting

brushes
A full range of brushes from a #10 for the initial washes to #000 for the detail

watercolors

Indian Yellow	Emerald Green	Prussian Blue
Chinese Orange	Chromium Oxide Green	Cinereous Blue
Olive Green	Sepia	Cobalt Blue
Phthalo Green Light	Terre Verte	Chrome Grey

The painting was primarily worked in watercolor with a few finishing touches with watercolor pencils. The pencils allow me to enhance color or tone in an area without disturbing the texture/wash or interesting effect produced by the brush.

Angus McEwan lives in Newport-on-Tay, Fife, Scotland → www.angusmcewan.com

To get this mood, I let the overall atmosphere blend with the subject.

Sleeping Tulips, oil, 11 x 12½" (28 x 31cm)

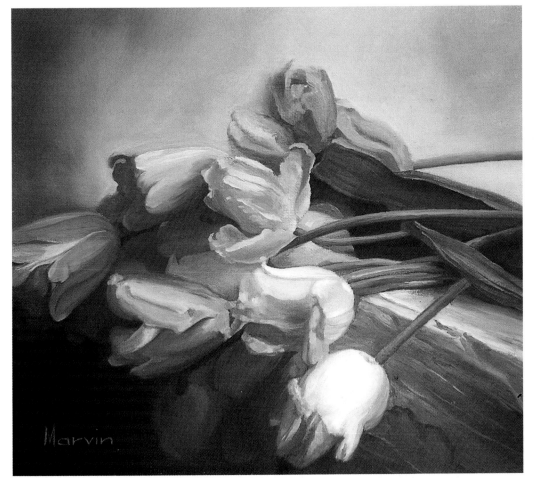

my inspiration

My primary concern was to create a dreamy, diffused mood that enhanced the delicate softness of the tulips. This softness is partially interrupted by the hardness of the stone wall, but I felt this contrast in texture could be very appealing, as long as the overall unity was not disrupted.

my color philosophy

When you look at natural subjects, everything is directly affected by the color of the atmosphere surrounding it. In this subject, for example, the flowers and stone wall were strongly influenced by the surrounding atmosphere (background) color. I wanted to emphasize this continuity in color to create the harmony and unity essential in conveying my mood. I chose a limited palette of oils so I could blend and soften transitions between colors and values,

thereby creating the diffused mood I required.

my working process

- Over a thin, neutral wash, I sketched in the basic shapes of the composition, working directly from life.
- Using a large, flat brush, I quickly applied turpsy washes, creating a tonal underpainting essential to establishing light, dark and mid-tones.
- Once the underpainting was dry, I began blocking in areas of tone and color, using a thicker paint mixture.
- For the background (atmosphere), I decided on a cool color that would complement the warmth of the tulips. Using a cool background helped push the warm tulips into the foreground, thus creating greater depth.

- Once I'd covered the canvas and was happy with the color values, I began exaggerating the light and dark areas, creating more drama.
- In the final stage of the painting, I began using undiluted paint, especially around the focal point. Using smaller synthetic brushes, I proceeded to blend

the background color into the outer edges of the tulips so the atmosphere could influence the subject. The more the subject receded into the background, the more obvious the effect needed to be.

- To complete the painting, I used a soft blending brush to diffuse any harsh edges.

what the artist used

support
Canvas board primed with an acrylic gesso

brushes
Long flat synthetics; long flat bristles; small sable; soft blending brush

other materials
Turpentine

White spirits

Rags for cleaning

oil colors

CADMIUM YELLOW CADMIUM RED ALIZARIN CRIMSON HOOKERS GREEN

ULTRAMARINE BLUE PAYNES GREY TITANIUM WHITE

Marvin Johnson lives in Northumberland, England → tubegallery@yahoo.co.uk

When I place lots of objects I make sure I overlap shapes.

Summer Lunch, oil, 32 x 29" (81 x 74cm)

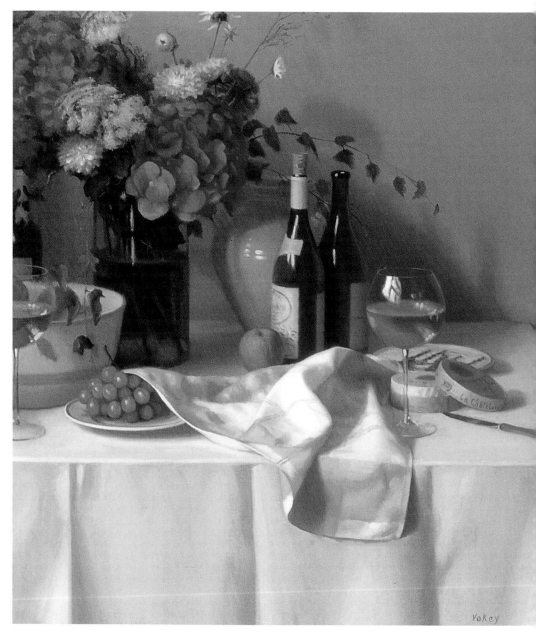

my inspiration

I like to paint still lifes that look like contemporary scenes from everyday life. This painting was set up to be a summer lunch of wine, cheese and flowers that anyone might enjoy.

try these design tactics yourself

- When setting-up a still life, I like to start with lots of objects on the table and then take things away to develop the composition. Variety of materials, textures, shape and color all add richness to a painting, so I often have glass, china, silver and different fabrics and fruits or foods all gathered together.

- I find that overlapping shapes accentuates the contrasts among the different objects and creates the illusion of depth.

- I also use big, diagonal rhythms of shape, color and line to instill strength. Rectangular pictures have four identical 90-degree corners, which are a powerful draw to the eye, so I use diagonals to help keep the attention away from the corners and connect other vertical and horizontal passages, thereby uniting the design.

- Background colors should be carefully considered. They can be used for contrast or, as in the case here, allowed to blend together to create a little mystery.

working toward the finish

I paint directly from life in the north light of my studio. After the design is established, I lay in the painting, using the biggest brushes I have. I ignore the details for as long as possible. Each day I arrive in the studio and try to paint the thing that is the most unfinished. I try to bring forward all the parts of the painting at the same time. Everything in a painting relates to everything else so that when I bring one part forward, another part that looked good yesterday suddenly looks less finished. Basically, I keep repainting and improving the part of the painting that looks the least finished until suddenly, one day, the painting really is finished.

HOT TIP!

Spend a lot of time setting up and designing the still life before you start. If you are going to be investing a lot of time in a painting, it is worth spending as much time on the composition as it takes to get it right.

what the artist used

support
Oil-primed linen

brushes
Bristle brushes in rounds, flats and brights

oil colors

CADMIUM YELLOW LIGHT CADMIUM YELLOW YELLOW OCHRE CADMIUM ORANGE

CADMIUM RED LIGHT ALIZARIN CRIMSON VIRIDIAN CERULEAN BLUE

ULTRAMARINE BLUE TITANIUM WHITE

Sam Vokey lives in Boston, Massachusetts, USA → www.svokey.com

Strong design elements pull the viewer's eye where I want it to go.

Sharpening My Skills, oil, 16 x 20" (41 x 51cm)

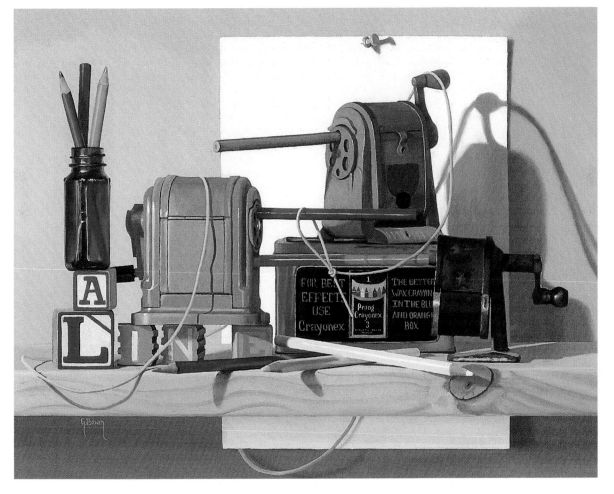

what I wanted to say
My beginning inspiration for this painting was my old crayon box — I loved the colors in it! Then the other objects just started to fall into place, creating a sense of nostalgia. By spelling out "a line" with the blocks and adding the pencils, sharpeners and paper, I saw myself "Sharpening My Skills". It became a reminder to always sharpen our skills in life.

my design strategy
One of the most exciting parts of any painting project is setting up the still life objects. I set these up in a basic pyramid, adding the colored blocks to raise the gray pencil sharpener and to help tell my story. I love color so the colored pencils and the blue jar added some pizzazz. The set-up was feeling a little dark so I tacked the white paper to the wall. I put

the pencils in opposing directions to lead the eye in a stair-step fashion, and then I put the yellow string in to lead the eye all around the painting.

my working process
• The set-up was lit by the north window in my studio, but I added another light source to create strong shadows and light.

• Working from life, I did a detailed drawing to get to know my subject matter better before I started painting.

• On a stretched canvas, I then did a detailed charcoal drawing, sprayed it with fixative and toned the canvas a medium gray.

• Over the course of a few days, I painted from darkest darks to lightest lights, correcting any problems in the drawing as I went. Naturally, I followed the fat-over-lean rule.

• Finally, I did all the highlights and fine details, like the printing on the can. When I stepped back, wow!

the main challenge in painting this picture
Getting the angles and values right was tough. With every painting, I try to challenge myself to draw better and to paint the colors and shapes as accurately

as I can. I love this challenge, and I hope viewers appreciate the realism in my painting.

try this yourself
If you're used to painting from photographs, I highly recommend setting up some objects that excite you and painting from life. You'll improve both your drawing and painting skills.

what the artist used

support
The smoothest, acrylic-primed linen canvas I can find

brushes
Hog hair filberts and brights in larger sizes for the early stages; mongoose hair in smaller sizes as I get to the details

oil colors
Lemon Yellow
Cadmium Yellow Medium
Naples Yellow
Cadmium Red Light
Alizarin Crimson

Raw Sienna
Burnt Sienna
Raw Umber
Sap Green
Phthalo Green

Purple
Prussian Blue
Titanium White
Ivory Black

Ginger Bowen lives in Paradise Valley, Arizona, USA ➔ www.gingerbowen.com

This deeply personal memento of my mother still manages to engage others.

Carnations and Threads, oil, 20 x 16" (51 x 41cm)

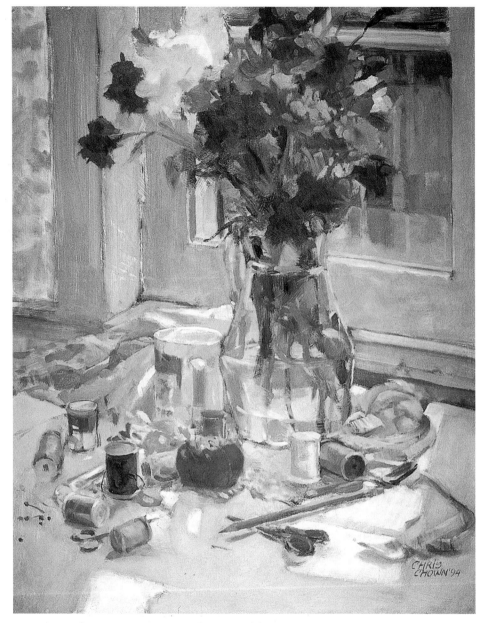

a specific concept

I had a desire to remember and record my mother's special talents and celebrate her spirit in a quiet painting. I also wanted to recall the skills she taught me and the times we shared. Some of the sewing materials are hers, some mine.

my design strategy

In order to set the mood I was after, I decided to:

- Use a cruciform composition to create quiet stability in the verticals and horizontals dividing the space.
- Crop in close, allowing some objects to touch or break out of two or three edges to give the painting a more intimate feeling.
- Incorporate morning light in order to create a neutral, quiet backdrop for the smaller, colorful, interesting areas.

my color philosophy

My aim was to create a quiet, pensive, thoughtful mood, to evoke past memories and perhaps to elicit a little sadness. The overall tone is a silvery, muted blue punctuated with color "patches" and shapes of light to move the eye through. The Russian painter, Leon Gaspard, who lived in Taos, created jewel-like wonderlands with a similar approach.

my working process

- After arranging my objects, I made several pencil thumbnail sketches to consider various value patterns.
- When I had selected one, I started in with oils thinned with turps. I was simply dividing the space into large areas of similar colors and tones.
- Fattening up my oil paints with my medium, I began to define the smaller areas in individual strokes, taking care to get the color and tonal value of each stroke just right. I always stand while painting so that I can constantly step back to view the overall effect of these strokes.
- Finally, using pure paint with no medium, I added my final dark and light accents and highlights.

special techniques

Thanks to careful observation, I was able to create the illusion of the objects with a multitude of color spots, adding very little detail. Because of this, the eye and past experiences fill in the gaps and finish the painting for you. In this way, my own memory piece becomes engaging and interesting to others.

something to think about

A still life shouldn't be still — it should be alive with reflections, bouncing colors, variety in edges and textures, and ingredients that surprise even the artist.

what the artist used

support
Masonite primed with white gessoed ground

brushes
Hog hair bristle brights and flats in #4, 6, 10

mediums
Turpentine for washes

Stand oil, turp and copal varnish for further painting

oil colors
Cadmium Yellow Light
Yellow Ochre
Cadmium Orange
Cadmium Red Light
Alizarin Crimson
Viridian
Cobalt Blue
Ultramarine Blue
Titanium White

I chose classic, dramatic lighting and subdued complementary colors to transform a simple vase and pears.

Offerings From the Orient, oil, 22 x 18" (56 x 46cm)

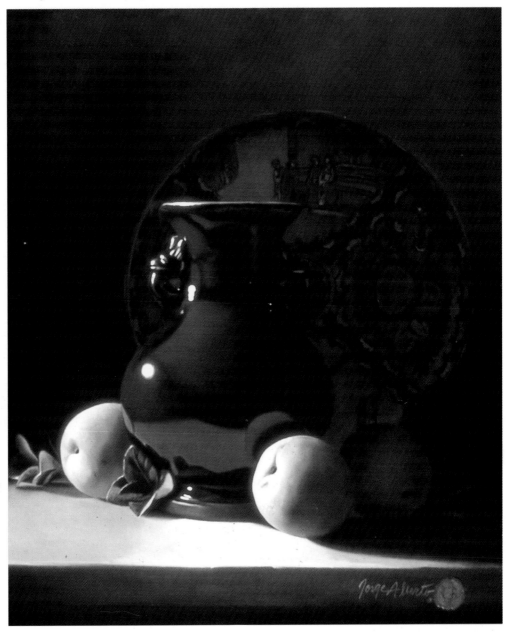

the glow from within

My paintings spring from a life-long fascination with light and how light affects mood. This fascination, present even in my earliest memories, has greatly influenced my way of seeing. Rather than just representing an object, I concentrate on achieving the glow that comes from within. This guiding concept is evident in this painting of a burgundy vase contrasted against yellowish Asian pears and lit with the dramatic light of a classical Dutch still life.

my working process

- After studying the set-up for a few days and perfecting the relationships among the objects in the composition, I made an accurate drawing of the outlines and shadow shapes of the objects.
- Only when totally happy with the accuracy of this drawing did I transfer it into the canvas using soft charcoal.
- Now the fun part began. Always referring to the set-up, I started blocking in shadows and tonal values, not getting too dark and always keeping the integrity of the drawing intact.
- Working from dark to light and back to front, I covered the entire surface with paint. At the end of each session, I went over it with a large, soft brush to knock down the paint.
- Next, I started building up the light areas and details by painting in thick, impasto applications. It was a challenge to include enough detail in the subordinate objects without losing my center of interest.

try these tactics yourself

- No two flowers or apples are the same. Don't paint your generic impression of an object; paint the one in front of you.
- Make sure your set-up is well composed. If you feel something is not right but you can't tell what it is, take a picture of the set-up to identify what needs changing. Digital cameras are great for this.
- Remember, a painting is only as good as the drawing.
- When painting, try to be aware of the relationships between the objects and the space surrounding them. This is achieved by observation and understanding of scale.

a word on materials

I love Maroger Medium. Not only do I add it to freshly grind my paints, but when mixed with Damar varnish, it allows me to create translucent glazes. It also allows me to work the next day over a previously painted section of my painting without lifting the color beneath.

what the artist used

support

Linen or wood panels primed with rabbit skin glue and two or three coats of Cremnitz White, applied with a palette knife

brushes

#8, 7, 6, 4 bristle filberts; Kolinsky sable rounds #1, 3, 5; a #24 flat, soft ox-hair for light blending

Jorge Alberto lives in Baltimore, Maryland, USA → www.jagart.us

It is surface form and texture that I wanted to convey here.

Onions, oil, 9 x 12" (23 x 31cm)

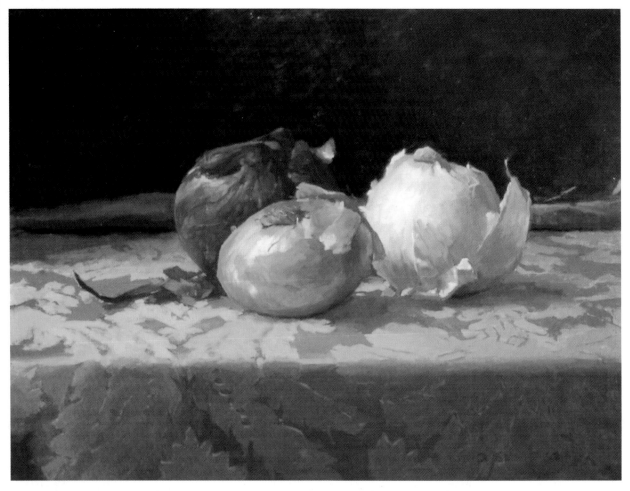

my design strategy

I was at the grocery store when I noticed the onions' flaky textures, varying colors and multiple values. This new visual appreciation of onions prompted a painting.

In composing the painting, I figured the viewer's eye would begin to scan the painting from left to right and be drawn very quickly to the highest point of value contrast. With this in mind, I placed a flake of the red onion on the left to help the viewer engage the grouping of onions. I placed the lightest white onion, which against the dark background is the highest point of contrast, on the right to delay the eye from exiting as long as possible.

my working process

- I started by loosely, yet accurately, blocking in the overall tonal scheme with Raw Umber on a white ground.

- Once this was dry, I started at the highest point of contrast and moved from region to region of the work deliberately placing each stroke of paint with the aim of finishing as I went. For the most part, I used wet-on-wet or wet-next-to-wet brushstrokes and some scumbling.

try these tactics yourself

- I paint from life. I believe painting from photographs puts me one step removed from my subject matter and degrades the values, color and sense of three-dimensional form.

- As I paint, I remain conscious of what I am registering optically in terms of value, hue and chroma, but I also try to imagine each stroke of paint as representing the surface form of a particular object. Additionally, I try to envision the surface form in relation to the light source angle.

- Many artists try to match what they see, in essence copying. Instead, I strive to create metaphors for what I see based on observation. Despite not copying, it can still appear realistic if the metaphors are based on some perceived "truth" and are consistent throughout the work.

my advice to you

- Become aware of your thought process while working.

- Form questions that you force yourself to consciously answer.

- When learning from another artist, don't ask what they did but what they were thinking about while they did it.

what the artist used

support
Finely woven linen with multiple coats of an oil-based ground

brushes
Natural hog-hair bristle rounds; synthetic mongoose-hair rounds

oil colors

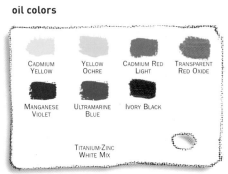

CADMIUM YELLOW · YELLOW OCHRE · CADMIUM RED LIGHT · TRANSPARENT RED OXIDE

MANGANESE VIOLET · ULTRAMARINE BLUE · IVORY BLACK

TITANIUM-ZINC WHITE MIX

Douglas Flynt lives in Sanibel, Florida, USA → douglasflynt@yahoo.com

My challenge was to preserve the delicate translucency of the petals while using dark, strong colors.

Still Life with Roses, watercolor, 28 x 20" (71 x 51cm)

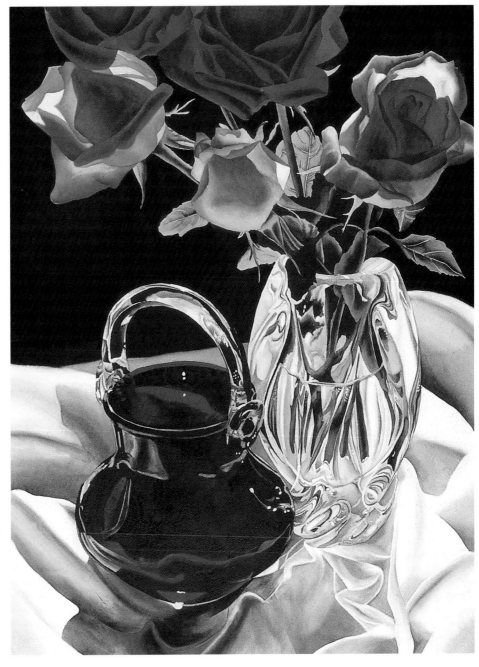

finding a ready-made subject

When growing up in Warsaw, Poland, I loved helping my grandmother and my mom take care of the garden. Roses were my grandmother's favorite flowers, and thus roses always remind me of my childhood.

One particular day I got some roses, put them in one of my favorite glass vases and placed them by a window. The strong sunlight casting dark shadows on the roses and the glass created a lot of contrast, which I found very interesting. It was not my intention to do a painting, but the roses looked so dramatic that I decided to take up the challenge.

my design strategy

Before I could get started, I had to improve the composition. I added a red glass container to balance the red roses and a white tablecloth to create contrast against the dark background. I placed them close to each other, overlapping to allow the viewer's eye to move from one shape to another without stopping.

I always prefer bright, natural sunlight over artificial light because everything looks more dramatic and three-dimensional. However, my painting process takes a long time (sometimes several weeks), so my solution is to work from photographs. To record all of the information I would need regarding the objects, lighting, color and so on, I took several photographs of my roses from various angles.

my working process

- Working with my photo references, I began with a value study and then prepared a pencil sketch.

- I gradually developed shapes, colors and values by applying watercolors in multiple layers of warm and cool colors. The white tablecloth was created by reserving the white of the paper and then adding shadows.

- One of the most challenging tasks was painting the backlight effect on the roses. I wanted to show the translucency of the petals, but at the same time I had to work with quite dark and strong colors.

- At the end, I lifted some highlights on the glass and softened edges with a scrubbing technique. Achieving a high degree of value, color and texture contrasts was integral to my vision of the painting.

HOT TIP!

Beautiful and interesting shadows aren't black or gray. In the case of my painting, you can observe that the shadows on the tablecloth have yellow, orange, red, brown and pink underneath the blue-gray.

what the artist used

support
300lb rough watercolor paper

brushes
Rounds # 8, 10, 12; flats ½", 1"

oil colors
New Gamboge
Vermilion
Alizarin Crimson Permanent
Ultramarine Blue
Sap Green
Cobalt Blue
Burnt Umber
Quinacridone Gold
Indigo

Monika Pate lives in Ames, Iowa, USA → mpate65@mchsi.com

I built a theme around one important object.

biding my time

Many years ago I visited Japan and brought back a number of objects, including a Japanese doll in a glass case. I had often thought about including it in a still life, but was not sufficiently inspired to do so until recently. It happened that the Society of Women Artists, of which I am a member, decided to put on an exhibition of paintings with a Japanese theme in honour of a city-wide celebration of Japan, so I decided to work with the doll.

In looking for organic objects to complement the doll, I immediately thought of lilies and cherries, both of which appear in Japanese imagery and often appear in my watercolors. The light values of the flowers and fan, coupled with the dark greens of the leaves, made a nice foil for the rich reds of the doll's kimono and screen.

my working process

- I began by arranging my set-up and taking many slides from different angles and with different lighting. Throughout this process, I rearranged objects as necessary.

- After choosing the best composition, I projected my slide directly onto my paper, correcting and cropping the drawing as necessary for maximum impact.

- I painted the background first with flat washes so I could relate all of the foreground colors to it.

- Working wet-on-dry, I painted in all of the shadows.

- Next, I glazed layers of local colors over the individual objects, looking at the actual objects for color accuracy. I did the objects in the middle ground before painting the foreground objects in my brightest colors.

HOT TIP!

When painting floral still lifes, I recommend using supporting objects that harmonize with your main flowers and objects. Then, choose the background for color contrast.

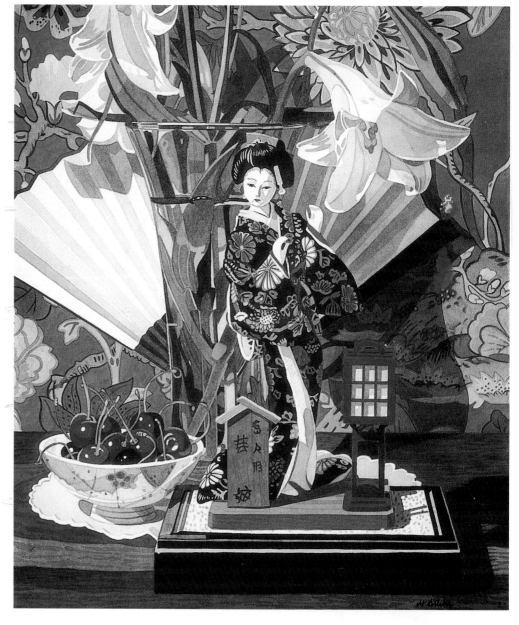

Japanese Still Life, watercolor, 28 x 20½" (71 x 52cm)

what the artist used

support
300lb cold pressed watercolor paper

brushes
Rounds #12, 8, 5 and 4

watercolors

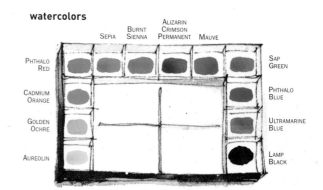

Marjorie Collins lives in Oxford, England → www.marjoriecollins.com

I like to create a feeling of movement.

Yellow Roses with Lilies and Trumpet Vine, oil on linen, 16 x 20" (41 x 51cm)

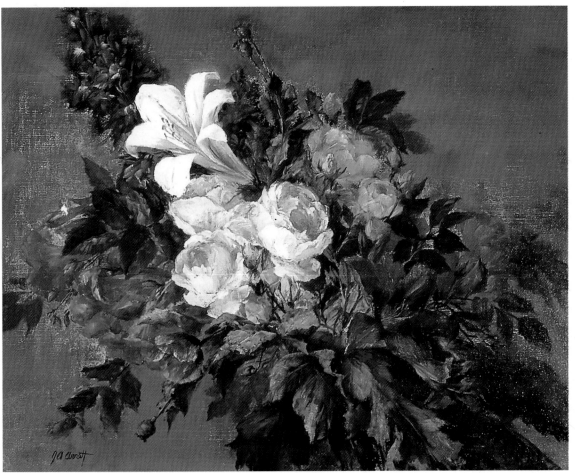

my inspiration

More than a decade ago, I moved into a small adobe house in Santa Fe. My husband and I slowly converted the weed-filled yard into a magnificent cutting garden full of flowers for my paintings. A summertime walk in my own sweet garden is all the inspiration I need.

my design strategy

For this painting, I began by cutting some fresh blossoms. The yellow roses and white lily were the central focus. I then chose supporting blossoms. Some blooms continued the warm feeling, while a few touches of purple provided an engaging complement. In my studio, I worked to arrange the flowers in an exuberant thrust, creating the feeling of motion within the composition. There are also lateral movements, such as the leaves that lead the eye back to the yellow roses. I moved and shifted

elements until the composition was exciting enough to begin.

my working process

- Taking my cue from the dominance of warm colors, I toned the canvas with a wash of Red Oxide, which I allowed to dry before beginning the painting.
- I then went directly to painting, placing a few lines to indicate the positions of the major elements. Beginning with the group of flowers that were most important, I painted wet-into-wet, finishing each bloom or area as I went. If it didn't go down with freshness the first time, I scraped it off and did it again.
- I worked out from the main group, working on the leaves and surrounding flowers. While edges were still wet, I made decisions about which to make crisp and which soft.

- I wanted the background to have a very casual, under-finished look so I painted a slightly cooler color over the warm ground, and then scraped over it with a palette knife.
- As tempting as it was to add just one more blossom or leaf, I stopped when it looked fresh and said what I wanted it to say.

special techniques

- The rich textures in the center of this composition are impasto, done with soft, synthetic brushes and a few "hits" of a palette knife.
- Flowers in nature are never flat, solid colors. By under-mixing my pigments, I can suggest lovely color variations.

what the artist used

support
- Linen mounted on a rigid board support made the background scraping possible.

brushes
A variety of brushes, both filberts and flats, preferably softer synthetic brushes, and a palette knife.

oil colors

Naples Yellow	Cadmium Red	Manganese Blue
Yellow Ochre	Transparent Red Oxide	Cobalt Blue
Cadmium Yellow Pale	Permanent Alizarin Crimson	Ultramarine Blue
Cadmium Yellow Light	Permanent Rose	Flake White
Cadmium Red Orange	Viridian	

Joe Anna Arnett lives in Santa Fe, N Mexico, USA → www.joeannaarnett.com

One of my hallmarks is letting the canvas show through.

Still Life with Embroidered Pig, oil, 13¾ x 18" (35 x 46cm)

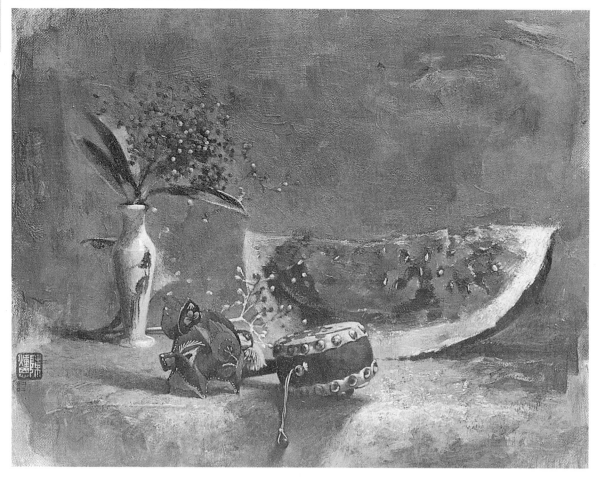

what I wanted to say

In my student days, I went on an incredible overseas exchange trip to China. On that trip, I bought a set of Chinese zodiac animals done in embroidery. Ever since, I have wanted to include this cute pig in one of my pictures. The addition of the toy drum and the huge slice of melon hint at the idle and innocent concerns that revolve around children, which is the theme I wanted to accentuate.

my working process

- The painting was lit from overhead because the set-up occupied a small area and was straightforward and simple. There were neither heavy ideas nor dramatic shadows that I wanted to portray.
- There was not much designing involved. Spontaneity, colors and mood were of utmost importance to me.

- I started off without the flowers and painted the pig, drum, vase and watermelon. After a general roughing out of the main items, I switched between the smallest brushes for the details and the larger ones for the background, leaving the painting to dry between layers. Every element was painted at the same time, to achieve cohesiveness.
- Next, I re-stated the first melon and then placed the flowers in the stone vase.
- The small and playful highlights of bright green and magenta provided jewels for the eyes to rest upon.
- Finally, I added glazes of Transparent Yellow Oxide and Transparent Red to unify the elements and to enhance that particular atmosphere I was looking for.

special techniques

I enjoy using paper towels dipped in solvents to lift off unwanted areas. Otherwise, I use wet-on-wet and dry-on-dry for main elements in the painting. There are many layers of glazes in the background. For extra texture, I use the knife for applying and scratching thin marks and to paint in subtle variations in the background.

something you could try

Leaving some of the canvas showing through has always been a personal hallmark. I find it claustrophobic to fill up the entire canvas with thick, opaque paint. Instead, scraping or removing paint from the background with a palette knife, paper towel or a stiff brush and then glazing with knife or brushes creates an uneven, atmospheric background. With this approach, I can go for the overall mood, which can never come from recreating the tiniest details.

what the artist used

support
Canvas

brushes
A selection of larger rounds and flats; very small pure red sables for detail; a palette knife

other materials
Glazing and painting medium

oil colors

Transparent White	Raw Umber
Off White	Burnt Sienna
Titanium White	Olive Green
Transparent Yellow Oxide	Turquoise
Yellow Ochre	Cobalt Blue
Light Red	Ultramarine Blue
Transparent Red	Oxide Black
Carmine	

Contact Chen Chong 'En at Blk 80, Nicoll Highway #04-84, Singapore 188836

Contrasting lines and tones, and the glitter of highlights, echo the spicy excitement of my subject.

May I Taste This?, watercolor, 35 x 53" (89 x 135cm)

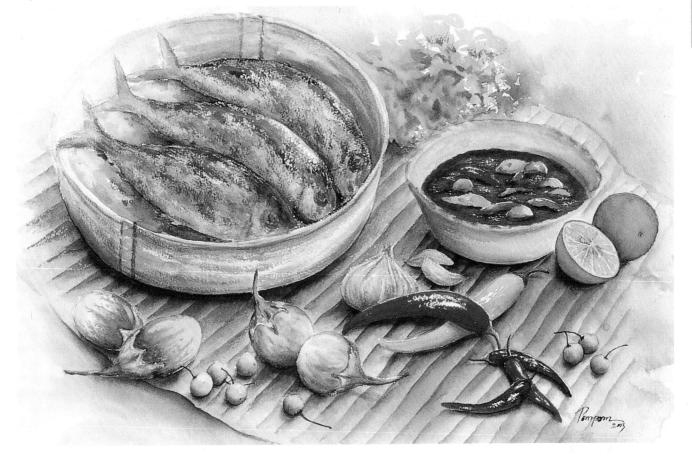

a tempting subject

Nam-Prik Pla-Too is one of many favorite Thai foods. The bright colors of chilies represent the hot and spicy taste, which is an essential characteristic of Thai food. Together with the color of the cooked fish (the Pla-Too) and vegetables, they made a tempting subject. Adding another oriental touch to the painting, all items were laid on a beautiful banana leaf.

my design strategy

This painting was done from life. I made a separate sketch first to study the light, shadow and composition, then finalized my design on the watercolor paper.

My entire arrangement was built around contrasts, especially of colors, in order to attract attention. Notice how the banana leaf background and surrounding vegetables in cool tones harmoniously offset the warm tone of the chilies. The diagonal lines of the leaf in the background were intended to contrast with the curves of containers and vegetables. Additionally, I set the fish with their heads to the center of the painting, again in opposition to the direction of the banana leaf. I even positioned the light source in such a way as to make the shadow drop in the same direction as the lines of the banana leaf.

With my arrangement in place, I took a photograph to observe and retain a memory of the colors of the food. I then began to develop the painting.

try these tactics yourself

- To create rough textures in some areas, such as on the fish scales, I painted wet-on-dry, using dry brushstrokes.
- Wherever I wanted to make an object look shiny, I painted wet-on-dry, carefully working around small white areas to create highlights.
- Another way to create highlights is to scrape off the dry pigment with a sharp knife.
- For the texture on the banana leaf, I painted each thin line, then used a wet brush to soften.

what the artist used

support
Rough, 140lb watercolor paper

brushes
Rounds in sizes 3/0, 2, 4, 6

watercolors

Black pastel paper helped me emphasize the glow emanating from these eggs.

Eggs and China, pastel, 13 x 19½" (33 x 50cm)

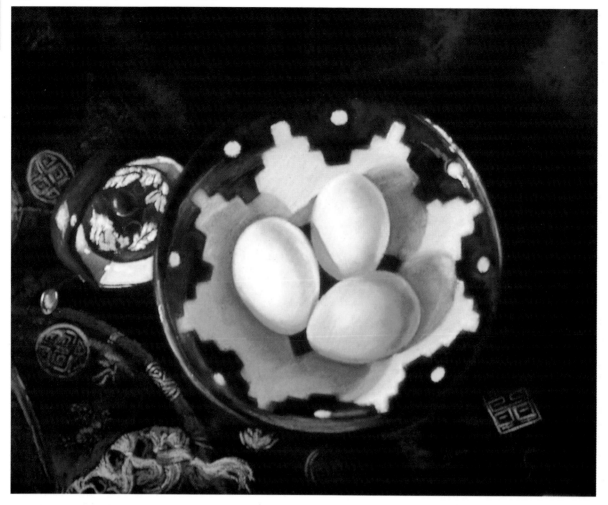

my inspiration

The setting up of a still life is always exciting for me, and I usually begin with some sort of theme or favorite piece on which to base the composition. The initial focal point for this painting was the blue silk, but as soon as I saw the eggs and their beautiful shadows, I knew that the silk would have to take a back seat. The main concept of this painting from then on was to show the many colors and tones within the shadows and the beautiful glow on the eggs. What better way to highlight these elements than with an overhead viewpoint? The title refers to both the china objects and the Chinese silk.

my design and color philosophy

I set up the arrangement in my studio where it could stay undisturbed until the painting was finished. My primary interest was one of dramatic contrast, that is, the glowing eggs surrounded by darkness. This also explains why I used near-complementary colors to accentuate the focal point, with the blues making the golden yellow tassels and the eggs and their shadows glow.

Once I had the composition I wanted, I immediately took photos for future reference because I know how easily things can become rearranged — especially by a curious cat! The majority of the painting was done from life but I was glad of the photos because the light changed (as it has a habit of doing!) and the shadows became rather ordinary.

my working process

- I began with simple pencil studies to establish the main values, and then drew the ghost image onto the pastel paper with a white pencil.

- Starting with the eggs I worked from dark to light, finishing them completely before working on the next section, the shadows. When the bowl was complete, I went on to the teapot, always finishing each section before moving on and always working dark to light.

- Layering and unifying with the many colors that made up the shadows, particularly those cast by the eggs and the teapot handle, was great fun.

something you could try

I always work on a black or near-black surface because I find it adds extra depth and sets off colors beautifully. It's yet another type of contrast that will add drama to any subject.

what the artist used

support
A sheet of black pastel paper

pastels
A combination of very soft brands of pastels, including various tones of burnt sienna, gold ochre, orange ochre, indigo, ultramarine deep, phthalo blue, bluish green deep, yellow, brown-earth, blue-violet and white

Soft charcoal pencil and pastel pencils

No fixative

Catherine Lidden lives in Braidwood, NSW, Australia → cjlidden@yahoo.com.au

A high eye level let me concentrate on reflections and enhance surface texture.

Ginger Jar and Spoon, oil on canvas, 10 x 12" (26 x 31cm)

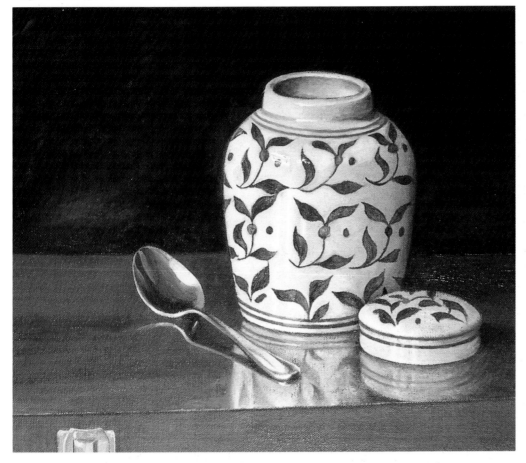

the main challenge in painting this picture

The challenge for me is always to express the qualities of the surfaces of the subject and to create a convincing three-dimensional illusion. I never aim for a photographic likeness but nevertheless try to convey the truth of the subject. My inspiration is Jean Simeon Chardin, who showed that painting simple subjects truthfully can demand great skill and yield dramatic results.

my design and color philosophy

I wanted to show the objects sitting on a surface, particularly their reflections, which meant placing them at a relatively high eye level. I began to move the objects around until I found the right composition. The angle of the box with its small metal clip was vital to the balance within the painting.

The box upon which the objects are sitting was chosen to contrast with the blue of the pot decoration, and the contrasting dark background was meant to enhance the illusion of light. I then placed a single light source at about 10 o'clock, slightly in front of the grouping, to describe the forms of the subject.

Thanks to these decisions, we are led in diagonally from the bottom right, following a path of light on the lid and side of the jar that leads to the spoon. The eye is rewarded by finding the spoon and the other metallic item, the catch on the box, on which the objects are standing.

my working process

- I did a pencil drawing first to check the composition.
- I then started with a charcoal drawing on a colored ground.
- Following the fat-over-lean principle, I began the underpainting with thinned colors and built up to full-strength paint when establishing the forms.
- Finally, the detail, reflections, highlights and fine line work were done.

my advice to you

- Study the work of the masters. (Chardin, Henri, Fantin-Latour and Manet are particular favorites of mine.)
- Look carefully and paint what you see, not what you think should be there.
- Use a limited palette and you will create a more coherent painting.

something you could try

Substitute Unbleached Titanium Dioxide for Titanium (or other) White when lightening colors. Reserve bright white for the final highlights. This gives a more subtle effect.

what the artist used

support
Linen canvas, because of its irregular texture and reliability

other materials
Pure gum turpentine and sun-thickened linseed oil, which I make myself, as a painting medium, the latter being a wonderful all-round vehicle

oil colors

| CADMIUM YELLOW DEEP | LIGHT RED | CADMIUM RED DEEP | RAW UMBER |
| COBALT BLUE | ULTRAMARINE BLUE | UNBLEACHED TITANIUM DIOXIDE | TITANIUM WHITE |

Gerald Hannibal lives in Watford, Hertfordshire, UK → studiohannibal@aol.com

I particularly liked the way these daffodils were bending in a slight breeze, suggesting movement and life.

Unleashed At Last, acrylic, 20 x 30" (51 x 76cm)

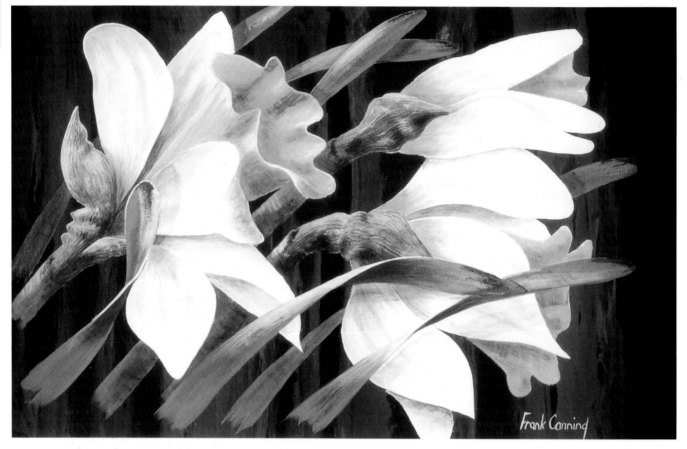

my inspiration

Flowers are my specialty. This comes — I think — from the years I spent as an underground coal miner. I remember how brilliant and stunning the colors appeared to me each day after spending seven or eight hours underground in total blackness.

I grow lots of flowers in my garden, and some I use in my paintings. I particularly liked the way these daffodils were bending in a slight breeze, suggesting movement and life. With the light shining from left to right, the subject also had interesting shadows under the leaves and inside the flowers.

how to photograph flowers

Although I prefer to paint from life when possible (my color remains fresher and more accurate that way), I also take a lot of photographs for reference. I use my macro lens for extreme close-ups. I photograph every inch of the flower, inside and out, from all angles and at different ranges. I also photograph the stems, leaves and even the ground. I take pictures in all types of light to record the changes in shades and tones.

my working process

• Working at an architect's drawing board, I surrounded myself with a number of my reference photos and a few flower heads and leaves.

• Taking note of the flowers' colors, I determined which colors to use for the background. For this picture, I wanted a sort of contemporary background with runs of complementary colors.

• Once the background was completely dry, I covered it with a sheet of architectural tracing paper and drew out my composition. This method allows me to design to fit my background, correcting the drawing without spoiling the art board. Once I had the desired layout, I transferred the image onto the background with graphite transfer paper.

• Painting the flowers was simply a matter of building up the color and describing the forms with as many as 12 transparent layers.

• To finish, I topped it with white highlights and used Paynes Gray for the deeper shadows.

something to think about

I think acrylic colors are the most brilliant and stunning in color, which makes them ideal for painting flowers. Plus, they dry quickly and layer well.

what the artist used

support
"Not" watercolor board

brushes
Sable/synthetic blends (I am a brush fanatic and have pots of brushes!)

acrylic colors

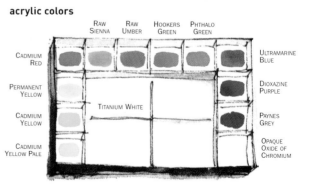

Frank Canning lives in Retford, Nottinghamshire, England → www.frankcanningartist.co.uk

Study the way I used texture and tones.

Lilac, oil, 20 x 24" (51 x 61cm)

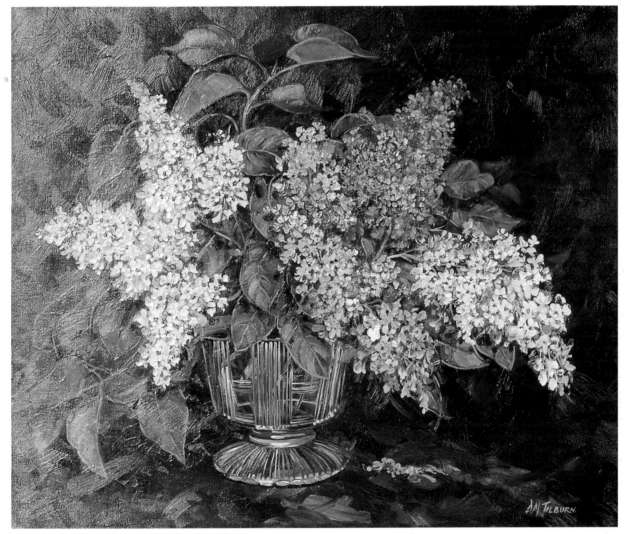

my design strategy

I tried to structure my composition in such a way as to invite the viewer to enjoy both the cohesive whole as well as the intricate details. I arranged the flowers in a natural balance, creating a sense of movement and rhythm. The contrast of busy against peaceful areas supports this. At the same time, through a convincing range of tonal values, you can appreciate the weight of the flowers and observe the delicate, individual flower heads against the intricate pattern of leaves.

my working process

• I started in on the background, using thick strokes of paint in all directions in a wet-in-wet technique. First I applied blue-green shades in the shadowed areas of the leaves. Then, while the paint was still wet, I used a 1" sable and yellow-green paint, moving in various directions to create the leaves. This color picked up the blue shades from beneath, creating interesting shades and patterns.

• The following day, I used a sable brush again to stroke through the semi-dry paint in opposite directions, here and there. This put a sheen on the leaves.

• Next, I used a knife for the blossoms, trying to make convincing clusters of flowers. Still, I remembered my need for busy and quiet areas.

• Using a mahl stick to steady my hand, I used a fine rigger to suggest the glass reflections.

• To complete the painting, I used the wrong end of the brush dipped in thick paint as well as the rigger brush to put in some accents and details. It was important to link up the twigs and mark in the leaf veins.

something you could try

The wet-in-wet technique, especially with oil paints, is a wonderful way to get interesting blends or near-blends of color. Darkest darks, especially, can end up with exciting dabs of a color from a nearby object.

what the artist used

support
Canvas panel
(medium grain)

brushes
Filbert #4, 8, 12
and larger;
1" wide flat sable;
rigger #3;
knife (trowel shape)

oil colors

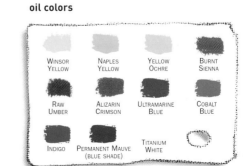

WINSOR YELLOW · NAPLES YELLOW · YELLOW OCHRE · BURNT SIENNA · RAW UMBER · ALIZARIN CRIMSON · ULTRAMARINE BLUE · COBALT BLUE · INDIGO · PERMANENT MAUVE (BLUE SHADE) · TITANIUM WHITE

Dorothy Tilburn lives at "Oakdene", Morton-on-Swale, Northallerton, North Yorkshire DL7 9RF UK

This is all about patterns, textures and reflected colors.

Still Life with Tulips and Teapot, watercolor, 12 x 17" (31 x 44cm)

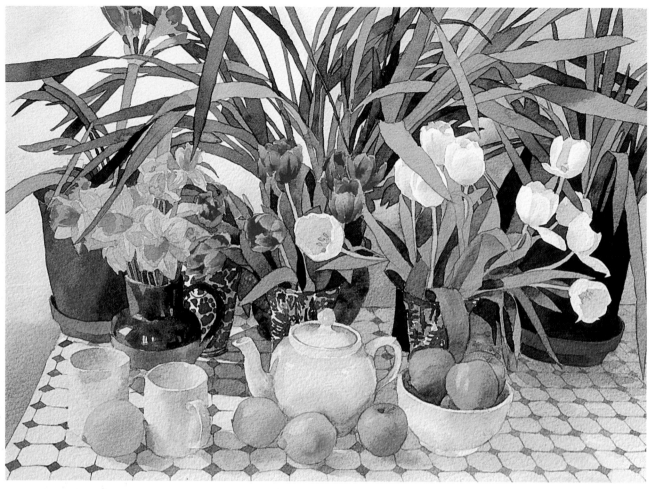

my inspiration

One spring morning I walked into my studio to find the early light coming through the window, shining on the flowers and pots. I wanted to capture that moment of promise that spring holds after a long winter.

my design strategy

I felt that using contrasting tonal values as well as complementary colors of red and green would express the excitement and anticipation of the moment. The patterns, textures and reflected colors in the white china pots were also vital to the feeling I was after.

I began with a sketch and took a photo to capture the way the light was falling on the objects. I continued drawing in more detail, allowing the design to evolve as I sorted out the potentially awkward shapes and placed the important color notes within the whole composition. Throughout this period, I took more photos as the light moved so that I could later choose the best angle for the shadows.

my working process

- Using my notes, sketches and photographs, I carefully drew up the painting.

- A background wash enabled me to see some tonal contrast. I then worked from back to front in a series of flat washes to establish the shapes and to see the composition.

- Moving around the picture, I strengthened the colors of each object from light to dark, exaggerating the tonal value and color contrasts around the focal point.

- I used a wet-into-wet technique for the fruit, shadows and reflections on the white china, and a wet-on-dry approach for the foliage and some flowers.

try these tactics yourself

- If you're going to paint flowers, spend time studying how they grow and learning to draw them accurately.

- Keep the glow in your watercolors by darkening your colors and mixing neutrals by adding red, blue and yellow instead of gray or black. To enhance the effect, allow the pigments to mix on the paper.

- Take a series of photos as the sun moves across your set-up. When your sketching and initial washes are complete and you're ready to add definition, you'll have your choice of the best possible angles for the shadows.

what the artist used

support
140lb rough watercolor paper, stretched onto board

brushes
Kolinsky sable round designer brushes (a slightly longer hair length than standard)

watercolors

Lemon Yellow	Russian Green
Indian Yellow	Olive Green
Raw Sienna	Ultramarine Blue
Quinacridone Red	Cobalt Blue
Burnt Sienna	Indigo
Sap Green	Paynes Gray

Mary Rodgers lives in Harboro, Leicestershire, UK → www.langtonstudios.com

Try my bold, bright, saturated approach to color.

Spuds — Onions, watercolor, 15 x 28" (38 x 71cm)

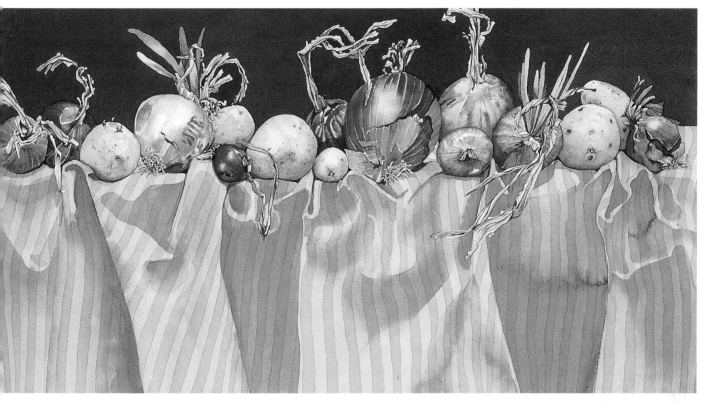

one in a series
One of my favorite themes in art is an appreciation of earth's bounty and finding beauty in simplicity. Here, the lowly spud fit in nicely with these aims, and specifically with the series I'd been doing of vegetables and fabric. A bonus was that the durable potatoes and the colorful onions would not rot in my studio during a summer heat wave.

try these design tactics yourself
Notice how these common objects became fascinating because I:

- Chose an unusual angle and positioned the horizon extremely high
- Created a dynamic feeling by representing horizontal, vertical and diagonal directions
- Overlapped the objects and let them hang off the page
- Incorporated variety in texture, size and value

- Exaggerated the colors, especially any reflected color, to add excitement (any color will work as long as the value is correct).

my working process
- I set up the still life, using natural, overhead light from a skylight in my studio.
- Once I had decided on the format, I stretched the paper using brown packing tape at the edges.
- Then I drew the entire composition out in pencil, very detailed. I lifted some of the darker lines of graphite and saved some of the fine, detailed areas with liquid frisket.
- I painted in the fabric shadows wet-in-wet, then painted the fabric solid yellow wet-on-dry. I went over this with a dark ochre for the stripes. I tend to use a lot of pigment and little water.

- After putting in the solid background, I worked on the onions and spuds, again painting wet-in-wet followed by glazing. While this was still wet, I lifted out the highlights.
- I painted last the tails, roots and sprouts after I'd removed the protective frisket.

my advice to you
I've developed my bold, bright, saturated approach to color theory by studying what other artists have done, both throughout the world and throughout history. Tiles, fabrics, wallpaper, nature (birds, insects, fish and so on) all have incredible color combinations. I recommend jotting these colors down or making color swatches for later reference.

what the artist used
support
Cold pressed watercolor paper

brushes
Small to medium synthetic rounds

watercolors
A harmonious assortment of colors to limit the chaos

other materials
Liquid frisket

Katerina Ring lives in Lucca, Italy → www.katring.com

As a watercolorist, I never forget to enhance the whites!

Flowermarket, watercolor, 22½ x 29½" (57 x 75cm)

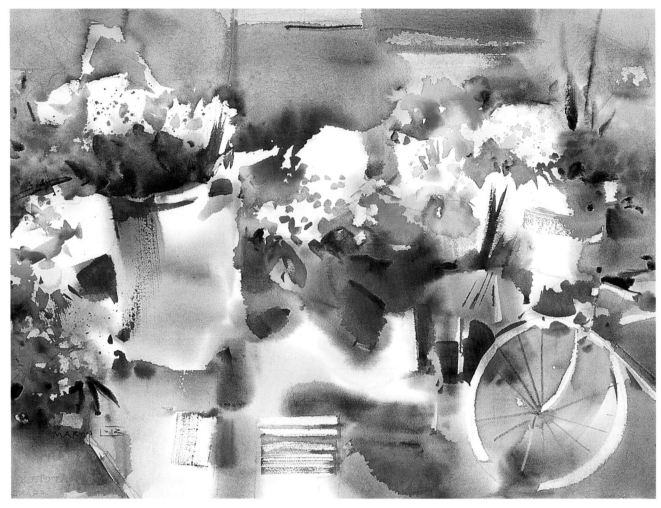

my inspiration

When I stroll through our weekly outdoor market, there is always a lot to see. Depending on the time of the year, beautiful fresh-cut flowers are a feast for a painter's eye.

my concept

A configuration of white shapes became my center of interest. My design would play neutral colors in the background against brighter colors for the flowers and the all-important whites. Because I prefer to paint my larger watercolors in the studio from sketches, I worked this out in a simple, postcard-sized pencil drawing of the main shapes in my sketchbook on site.

my working process

- I painted this picture using classical watercolor procedure: from light to dark, from wet to dry, from the large shapes to the small shapes.
- After a rough pencil outline on my watercolor paper, I started to paint the blue-gray background color all over the sheet, leaving the whites open.
- When this first wash was still wet, I dropped in darker colors — Permanent Rose, Ultramarine Blue and Violet. These darker values made the white shapes appear even brighter.
- The orange and red flower symbols were painted next, while the paper was still a bit wet. These shapes formed soft edges, too.
- With the side of my knife, I scraped out the lines of the box in the foreground. The dark spokes of the bicycle were scratched in with the tip of the knife.
- Some drybrush strokes and details — small lines, dots and spatter — came last.

please notice

The wheel of the bicycle is important. It shows the relative size of the flower pots. Without this wheel, the viewer would have no sense of scale. Cover the bicycle with your finger and you'll see what I mean.

my advice to you

If you are a representational painter, learn to simplify your paintings by thinking in terms of abstraction. Try to find the essence of your motif. Don't get lost in details. Try to form configurations of shapes and make connections as much as possible. Also, follow your color sense, but if you're a watercolorist, play the whites.

what the artist used

support
Rough, 140lb watercolor paper

brushes
Flat nylon hair brushes, size 1", 2" and 3";

a long-haired pointed brush;

a knife for scratching

watercolors

Indian Yellow	Phthalo Green
Vermilion	Cobalt Blue
Permanent Rose	Ultramarine Blue
Indian Red	Violet

Martin Lutz lives in Dudenhofen, Germany → www.aquarellschule.de

A diamond-shaped design did the trick here.

Flowers & Fruit, oil, 20 x 16" (51 x 41cm)

my inspiration

Glancing about the kitchen, some colorful fruit and white flowers sowed the seeds for a new painting. Moving the objects to the table near the window where morning light brought out the color and reflections, I was struck by the power of the image. A little finesse was all that was needed.

my design

A diamond-shaped layout created by the overlapping objects and the table itself began to take shape. I felt such a design would draw the eye into the center of the picture and prevent it from falling off the bottom. I decided to put something in front of the flowers and fruit for balance. I looked around and spotted the small, yet strong, brass candleholder — perfect! A neutral background and white tablecloth were added to define the objects.

my working process

- Several light charcoal sketches were wiped out and re-drawn directly onto the canvas before I committed myself to the final composition.

- I then drew in the elements with a mixture of thinned down Ultramarine Blue and Burnt Sienna, still refining the composition as I went.

- Placing stroke against stroke, I began to establish tones and color values over the entire canvas. I used a rag to smudge and wipe away paint that got too thick and messy. This process helped to push back objects, distribute color over the canvas and unify the image.

- Once again, I squinted at the set-up and refined the value pattern and composition, restating strokes as needed.

- I then used a palette knife to model and reduce the detail on the petals, giving the impression of depth to the painting. I also drybrushed to soften a few edges and blend areas together.

- Finally, I added the highlights, taking care not to overstate them and destroy the picture's impact.

HOT TIP!

Try not to paint each object one by one. Instead, bring cohesion to your image by developing the whole painting at the same time. Address the overall patterns of shape first, then tonal values, colors, definition and detail.

what the artist used

support
12 oz cotton duck, stretched

brushes
Hog hair flats #2, 3, 4, 8, 10 and rounds #2, 3, 4; palette knife

oil colors

LEMON YELLOW · CADMIUM YELLOW · YELLOW OCHRE · ALIZARIN CRIMSON
BURNT SIENNA · VIRIDIAN · COBALT BLUE · ULTRAMARINE BLUE
TITANIUM WHITE

W.D. Carney lives at 75 Baker St, Potters Bar, Hertfordshire, EN6 2EX England

Sometimes a painting becomes a metaphor for life.

Blooms in Cycle, pastel, 17 x 21" (44 x 54cm)

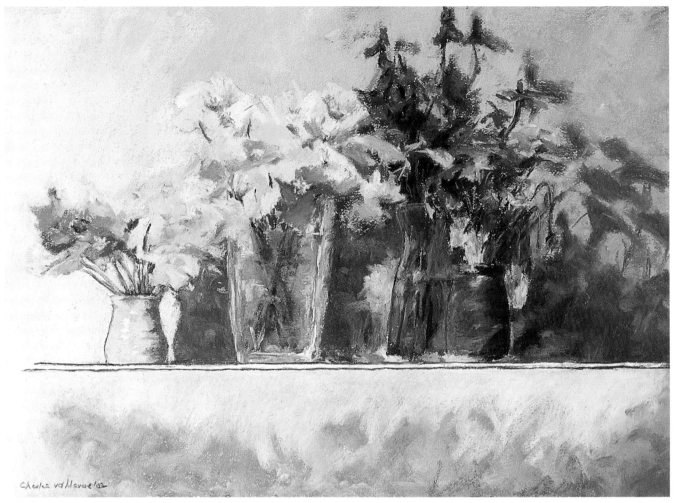

what's the story?

Having decided to attempt a rare (for me) flower study, I bought two bunches of Iceland poppies, placing them in vases. Five days passed without inspiration. Depicting a pretty bunch of flowers is not enough for me, because I believe it is necessary to have some sort of feeling or story to convey.

I bought further bunches of poppies, placing them next to the initial wilting group, but still without an idea of how to portray them. Later, I realised that the new and the old complemented and offset each other and could be depicted as a metaphor for the passage of life. Now I had a satisfying reason for starting.

my design strategy

My initial design strategy was to depict the cyclical process from left to right in the sequence of light, bright colors to rich maturity to dark decay and shadows. It seemed natural to then place the light source marginally above and to the left of the table. The white wall and white tablecloth dramatized the colors and accentuated the cast shadows.

my working process

- I attached a pre-cut sheet of pastel paper with large clips to my 6-ply board over several layers of paper. This provides a cushion for my method of pushing the soft pastel for thick, impasto effects.

- Foregoing all preliminary sketches, I broadly laid in similar color masses to establish tonal contrast.

- Using a variety of semi-soft and soft pastels, I then proceeded to establish object forms (without too much detail!), ensuring that the essence was captured and easily recognizable. At the same time the background and other aspects were also roughly laid in to ensure organic growth and color compatibility.

- When almost complete, I left the painting for a while against my studio wall to allow any mistakes to identify themselves. Later I made corrections until the painting felt right.

please notice

Only near completion did I decide not to follow my initial plan to have the table surface running uninterruptedly from border to border. I felt I needed something to lead the eye round the picture so the viewer could choose where to stop (or start!) in the "life cycle". This then led to the table surface being indicated by a double line that does not reach to either the left or right borders. The gap conveys the passages of life, renewal and rebirth.

what the artist used

support
pastel paper

pastels
Soft, buttery pastels

Charles van der Merwe lives in Cape Town, South Africa → cvandem@iafrica.com

Carefully placed shapes and color notes bring vitality and harmony to this appealing subject.

Still Life with Brass, pastel, 13 x 18" (33 x 46cm)

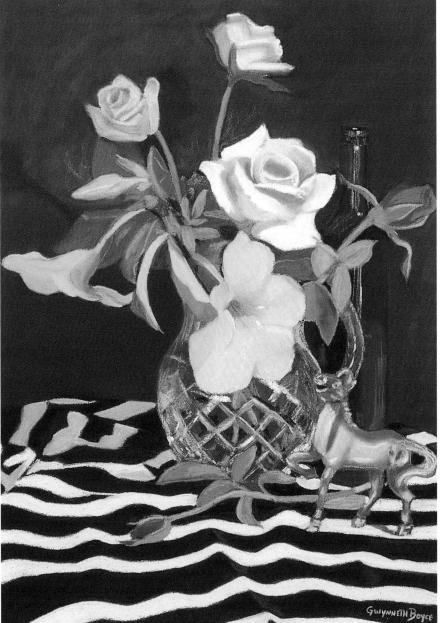

how I arranged my set-up

When I noticed the new rose blooms in my garden, I felt they were just asking to be my next project. I wanted to capture their color and just picked freshness. I arranged the still life by gathering together many objects from my home, carefully considering their compatibility, specifically:

- The formality of the roses contrasted with the soft, drooping effect of the allamanda.

- Because of its transparency, the crystal jug would not detract from the flowers, including the stems.

- The prancing horse provided some movement.

- The dark background made the roses stand out, and the blue was repeated in the stripes of the foreground.

- The horizontal lines acted as an anchor for the vertical elements.

- The red rose on the right had a leaf that curled around and touched the pink rose, creating an aperture through which the bottle could be seen.

- The handle of the jug shape was repeated in the allamanda leaf and the round jug.

- A soft spotlight from the left gave tone without casting too many shadows, making the flowers look fresh and light.

The careful consideration of shape and color placement brings light, vitality, harmony and unity to this subject.

my working process

- With a pale gray soft pastel, I drew in the basic shapes on the dark blue paper. I confirmed the placement of the objects before proceeding.

- By squinting, I identified the tones. Working around the entire surface, I placed my darks, then my mid-tones and finished with the very light areas.

- I built layer upon layer of soft pastel, giving color vibrancy and transparency to the petals. I tried to incorporate related colors into the local colors within each object. For example, I put deep red and crimson into the dark folds of the pale pink rose.

- In some areas I blended with my finger. I typically blend only lightly between each color, leaving the last application alone so it remained fresh. This gave a wonderful glow.

- While blending, I also lost some edges — such as on the bottle — to push less important objects into the background.

- I continually stood back and evaluated, taking careful note of tone and color, until I was happy with the results.

what the artist used

support
140 lb acid-free, cold pressed watercolor paper coated with a dark blue, toothy, acrylic pastel prime

pastels
I use only artist quality pastels: blue black, ultramarine blue, burnt umber, pale blue, gold ochre, light yellow, sienna, green ochre, mid grey green, pale sap green, pale grey green, pale rose permanent, alizarin crimson, deep red, madder lake deep and white

Gwynneth Boyce lives at 7 Collins St, Woody Point, Queensland 4019, Australia

I used a glass dropper to apply strategic color globules.

my inspiration

Finally realising my dream of visiting Provence, I was struck by the vibrant colors, light and ambience of the place, particularly this apple orchard. Backlighting, transparent watercolors, carefree application techniques and a lazy "inverted S" design seemed the perfect way to capture Provence's warmth and presence.

my working process

- Using my color notes and close-up photos, I made a fairly detailed pencil study, refined with waterproof ink.

- Next, I applied watered-down masking fluid wherever I wanted to suggest sunlight coming from behind. By blowing through a straw, I moved the wet fluid along to obtain varied shapes, later removing any overly large blobs or scary-looking shapes.

- The actual painting process began with a variegated wash of Transparent Yellow over the leaves and apples. I lifted the central areas with soft tissue to create the lightest sunlit part of the painting.

- When dry, I masked out a few more details.

- I used a size 14 brush to apply water to leaf areas, rolling the brush to obtain wetter and drier areas. After mixing Green-Gold, Sap Green and more Transparent Yellow to a fairly fluid state, I used a glass dropper to siphon up the paint and literally drop globules of paint strategically amongst the leaves and lighter parts of the apples. This method can be quite risky but offers a very free beginning. Any very obvious runs of color were removed by soft tissue. Again the painting was allowed to dry.

- Then I worked up the leaves and the apples to create my own painterly interpretation of the forms, using wet-on-wet and wet-on-dry techniques.

- Gradually, I removed all masking fluid and glazed over some areas to create depth and definition.

- My final step was to create a feeling of roundness on the apples by applying thin glazes of paint.

something you could try

My fellow watercolor artists might like to try blowing through a straw to move wet, watery masking fluid into finer, more natural-looking shapes. They might also like to practice obtaining random splashes of color by applying the wet pigment with a glass dropper.

Recolte de Provence, watercolor, 18 x 12" (46 x 31cm)

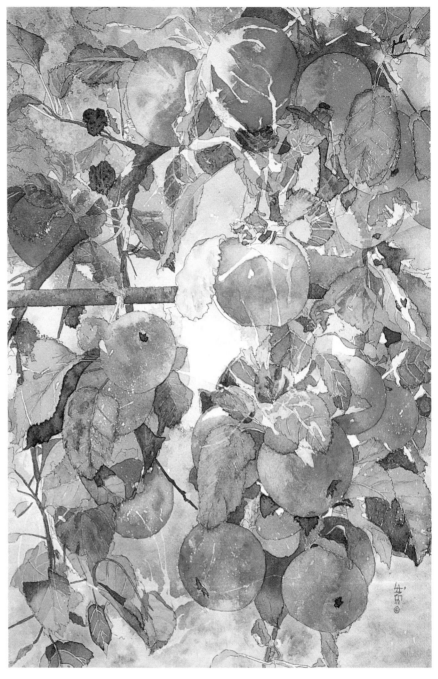

what the artist used

support
140lb not surface paper

brushes
Sizes 6 and 14 rounds (sable) and sizes 0 and 2 riggers (sable)

watercolors
A limited palette of seven transparent colors

other materials
Masking fluid
Glass dropper
A straw

Elaine O'Donnell lives at "Westgate", Smithfield Road, North Kelsey Moor, Market Rasen, Lincolnshire LN7 6HG, England

Vivid color and intriguing rhythms entice you to enter my imaginary world on a table.

Tulips & Celestial Clock, watercolor, 22 x 30" (56 x 76cm)

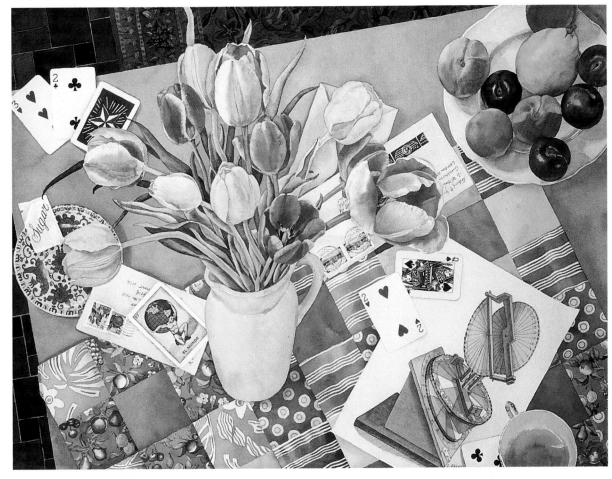

what I wanted to say

These May tulips were the first color in my garden after many months of a white Vermont winter. To make the set-up more unusual, I created an imaginary table with its own rules of perspective and its own patterns and lighting for the flowers to inhabit. I like my florals to have some ambiguity or mystery, to be evocative of other subjects or meaning. I don't want to be overly sweet or insipid.

my design strategy

Though the objects seem randomly placed, I have a very deliberate underlying design based on the triangle formed by the tops of the flowers and running down to both sides of the format. This triangle creates movement, but also stability.

The aerial perspective allows me to design very abstractly, here using rectangles of varying sizes to create a rhythm of repeating shapes. The diagonals of the rectangles create directional thrusts that move the viewer through the composition. A repetition of circles creates another rhythm.

I'm always conscious of bridges that can unify separate objects. For example, I linked shapes by overlapping the yellow tulip with the plate, sugar packet and envelope.

my color philosophy

The mood of this painting as I envisioned it was optimistic, delicate and cheering, much like a Vermont spring after our long cold winter. The tulips set this color theme with their vivid, delicate pinks, oranges and yellows. The other objects counterbalanced the sweeter pinks and mauves. The gray table, pale yellow pitcher and white cards and letters provide quiet resting areas within the color pattern.

my working process

- Small gesture drawings helped me figure out the main shapes and movements of the composition, as well as the tonal value placement.

- I then began a precise contour drawing (using an H pencil) of the flowers — the major element.

- Since the tulips were opening and I had to work quickly, each flower was painted completely before moving on to the next. I continued across the paper, always considering the value and color relationships of each adjoining shape. I used a wet-on-dry technique, yet still allowed the colors to mix in small areas on the paper, so that I could control my color changes.

- The last areas painted were the tabletop and the floor, because these were dark shapes that cut around the lighter objects.

what the artist used

support
300lb, 22 x 30" cold pressed watercolor paper, affixed with linen tape hinges to Foamcore board allows me to paint to the deckle edge

brushes
Kolinsky sable, medium to large rounds

watercolors
Transparent colors in a variety of mostly primary colors:

Cadmium Lemon
Permanent Rose
Permanent Red
Cobalt Blue
Alizarin Crimson
Ultramarine Blue

Susan Abbott lives in Marshfield, Vermont, USA → www.susanabbott.com

Painting only what moves me increases my chances of success.

Dutchmen with Cutting Garden, watercolor, 15 x 22" (38 x 56cm)

 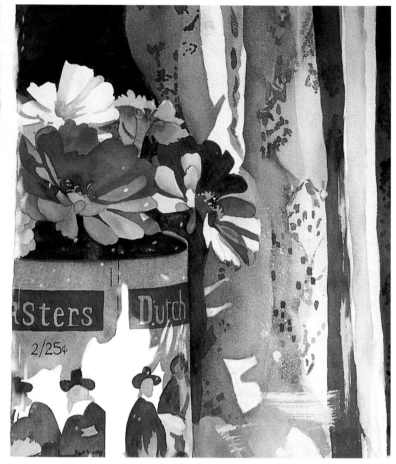

my inspiration

I don't spend much time thinking about interpretations, hidden meaning or philosophy, but I do like to paint objects from personal experience. These zinnias were a gift from an art supplier, and the old cigar box reminded me of my father, who used to smoke this brand. Who could resist reds, pinks and complementary greens, with touches of black as icing on the cake?

my design strategy

Wanting to present this subject in a way that was unique and different, I took the cigar box and flowers to a friend's house and put them in the window with the lace curtains. I then shot several rolls of film of the subject, choosing one shot when it called to me. It needed surprisingly few adjustments, since the composition in my photograph had a nice variety of shapes

(I always want poppa, momma and baby shapes) as well as good negative shapes in the background, including some that bled off the edges. I did several black/white/gray sketches to map out my values.

my working process

- I drew the image on the 300lb paper and then began to paint, establishing my white areas. I tend to paint light and preserve more open paper at this stage because I can always knock the value back later.

- I then began to develop the flowers, still painting wet-on-dry.

- Mid-way through, I punched in some of the darks to give myself a road map of values.

- I then painted the shadows on the curtains, softening some of the edges. When painting the pattern in the curtains, I avoided painting every hole to keep it suggestive rather than literal.

- When I thought the painting was done, I set it aside and took a fresh look at it a week or so later. It was clear that I needed to do some value adjustments. For example, I glazed over the curtains (best done with a transparent pigment like Verditer Blue) to subdue them.

my advice to you

Never give up! This painting was previously ignored by judges and customers — and now look, it's published in a book! See what patience can do? There is a time and place for every good painting.

what the artist used

support
300lb cold pressed paper

brushes
Rounds #10 and 12; flats ¾" and 2"; a flat fabric brush to soften edges

watercolors

VERDITER BLUE — INDIGO

BROWN MADDER

SCARLET LAKE

PERMANENT ROSE

AUREOLIN

Anne Abgott lives in Cortez, Florida, USA → anneabgott@aol.com

This glowing color was achieved by layering pastels over watercolor.

Orange Orchid, pastel & watercolor, 30 x 40" (76 x 102cm)

what I wanted to say

Flowers help people get in touch with the eternal core of life and appreciate its beauty at every moment. When I grew this orchid, the bloom was extraordinary and I just had to paint it. This is a reflection of my heart, and I hope that it touches other people's hearts.

my design strategy

Under natural daylight, I made several photographs of the orchid in full bloom. The composition was a combination of several of these images. I wanted to create depth, as well as the feeling of being right in the flower within the space. I composed the painting to lead the eye in a continuous circle and to make the flower look very real, as if it was going to move.

my color philosophy

I wanted the color to be warm and rich to show the texture and beauty of the orchid. I felt it would be best to accentuate the orange by surrounding this color with pink and red and setting it off from the background with deep green and black.

my working process

- After reviewing several angles and cropping options from the various photographs I had taken, I designed the layout. I then transferred the design onto watercolor paper.

- A few washes of various warm colors set the tone for the painting.

- As I typically do, I started in the upper left corner and began to work across and down the paper with layers of pastel, blending and scumbling to build up the glowing colors.

- After I had the basic colors and shapes in place, I went back and put in the details and more layers throughout.

the main challenge in painting

I always tell myself to have courage when I begin a painting. The challenge is to stick by my design and to make it come alive.

something you could try

Try combining different mediums — the richness is amazing when you get it right. For example, rich translucence can be achieved by combining pastel, watercolor and ink.

what the artist used

support
140lb watercolor paper

brushes
Various flat wash brushes

materials
Pastel, watercolor and ink

other materials
Masking tape
Facial tissues

Kathryn Aiken lives in Bowie, Maryland, USA → www.kathrynaiken.com

Here's my recipe for success: focus, observe, paint just the right stroke, then leave it alone.

Roses and Crabapples, oil, 12 x 16" (31 x 41cm)

my design strategy

Inspired by the delicacy of these English roses, I wanted the main color focus to be the classic combination of pink flowers and blue and white china. I added the green pot, the red crabapples and the dark background to cut the sweetness.

When setting up the still life, I put the focus on the roses, using every other element of the design — colors, shapes and tonal values — to complement, not compete, with them. After choosing my objects, I moved them around until I found a composition that created interesting positive and negative shapes, overlapping the objects just enough to unite them into a whole.

my working process

- Working from life, I used the smoothest canvas I could find — double-primed portrait linen

stretched and toned with a light coat of Burnt Sienna. I loosely sketched out the composition with the same Burnt Sienna and paint thinner.

- I was careful to find a day with at least five hours of uninterrupted painting time because this subject had to be completed the first day.

- I worked from dark to light, laying down a thin wash of the roses' interior color and shadow, with the highlighted petals painted on top with impasto. I painted parts of the adjoining pottery and background around the flowers to check color accuracy, but did not complete them until the flora were done.

- I made a final sweep for compositional errors and checked my edges, making sure they were blurred or sharp where needed.

try these tactics yourself

This way of working takes a great deal of focus and concentration, but it is the best way to keep things fresh, not overworked.

- A smooth surface is the key to achieving crisp strokes and avoiding muddy, fussy layers. There is nothing more disappointing than to watch a brushstroke sink into an absorbent canvas.

- Equally vital is for the strokes to be bold, the right size, value, color and direction. To achieve this, make accurate observations, paint with confidence and aim for a finished look with each stroke, leaving it undisturbed while moving on to the next one. When you get a stroke right, use it as your basis of comparison for the next, and so on. Anything you put down that is wrong will jump off the canvas.

what the artist used

support
Double-primed Belgian portrait linen

brushes
Bristle brushes

medium
Linseed oil

water-soluable oils
Titanium White
Cadmium Yellow Light
Lemon Yellow
Naples Yellow
Yellow Ochre
Orange

Cadmium Red Dark
Alizarin Crimson
Burnt Sienna
Phthalo Blue
Ultramarine Blue

Elizabeth Allen lives in Williston, Vermont, USA → ElizabethAllen6@hotmail.com

The Brown Method — a great way to make delicate colors and lyrical shapes stand out.

Green Glass & Pansies, oil, 16 x 15" (41 x 38cm)

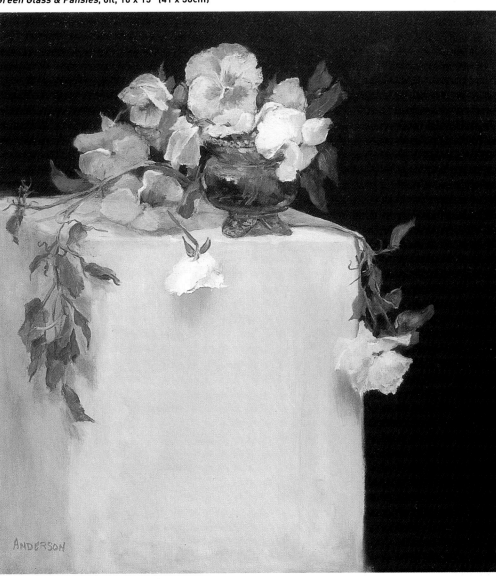

my inspiration

The moment I spotted this vase, the composition took shape in my head. I knew right away that I wanted to fill it with pale pansies, and contrast the delicate shapes against a dark background. Pansies are my favorite flower — they evoke different moods each time I paint them.

try these preliminary tactics yourself

- Immediately after arranging the still life, I take many digital photos to work from when the flowers have moved, drooped and died. I also find the photos helpful in keeping the light consistent as the natural light in my studio changes.

- I usually make a small preparatory oil on scrap canvas taped to a board to make sure my composition works in the painting. Here, I looked for a balance of tension and restful areas in the shapes, values and colors.

- When I want to create an extreme value contrast between the main subject and the background, I use the Brown Method, which I adapted from Dennis Sheehan. I cover the whole canvas with a rich, dark mixture of Transparent Oxide Red, Sap Green, Ultramarine Blue and a little Alizarin Crimson. With a paper towel dipped in my medium, I wipe out parts of the surface, cleaning almost to the canvas for the lightest lights and leaving a soft pigment for the medium values.

- Before continuing, I stop to evaluate my monochromatic underpainting. If my heart and instinct are telling me that something isn't quite right, I believe it! I've found its best to solve all of my problems in the block-in, otherwise it will be much harder to solve them in the finished work.

the rest of my working process

- When the canvas is dry, I go in with the local colors, using brushes and a palette knife.

- Two or three layers of color are usually needed before the flowers really begin to come alive, but I try to avoid overworking. A few dabs of paint sharpen select edges and provide just enough details and highlights to look convincing.

what the artist used

support
I prefer the smooth surface of extra-fine, double lead-primed portrait linen

brushes
Good quality mongoose brights and filberts (#14, 16 and 18) to lay down color; synthetic rounds in #2 for detail

medium
1 part damar varnish, 1 part stand oil and 5 parts turpentine

oil colors
Titanium White
Cadmium Yellow Pale
Yellow Ochre
Cadmium Yellow Deep
Magenta
Alizarin Crimson
Transparent Oxide Red
Sap Green
Viridian
Cobalt Blue
Ultramarine Blue
Cobalt Violet

Kathy Anderson lives in Redding, Connecticut, USA → kathyart@optonline.net

What's inside the fortune cookie? My painting holds a secret message for you.

Chinese Teapot, oil, 14 x 20" (36 x 51cm)

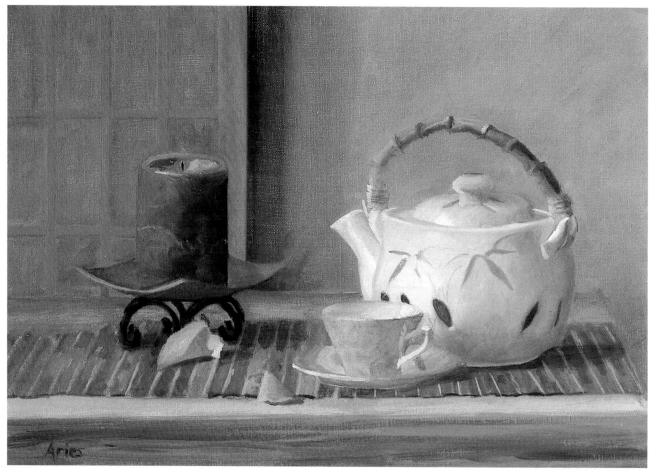

my inspiration
While browsing through second-hand stores for props, this teapot caught my eye — I had never seen one like it. It sat on my prop shelf for some time until I found just the right objects to go with it.

follow my eye-path
I wanted to paint a quiet painting, something that gave a feeling of tranquillity, yet still hinted at a little mystery. I wanted the focus of the painting to be the teapot, with the cup and saucer as a secondary focus. The angle and light of the cup handle brings the viewer into the painting. The tilt sends the eye over to the candle, which guides it to the fortune cookie. It's that little fortune cookie that provides the mystery.

my lighting
I paint under north light, and always adjust the amount of light and how it strikes the objects. With this painting, I used the screen to block some of the light on the left while adding interesting line and shadow in the background.

my working process
- First I made an accurate drawing on graph paper, which I transferred to my canvas that had been toned with a Raw Umber wash.
- Over this, I painted a bistre (Transparent Brown Oxide and Raw Umber) on the background and shadowed edge of the table.
- After glazing in the wall color, I painted the screen, making its value and cast shadow dark enough to show off the light on the teapot.
- While painting the rest of the objects, I kept comparing the darks and lights.

- I put in the highlights in order of importance.

the main challenge in painting this picture
When I began the painting, I wanted the candle lit. After much painting and scraping, I decided it really looked much better without the flame. The challenge for me was to give up my original idea and accept that it would not work. I had to listen to the painting.

try these tactics yourself
- To get the drawing right, try sketching on graph paper, then tracing on to your canvas. It helps keep manmade objects symmetrical.
- Don't rush when setting up the still life. The painting will go more smoothly if you don't stop to change or add objects.

what the artist used

support
Canvas

brushes
Filberts and flats, sizes #2, 4, 6, 8, 10

medium
½ sun-bleached linseed oil, ½ turpentine

oil colors

Cadmium Lemon	Cobalt Blue
Cadmium Yellow Deep	Ultramarine Blue
Yellow Ochre	Ivory Black
Cadmium Red	Burnt Sienna
Alizarin Crimson Permanent	Raw Umber
Viridian	A mixed white

Mary Aries lives in Rosemount, Minnesota, USA → maries@charter.net

My still life gets its quiet mood and understated strength from well-planned tonal values.

Summer, oil, 12¾ x 20" (32 x 51cm)

my inspiration

Delacroix says in his notebook, "In painting, as in external nature, proper justice is done to what the soul finds inwardly moving in objects that are known through the senses alone". Good still life, in other words, is not just a careful catalog of objects. It points the viewer elsewhere, to things happening beneath the surface.

When I set up this still life, I got a feeling that went beyond the paper, flowers and glass. I wanted to recreate that meditative experience of sitting at a table and looking up and out. My inspiration was an emotion, and the desire to record it.

my design and color philosophy

This painting was created totally from life and I spent a considerable amount of time setting up a cohesive arrangement. I designed it in the form of a wide "V" or arc shape to link both ends of the painting to the vertex. Then the blank space of the open page in the center leads your eyes into the background, creating more depth.

I also wanted this painting to be oriented around tonality. As such, I needed to rely on color variations from warm to cool and controlled value changes, rather than any intensity in either color or value.

my working process

- I began with a preparatory drawing on the panel, and then began to paint directly from life, in color.

- At first, I worked very abstractly and quickly, focusing on the large shapes to establish the drawing and the values. This very thin layer of paint diluted with turpentine functioned like an underpainting.

- The next layer of paint was applied wet-into-wet, without any medium. I corrected the drawing and started concentrating on smaller passages and more subtle relationships. Special attention was paid to losing large sections of edges.

- In the final pass of glazes, I unified the shadows and pushed the half-tones.

the main challenge in painting this picture

The sketchbook on the table posed a problem at first. It had an interesting design on the cover, which was personally significant for me. After painting the design, however, the notebook became too distracting. Once I was reconciled to the fact that the design had to be removed, the painting came together quite quickly.

what the artist used

support
Wood panel prepared with gesso

brushes
Filbert brushes from large to small

mediums
Turpentine
Linseed oil and
Damar varnish

oil colors

Titanium White	Vermilion
Naples Yellow	English Red
Yellow Ochre	Alizarin Crimson
Cadmium Yellow Deep	Ultramarine Blue
Raw Umber	Blue Ochre
Burnt Umber	Ivory Black

Juliette Aristides lives in Seattle, Washington, USA → www.AristidesArts.com

I know that all the beauty in the world won't save a painting with an inferior design.

Plums with Pitcher, oil, 12 x 18" (31 x 46cm)

my design strategy

I was primarily interested in exploring the relationship between the different shapes and textures. To make the pitcher dominant so it would attract the eye first, I set it where it would catch the most light. I placed a dark cloth in the background to set it off. The flowers are subordinate forms, light against dark, so I planned to make their values slightly darker and their edges softer in order to make the pitcher the focal point. The plums serve as a horizontal counterpoint to the verticality of the pitcher and flowers.

I placed the light coming from the left side at about a 45-degree angle to reveal the forms of the objects. I then chose a purple-blue and white color scheme, which I thought would harmonize well with the cool, silvery colors in the pitcher.

my working process

- After spending a considerable amount of time setting up the still life, I decided which canvas to use based on its proportion and scale in relationship to the composition I had in mind. At this point, I was eager to jump right in and get going while my subject was still fresh.

- I always work exclusively from life with no preliminary sketches or studies. So, with a neutral mid-tone of brownish gray, I began softly indicating the large shapes and composition.

- When I was satisfied with this, I started in with opaque color. I always start with the darks in the focal-point area and work out from there. In this first sitting, I applied the paint in a mosaic-like manner to establish color notes and planes, then

fused areas where needed. I tried to cover as much canvas as possible while still paying close attention to accuracy in form and color.

- In subsequent sittings, I completed the painting section by section, again working from the focal point outward. I scumbled or glazed areas as needed to enhance form, color and harmony.

my advice to you

- Think in terms of light and color so as to avoid the decorative. With these in mind, even the most simple objects can make a solid painting.

- Carefully plan your composition. All the beauty and accuracy in the world can't save a painting with an inferior design.

- Realism isn't found in piling up detail but rather in getting the drawing, form and color correct.

what the artist used

support
Oil-primed Belgian linen

brushes
Mostly bristle filberts, #2-8 or larger bristle; a smaller synthetic round

mediums
Cold-pressed linseed oil, cut with turpentine

oil colors

Titanium White	Raw Umber
Cadmium Yellow	Viridian
Yellow Ochre	Cadmium Green
Cadmium Orange	Ultramarine Blue
Cadmium Red	King's Blue
Alizarin Crimson	Manganese Violet
Raw Sienna	Ivory Black

Robert Armetta can be reached at The Long Island Academy of Fine Art, 49 East Main St, Riverhead NY 11901 USA

I wanted to keep cast shadows to a minimum and retain large, flat shapes.

Untitled, oil, 25 x 15" (64 x 38cm)

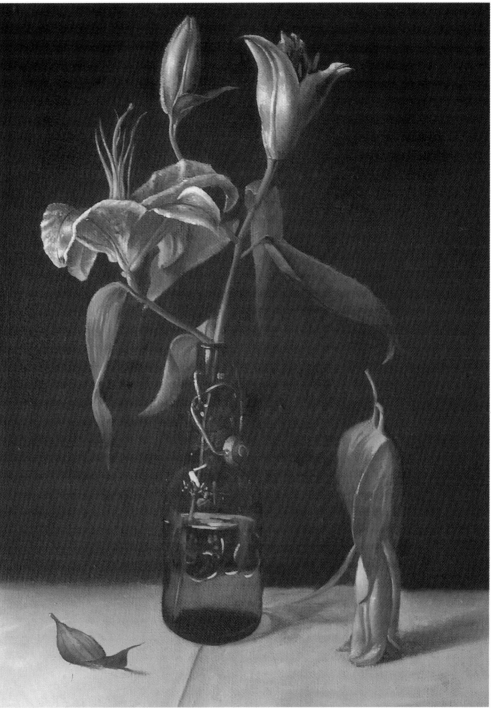

a new experience

I wanted this painting to be an exploration of the different values, colors and textures that are so evident in flowers. Flower painting is new to me, but one thing I discovered is that it can be difficult due to the constant moving and changing of the live flowers. In fact, part of the composition came about because the blossoms just would not open.

my design strategy

Before starting, I decided on a circular rhythm following the flowers around the painting. I then proceeded to work directly from life, preferring to resolve the rest of the design issues on the painting as I went along. I used mainly frontal lighting for this painting to keep the cast shadows to a minimum and retain large, flat shapes.

my working process

• Using big brushes and intense colors, I blocked in the big shapes and tried to get the proportions worked out on the first day.

• Not entirely satisfied with my arrangement, I made a few adjustments before continuing.

• After I had everything blocked in again, I started working from left to right across the canvas, painting little sections until they were done.

what the artist used

support
Oil-primed linen

brushes
Filbert bristles in #2, 4, 6, 8; filbert and round sables in #2, 4, 6

medium
Linseed oil

oil colors

Cadmium Lemon	Napthol Red	Viridian
Cadmium Yellow	Permanent Rose	Cerulean Blue
Indian Yellow	Alizarin Crimson	Cobalt Blue
Cadmium Orange	Cadmium Green	Ivory Black
Cadmium Scarlet	Cadmium Green Pale	Flake White

Eric Bader lives in Plainview, New York, USA → www.ericjasonbader.com

I seized an opportunity to use strong colors to create a bold, contemporary work.

10 Tulips with a Pear on a Blue Table, oil, 24 x 30" (61 x 76cm)

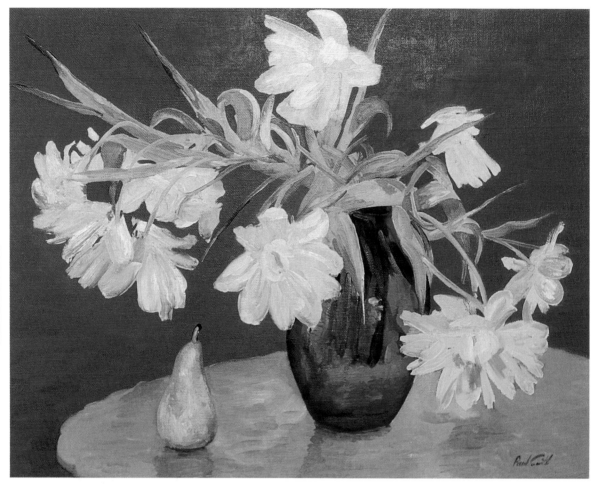

seizing the moment

I have always admired the way Vincent van Gogh and David Hockney created bold still lifes that were more than just a bunch of flowers in a vase. Each created memorable images that were contemporary and interesting. I hope to do the same in my work.

As often happens, something left to chance produced more than careful planning and thought could have. These flowers had been left too long in the sun, and as tulips are very sensitive, they were nearly dead and were about to be thrown out. However, I suddenly recalled the paintings by van Gogh and Hockney, and I realized that this arrangement had great potential. This was my chance to use strong, complementary colors to create a dynamic, striking composition.

my design strategy

A symmetrical arrangement would have been too predictable; I wanted a much more interesting and contemporary look. What happened was the yellow flowers looked a little like hands and the green leaves stretched to the boundary which added a dialogue and movement within the painting. All this was balanced by the simple shape of the pear.

my working process

- In a very basic sketch, I investigated the placement of the main elements on the canvas to achieve an interesting effect. I then used the grid method to transfer my design to an appropriately proportioned canvas.
- Using just enough paint to cover, I worked all across the canvas, establishing and refining the color-value relationships of the major shapes.

- Once that was clear, I then began to build up the paint thickness, using brush marks to add another factor of interest.
- Although it often takes me more than one sitting to complete a painting, I try to maintain the appearance that the painting was quickly completed.

my advice to you

- If an opportunity presents itself, as it did for me with these nearly dead flowers, act on it. If you delay, the opportunity may be lost and possibly won't come again.
- Try to arrange a functional studio for yourself, particularly with a north window or a skylight so you can work under natural light.
- Paint flowers directly from life. Photographs have their uses but you cannot beat the real thing.

what the artist used

support
Linen

brushes
Hog hair brights #3-12; sable riggers #1 & 2

oil colors

Cadmium Lemon	Cadmium Yellow Pale	Yellow Ochre	Cadmium Orange
Cadmium Red Light	Winsor Blue	Cobalt Blue	Titanium White

Paul Smith lives at 62 Fitzroy Avenue, Kingsgate, Broadstairs, Kent, CT10 3LT, England

Getting perspective and ellipses right is the way to a convincing still life.

Cherry Blossoms, oil, 28 x 22" (71 x 56cm)

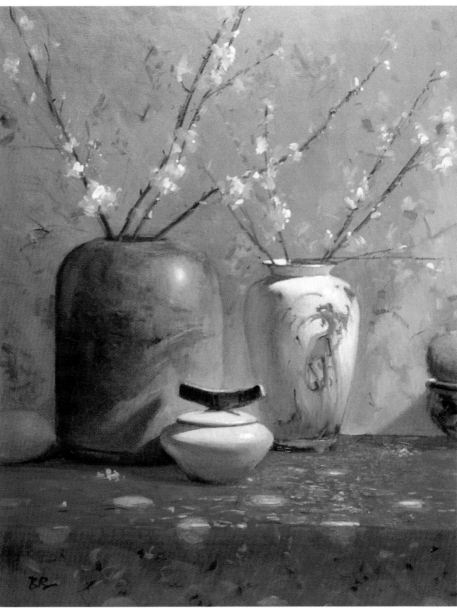

why I paint still lifes

I primarily paint landscapes but I like to shift gears every so often, and set up and work on a still life. I believe that this keeps me fresh and excited about painting. I also enjoy creating the entire still life project, meaning seeking out the props and elements and arranging and rearranging the composition until it's exactly what I'm after.

my design strategy

I usually try to have and/or convey some sort of theme with my arrangements. In this case, the center of interest rests with the smaller vase in the lower center of the painting. Juxtaposing it against the red silk fabric creates an interesting area of tension in the painting. The cherry blossom branches from a florist shop seemed the perfect ingredient for breaking up the simple background.

my working process

- When I was pleased with my arrangement and complementary color scheme, I chose an appropriately sized canvas and toned it with a warm acrylic wash.

- I drew out the important elements/objects, using compressed charcoal so I could correct my drawing and proportions. Once this was complete, I sprayed workable fixative to secure the drawing.

- I squinted to see my values and, using a large filbert, began to block in the dark masses, then the mid-tones and light areas.

- In my next pass, I pushed the temperatures as needed. I kept using the large brush so that I wouldn't focus on any details or get too picky. I was constantly moving around the painting, developing everything at the same time.

- Checking perspective, scale and values came next. I also refined my edges, reflective light and color relationships.

- Finishing touches, patterns and details came at the end of the painting. The last element I placed was the cherry blossom branches. Keeping them spontaneous and fresh was important.

my advice to you

Draw, draw and draw some more! Getting the perspective and ellipses correct is essential to painting a convincing, realistic still life.

HOT TIP!

I have a still life station set up in my studio that allows me great freedom regarding how my subject is lit. I use a single light source at a ¾ degree side angle. I then arrange panels around the subject to block out the other lights in my studio, which I need to work under.

what the artist used

support
Pre-stretched linen

brushes
Hog-hair bristle filberts and rounds

mediums
Turpenoid

A final coat of painting medium

oil colors

Cadmium Yellow · Cadmium Yellow Deep · Cadmium Scarlet · Alizarin Crimson · Burnt Sienna · Burnt Umber · Viridian · Cobalt Blue Light · Ultramarine Blue · Titanium White

I found a method that guarantees large, luminous passages of color.

Rosie Glow, watercolor, 14 x 20" (36 x 51cm)

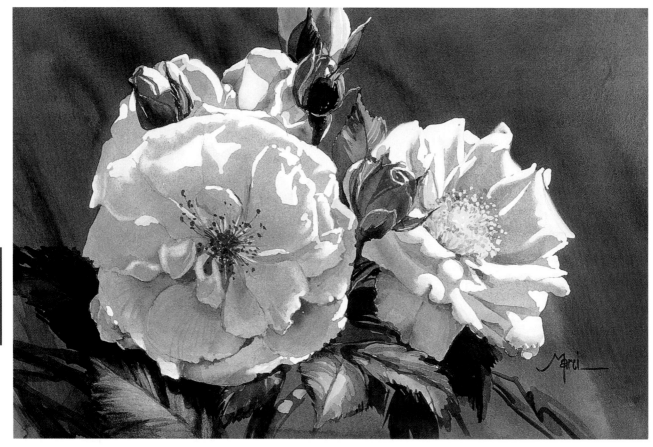

why I chose this medium and technique

Visiting Monet's garden, I loved the transparency of the rose petals with the sunlight on them. I wanted to capture that beauty. Because the vivid, glowing colors of the rose petals and the interplay of light and shadow were so important to my concept, I decided to use transparent watercolor. I used a pouring technique because it is the best way to achieve large, luminous passages of light mid-tone values and dark mid-tone values.

my design strategy

When photographing the roses, I looked through the viewfinder to find a composition that I liked, then snapped several frames. After the photos were developed, I created my own composition by drawing value sketches. I designed my composition so that my focal point (the star of my painting) was off-center, with the surrounding value shapes leading the eye to this star. I also looked for at least four different values that would help the viewer's eye travel through the painting.

my working process

• When I was happy with the composition, I drew the roses on tracing paper. Using a photocopier, I enlarged the design to fit the size I wanted. I transferred this design to my watercolor paper with the aid of a lightbox.

• Next, I stretched the paper on Foamcore board and let it dry overnight.

• The next step was to mask out the whites and pure colors.

• After the mask was dry, I wet the paper with a large 2" flat brush. Beginning with the yellow, I poured the color on the paper and moved it around. While the paper was still wet, I applied the rose, followed by the blue. With each pouring, I moved the color around on the paper. After the desired effect was achieved, I left it to dry overnight. This first session was for the light mid-tone values.

• The next day, I masked the areas that I wanted to save in this light mid-tone value. Following the same process, I poured again, using the same colors but stronger in value. I also introduced a fourth color of violet. I let the painting dry overnight again, and the next day I removed all the mask.

• I softened edges where needed with a small bristle brush, then painted in details and accents with my normal palette colors.

what the artist used

support
A stretched half-sheet of a durable 140lb cold pressed, brilliant white paper

brushes
A 2" flat for wetting the paper
Round brushes (#10 and #14) for direct painting
A 1" flat for glazing

other materials
Cosmetic squirt bottles for applying colors
Small jars for mixing
White masking fluid

watercolors
For the first pouring, I used a triad of staining colors: Hansa Yellow, Permanent Rose and Phthalo Blue; in the second pour, I introduced a fourth color, Violet; finished with my full palette:

Gamboge	Transparent Oxide Red
Hansa Yellow	Sap Green
Alizarin Crimson	Cobalt Blue
Permanent Rose	Ultramarine Blue
Vermilion	Prussian Blue
Raw Sienna	Violet

Marci Boone lives in College Station, Texas, USA → www.marci-mjbstudio.net

No happy accidents here — my pouring technique is a surprisingly well-controlled affair.

Bird of Paradise, fluid acrylics, 25 x 39" (64 x 99cm)

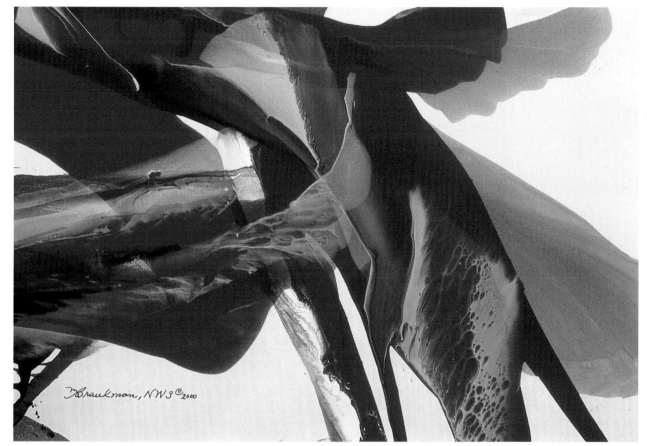

my inspiration

I live in Florida on the Central Gulf Coast. Bird of Paradise plants bloom year-round, and are similar to the elegant and dignified marine birds. They stand regally and have translucent petals, like wings. As I looked at our blooms, they reminded me of the glorious heron and ibis birds that are so prevalent here.

my game plan

This was painted from my imagination based on my familiarity with these flowers, which I have studied in depth. I planned to use a pouring technique to create fluid, varied veils of color. This may seem to be a random kind of application, but it requires several advance strategic decisions.

I thought it should be a horizontal format portraying only the many-winged area, not the entire body of the flower. I then spent considerable time figuring out the order in which to pour my primary colors so that I could achieve the effects and final colors I was after.

my pouring method

I heard it said once that 80 percent of painting is preparation and 20 percent is the actual painting. Never was this more true than with this pouring technique. I can't just splash on the color, letting accidents happen — I have to control the entire process.

- Since I do not use any brushes, I begin by mixing up large batches of my colors, which I dilute with water and polymer gloss medium to increase the pigments' translucency. I put these liquid colors in flexible plastic cups that I can "fold" into pouring spouts.

- Because I don't want the paint to puddle, I have to make sure it flows off the paper, but this gets very messy. My solution is to string up a sort of hammock to catch the excess paint, made from a plastic shower curtain attached to wooden sawhorses.

- Finally, I recall my visual image, and use this as a basis for determining how I want the colors and values to flow over the paper.

- I then proceed to pour my colors on a dry surface, without masking off any area. I take time to consider the results before and after each pour. I must think through the next step before continuing. In the end, sometimes I will splatter.

what the artist used

support
260lb watercolor paper

brushes
No brushes, only flexible plastic cups for pouring

mediums
Polymer gloss medium

fluid acrylic colors

Mary Alice Braukman lives in St Petersburg, Florida, USA → www.braukmanart.com

43

A flowing zig-zag of leaves and flowers bring movement to this centered, stable composition.

Le Plateau de Prunes et Gloires du Matin, oil, 20 x 16" (51 x 4cm)

my inspiration

Inspired by French paintings of the 18th and 19th in which still lifes were sometimes placed in gardens, I had a desire to combine nature with architectural elements. For some time, I had been chasing a suitable outdoor background for my still lifes when my wife, also an artist, noticed this pillar. With its surrounding leaves and flowers, it could easily have gone unnoticed, but I envisioned there a perfect set-up for a still life.

my design strategy

I took photographs of the background and sketched from life, then took photographs of the plums and plate. I did a preliminary sketch, combining lines and values to make decisions and visualize the shapes and value contrast.

Even though I wanted the main elements to be centered, I did not want the painting to be boring. I emphasized the life and action of the subject by opposing the stillness of the pillar and the plate of plums against the flowing zig-zag of leaves and flowers. Notice how your eye gets to the center of interest, especially the red plum, by following the leaves either from the top or the bottom. The textures of these parts (hard vs soft, gloss vs matte) add an extra note of contrast.

my working process

- After drawing studies, I did a careful line drawing with charcoal on the canvas.

- Over that, I laid in a thin, transparent, overall grayed-down green that I let dry.

- I worked in stages, gradually developing the whole and adding more paint until I finally arrived at the end result. I first applied the paint transparently over the charcoal drawing to sketch the general tones and colors, then translucently to develop further and then opaquely to almost complete the painting.

- Finally, I again painted translucently for slight corrections and subtle adjustments until I reached the final effect I wanted.

something you could try

For me, too much bright green can get very tiring. I needed to include greens, of course, to preserve the illusion of reality, but I softened their intensity to leave room for other subtly contrasting colors. Here, browns, purples and reds complement the grays and greens.

what the artist used

support
Linen canvas

brushes
Bristles, long and flat, in sizes #0, 2, 4, 6, 8; a small sable for fine details

oil colors
Oil paints in earth colors

other materials
Linseed oil
Oil-modified alkyd resin

Daniel Brient lives in Montreal, Quebec, Canada → www.danielbrient.ca

Careful cropping and warm colors make my painting successful.

Sunshine Harvest, oil, 24 x 30" (61 x 76cm)

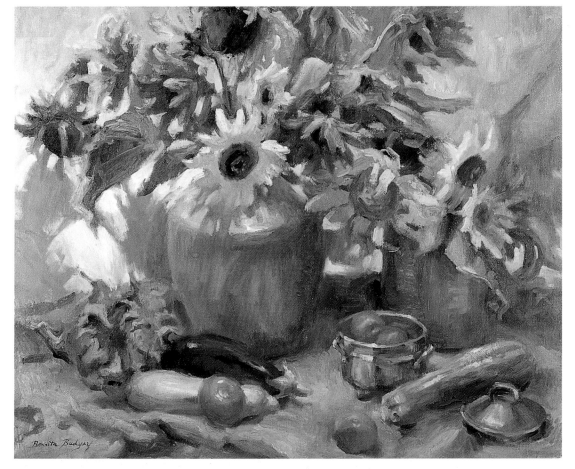

what I wanted to say

The great wealth of nature's bounty at harvest time, in both my flower and vegetable gardens, was my inspiration. An exuberant sense of "spilling over" was what I wanted to convey.

my design strategy

To get the feeling of fullness, I crowded the sunflowers together and let them reach beyond the boundaries of the canvas. Cropping was important. Through a number of thumbnail sketches, I worked out the rest of the composition, mapping my tonal values, placing the objects and providing active passages along with quiet areas, all to create a dynamic, pleasing and cohesive design. I also made sure to vary shapes by tilting, turning and using a variety of sizes to make them interesting and exciting.

my color philosophy

I wanted my color scheme to reflect warmth, sunlight and abundance as well. I planned to flood the piece with burnt oranges and sunny yellows, which would vibrate against punches of contrasting cools. Additionally, I wanted to use color to suggest that sunlight was radiating from the center of the painting.

my working process

- My goal throughout the creation process was to keep the mood of the piece and the purity of my initial emotional response intact.

- Over a warm, pale ochre wash, I drew directly on the surface with a #4 round with thinned Ultramarine Blue, paying attention to the shapes and sizes, not just of objects, but of the lights and darks and their relationships to each other.

- I then put in my darkest dark (eggplant) and lightest light (pale yellow sunflower) above it. This established my value range and my color vibration.

- All of my areas of shadow went in with my biggest brushes and slightly thinned paint, getting the color and value as accurate as I could.

- The middle values and lights were next, with emphasis on thicker paint and radiant, luminous color. I let the brushstrokes describe the textures of the different objects.

- I worked back and forth, making adjustments and employing a variety of edges. But mostly I made decisions, put the paint down and left it alone to maintain freshness and spontaneity.

- When the color and movement of the sunflowers seemed to sing and the relationship of all other elements in the painting felt fully realized, the piece was complete.

what the artist used

support
A stretched, gessoed canvas

brushes
Filberts and rounds, starting with #12, 10, 8 and gradually working down to 6 and 4

oil colors

CADMIUM YELLOW LIGHT CADMIUM ORANGE CADMIUM RED LIGHT ALIZARIN CRIMSON

ULTRAMARINE BLUE PHTHALO BLUE TITANIUM WHITE

Bonnita Budysz lives in Two Rivers, Wisconsin, USA → excelventures@lakefield.net

I wanted to express depth and weight in this light-filled scene.

In the Morning, watercolor, 29 x 38" (74 x 97cm)

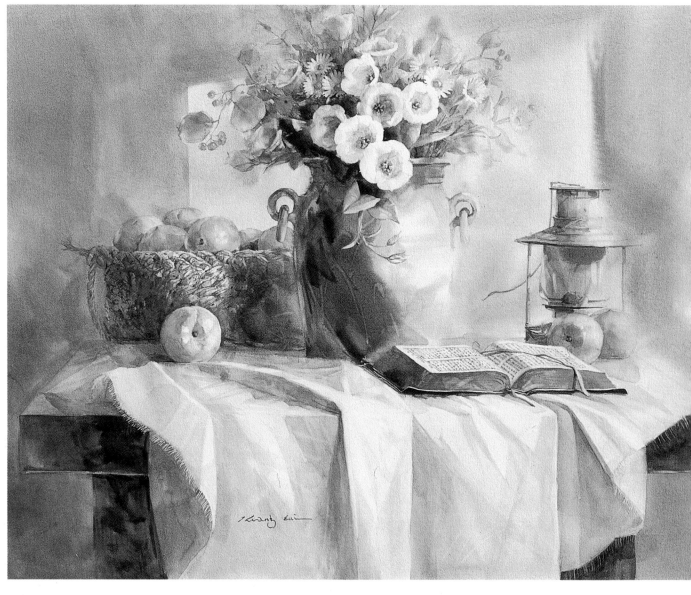

my inspiration

The sunshine through the window had mystery and warmth in it. The morning sunlight was abundant with life, especially the way the sunlight reflected on an object making its surface look like a jewel. Light and shadow and sunlight through the window was the basis of this painting.

the main challenges to painting this picture

I wanted to express both depth and weight through this watercolor painting. To depict distance, I used the detail of the fabric in the foreground and the lamp and basket near the back.

I also tried to capture the dimension and the life in the flowers.

my working process

• First, I meticulously sketched my subject in pencil and then I covered the main areas with masking fluid.

• I then used a large, oriental flat brush to paint the overall dimensions and darker, shadowed areas.

• Once I was satisfied with this, I removed the masking fluid and then worked in detail on my main subject one segment at a time.

what the artist used

support
140lb cold pressed watercolor paper

brushes
Sable rounds #3/0, 2/0, 3, 5, 7, 10; Oriental flat brush 3½", 5"

watercolors

Jacob Chang lives at 206 Cummer Avenue, North York, Ontario M2M 2E7 Canada

I didn't want to let the textures get away.

Crane, oil, 20 x 16" (51 x 41cm)

my inspiration

My three children inspired me. Ismael Jr. wanted to sell cold lemonade after I showed him the yellow ice crusher. Maggy surprised me with her origami design, and Samuel likes to play with boxes.

my design strategy

I visualized an X-shape and used the golden section to compose this painting. I believe a painting should have a relationship in its composition and its objects in its design. I use different geometric shapes, light and color contrast. The focal point is the crane, which is also the entrance to the painting.

a word on color and lighting

The overall color in this painting is cool, but it needed something warm, so I added the warm light to make it more interesting.

why I chose this medium

I thought oils would give me more control in describing the different textures on this particular painting, such as the chrome on the ice crusher, the origami crane and the fruits.

my working process

- I tried to visualize what I wanted before I started to paint. To help, I did a ballpoint pen drawing to plan what I wanted the light effect to be.

- I started composing right on the canvas with a gray-umber color, thinking about the big masses and separating big shapes of light and shadow. By keeping it simple, I could look at the overall design and make sure everything worked together.

- I then began to work fat-over-lean to bring out the details and the textures on the objects. I didn't want my painting to look like a poster with an even thickness of paint all over, so varied applications were important.

- My greatest challenge was to keep the origami crane simple, even though it is a white piece of paper with multiple folds and many details.

my advice to you

- Always work from life; paint still life if you don't have a model.

- Paint or draw every day, even if you only do it for one hour.

- Never stop trying new ideas.

HOT TIP!

By establishing the correct relationships of the values and colors in the larger areas first, you'll achieve the illusion of light right from the beginning.

what the artist used

Oil paints on single-primed canvas, for its tooth

47

Ismael Checo can be contacted at PO Box 5401, Astoria, NY 11105-5401 USA

See if you can see the N-shape design underlying this one.

what I wanted to say

After shopping with my wife, I noticed all of the different kinds of fresh vegetables sitting on the counter. It suddenly occurred to me that it would be lovely to paint a group of vegetables, just to express my grateful feeling for the harvest of the season.

follow my eye-path

After carefully picking several representative vegetables such as corn, pumpkins and potatoes, I began to set them up in my studio in an N-shape. I used this eye-path because I wanted the vewer to start off from the most detailed part of the painting (the potato bag), then move down to the potatoes on the ground, then go to the upper left corner and finally to the corn at the bottom. Along the way, I made sure to vary and contrast the square and circular shapes.

my working process

- I made several preliminary sketches to make sure everything would look comfortable on the canvas.

- I then mixed red with grey to create a rich, warm undertone applied over the whole surface. Using the complementary color of green, I redefined my drawing.

- Using flat washes and wet-on-dry painting, I then put in all of the local color. I allowed some of the red ground and green sketch to show through for an extra spark of color.

- Switching to smaller brushes, I then went back over all of my vegetables to define their shapes and add detail. Heavy impasto strokes provided the highlights.

- Finally, I used an airbrush to apply light glazes of color to unify and enhance the overall image.

Vegetables, acrylic, 24 x 24" (61 x 61cm)

why I chose this medium

The wide range of application techniques possible with acrylics is one of the reasons I enjoy this medium. It offers many of the same qualities as both oils and watercolors, plus it dries quickly which means I can add consecutive layers sooner.

what the artist used

support
Canvas

brushes
Filberts and rounds #2, 3, 8, 10 and 12; fan brushes; painting knife; airbrush

acrylic colors

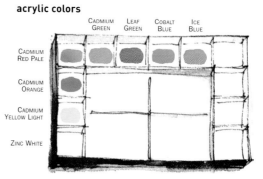

Xue Wen Chen lives in Toronto, Ontario, Canada → artistxuewenchen@yahoo.ca

Repetition of shape, color, line and size gave me the feel I wanted.

Tulip Extravaganza #1, acrylic, 12 x 12" (31 x 31cm)

preparing to paint

Inspired by the bounty of color and texture in spring after a long, dark winter, I allowed this image to flow from my imagination, but only after deliberate study. I did a lot of observation and sketches of real flowers to completely understand their structure and various stages of maturity. Only when I felt completely intimate with the flower did I attempt to translate it to canvas. My strategy was to steal from nature's design in terms of harmony through the repetition of shape, color, dynamic line and variety of size.

my working process

- With my 2" brush, I primed the canvas with three layers of gesso.

- Over this, I brushed on a generous helping of soft gel to allow the paint to mix easily and flow smoothly across the canvas.

- In preparation for painting the red tulips, I squeezed the Crimson and a little purple from the tubes directly onto the canvas. I then used a 2" brush to freely move the paint until the canvas was covered. I used a little purple, knowing it would appear, disappear and reappear randomly. During this flowing process of mixed colors, new colors were born.

- For the rest of the project, I used my 1" brush. Rough-mixing (not thoroughly mixing) yellow and red on the palette, I created an orange for the background. I used a negative painting approach to find the flowers' shapes.

- Again, rough-mixing yellow and white on the palette to create several shades of yellow, I set out to find the background blooms.

- As the final touch, I used lighter shades of existing colors to highlight desired areas.

please notice

There is an old saying, "less is more." I did this painting with much passion, without serious detail, to intuitively capture the essence of my subject. I simply allowed my hand to be guided from inner feelings. I know that everyone who senses nature — who feels spring, smells flowers, basks in the warmth of sunshine, deeply inhales clean air, acknowledges a gentle breeze — will appreciate the passion instilled in this labor of love.

something you could try

Rough-mixing (my own term for not thoroughly mixing colors on the palette) is a great way to allow different degrees of the desired color to emerge at random. It gives a painting a more spontaneous and varied appearance.

what the artist used

support
Canvas

brushes
1" and 2" household paintbrushes

medium
A soft gel medium

acrylic colors

NAPHTHOL CRIMSON
BRILLIANT PURPLE
CADMIUM YELLOW MEDIUM
TITANIUM WHITE

49

TK Daniel Chuang lives in Vancouver, British Columbia, Canada → we@lynx.bc.ca

I like to create a sense of familiarity that captures the viewer's imagination.

Images IV, pastel, 12 x 16" (31 x 41cm)

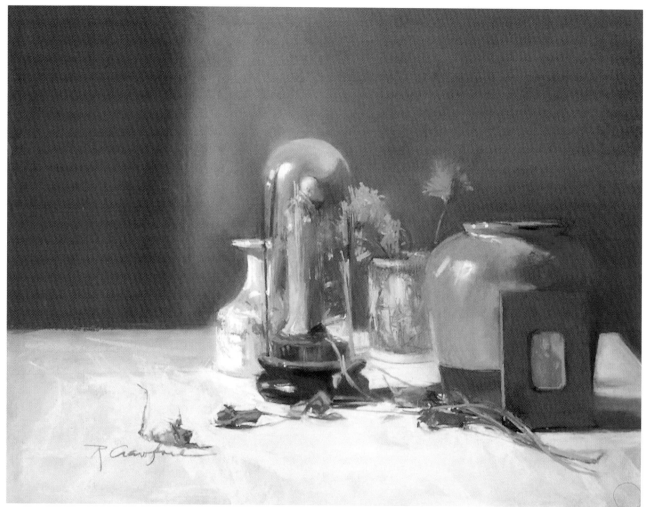

what I wanted to say

My main concern is always to arrange and light my objects to create mood and to connect with the viewer, to insinuate a sense of familiarity. In this case, the faded photo might seem like one from a family album. Old photographs found in antique shops and flea markets become my "instant ancestors". The objects become keepsakes or treasures from the past, the kinds of things found in almost every home. The barely discernable figures on the vase and jar repeat the theme.

my working process

- Once I found a satisfactory arrangement of objects, I positioned a spotlight quite high and to the left of the tabletop, looking for cast shadows that would add a natural flow to the composition.

- I made thumbnail sketches striving for a spatial quality and for interesting negative space.

- I loosely drew in the composition with vine charcoal, then began layering simple color shapes, working from dark to light and being mindful to control my values and colors. I believe a limited palette helps create mood.

- The sanded grit of the support allowed me to apply many layers of pastel to build richness of tone, especially in the center of interest, the figurine and dome.

- I squinted often to locate areas of soft and lost edges.

- I did not use fixative except where small corrections were necessary.

my challenge

- The challenge all along had been holding back on details. Now I could put in highlights and accents, using luscious strokes of my softest pastels.

HOT TIP!

I always paint from life, but I use a Polaroid camera to take black-and-white photos at different stages. The absence of color and reduced size of the polaroids helps me spot possible problems of composition and tonal values. Anyone who has difficulty reading color values might like to try this.

what the artist used

support
Fine tooth sanded paper

pastels
A wide variety by many manufacturers from hard to mostly soft pastels; dull reds and yellows, a range of greens, turquoise and ultramarine, gray violets and several pale tints and neutrals

Rainie Crawford lives at 21 Mountain View Avenue, New Milford CT 06776 USA

The push/pull dynamic of contrasting color temperature generates a pulsating rhythm.

Kettles, oil, 11 x 14" (28 x 36cm)

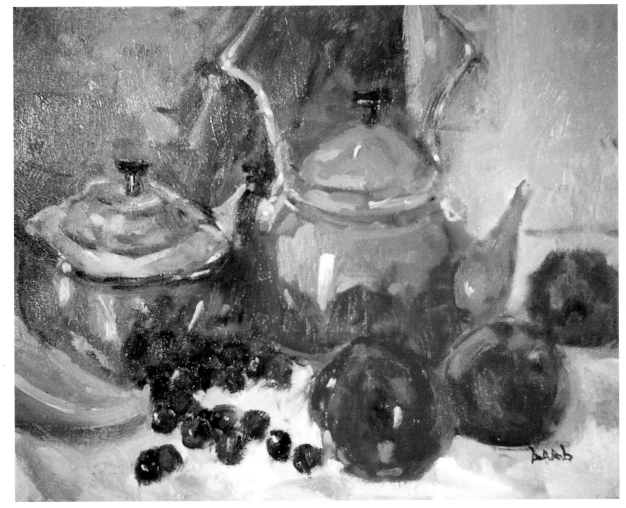

what I wanted to say

When I see the way light hits ordinary, everyday objects that we all take for granted, I feel there's a little story I want to tell. I try to express my feelings of this beautiful moment.

my color philosophy

The warm/cool contrasts throughout this entire painting create what I call a vibration. This push/pull effect adds a lot of interest and excitement to a simple subject. The temperature shifts also make some areas recede and bring others forward, making the painting exciting to look at.

please notice

The background and foreground are not literal. I created them with abstract shapes to enhance the painting.

my working process

• By toning the canvas with turpsy Burnt Sienna, I automatically created a mid-tone. I used pure Burnt Sienna to indicate my drawing and put in the darkest value pattern. I then used a cloth slightly dampened with turp to gently sculpt out the lightest areas, resulting in a monochromatic sketch. I let this dry a bit before I started with color.

• I scumbled in the local color, not really caring if it was right at this stage since I would be painting over most of it anyway.

• Returning the next day (I prefer the way wet paint goes on over a dry underpainting), I corrected any design flaws. With the mechanics out of the way, my intuitive self was free to take over and I could become lost in the joy of painting.

• I developed the elements, using both wet-in-wet and wet-on-dry techniques.

• For my final accent strokes, I loaded up a clean brush with buttery paint, swiped across the previous wet paint and left it. It worked!

my advice to you

If you are new to painting, there is no better way to learn than to set up your own objects and paint from life. But then, artists are always students. We never stop learning and isn't that great!

what the artist used

support
Canvas

oil colors

Titanium White	Cadmium Red Light	Viridian
Cadmium Yellow Light	Winsor Red	Ultramarine Blue
Winsor Yellow	Alizarin Crimson	Cobalt Blue
Yellow Ochre	Raw Sienna	Cerulean Blue
Cadmium Orange	Burnt Sienna	

brushes
Bristle brights and filberts from size 2 to 12

Anita Daab lives in Tacoma, Washington, USA → anitasart03@nventure.com

My goal was harmony through shape and color.

Two Mangoes, oil, 9 x 12" (23 x 31cm)

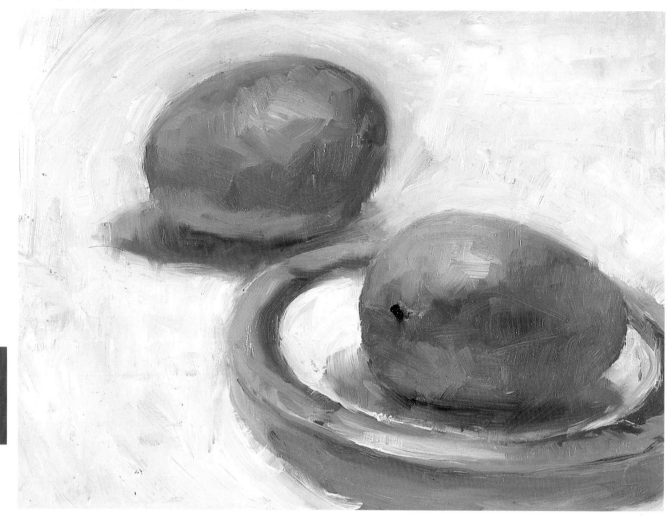

my inspiration

While putting away the groceries I turned and saw these two mangoes set up perfectly. The complementary red and green colors situated on the cool, white surface resounded throughout the space. I knew from that instant that it would make a beautiful painting if I could communicate the qualities that drew my attention to the subject. It was late in the day, but I'm glad I went for it!

my design strategy

This subject exemplifies the harmony that I strive for in positive and negative shapes and warm and cool colors. To convey my interests, I emphasized the two vibrating, complementary colors at the forward place of the front mango, creating a clear focal point. All of the other elements in the painting were adjusted to support it.

my working process

- A quick thumbnail confirmed my composition so I went to work.
- I stained the entire surface with a light wash of Burnt Sienna. Then I proceeded to draw the positive shapes of the mangoes in Alizarin Crimson, making sure I measured everything proportionately.
- When I felt comfortable with the composition and drawing, I filled in the shadow areas with a cool purple.
- Next, I blocked in the local colors carefully, making certain each stroke was similar in tone and color to what I saw in front of me.
- After covering the entire canvas in accurate strokes, the painting looked like a stained-glass mosaic. I then picked up a clean, dry hog-hair brush and selectively softened a few edges.

try this yourself

- I compare my colors on the palette as I mix them. If they harmonize well together there, they will harmonize in my painting.
- I try not to doodle, but rather make each stroke count. As I lay down a stroke, I constantly compare its value, hue, shape and position to the previous ones. If it's accurate, I leave it and move on.

what the artist used

support
Masonite prepared with two coats of unbleached gesso

brushes
Hog hair filberts, sizes 5 to 8; palette knife

medium
A three-part mixture of Turpenoid, linseed oil and Damar varnish

oil colors

Titanium White	Cadmium Red Medium	Viridian
Cadmium Yellow Medium	Alizarin Crimson	Cobalt Blue
Ochre	Burnt Sienna Medium	Ultramarine Blue
Cadmium Orange	Raw Umber	Ivory Black

Randolf Dimalanta lives in Olathe, Kansas, USA → www.randolfdimalanta.com

Try my unique color strategy for extreme light conditions.

Rendezvous Place, watercolor, 16 x 24½" (41 x 62cm)

all about light

I remember thinking "wow!" when I first saw this subject. I was in New York at the time, sightseeing and looking for subject matter to photograph, when I happened to see this little eatery. The sunlight filtering back into the space and bouncing off the front table onto the back tables really captured my attention. It was all about light and shadows.

my design plan

- I arranged the composition through my camera's viewfinder. This was done by shooting several shots of the same subject, only changing angles and positions. By bracketing the shots using different exposures, I also provided myself with good reference information about value and color.
- I composed the painting around the strong light source on the far left table to allow the eye to focus on the first chair behind

the second table, continuing back to the next chair in the dark shadows, then onto the chair on the right and then to the chair in the left foreground. Light itself provided the harmony that tied all of the elements together for a cohesive composition.

my color philosophy

Bright sunlight tends to make colors look muted and dull, but I wanted to portray just the opposite and bring out the colors. This conveys that the colors don't change when drenched in sunlight — they are still the same whether overpowered by the sun or covered by darkness.

my working process

- Projecting my favorite slide onto the watercolor paper, I carefully penciled in every detail of the image.

- Washes of color were applied to each area to establish the basic shapes.
- Through glazing, I intensified the colors, darkened the shadows and heightened the details to define and bring out the main subjects. Many glazes were

required to capture the transition from bright sunlight to pitch black.
- Some highlights were scratched out with a craft knife, while others were lifted out with a wet bristle brush or damp cotton swab.

what the artist used

support
Watercolor paper

brushes
Sable, sizes 2-8

other materials
Masking fluid
Craft knife
Cotton swabs

watercolors

53

Henry W Dixon lives in Kansas City, Missouri, USA → www.henrywdixon.com

Variation in edges and paint thickness allowed me to suggest depth.

Amaryllis, oil, 26 x 30" (66 x 76cm)

my inspiration

I often grow amaryllis for their big beautiful blooms in the winter when everything else in my garden is dormant. The beauty of these big, tropical-looking flowers excited me to paint them.

my color philosophy

I used a dark green vase to complement the red in the flowers, and carried that color scheme through the painting with the red apples and green leaves. The small wooden box and Chinese screen added more interest to the composition. The effect of light from one source (a north-facing skylight in my studio) as it falls on and describes colored objects is the concept I use in all my work.

my design plan

I composed this painting to attract the eye with the power of the flower's color and size. Then the ducks on the screen lead the eye to the box and across the table to the right, following the light as it describes the apples and leaves. The small red vase and white apple slices on the far right prevent the eye from wandering out of the picture.

my working process

- Once I was set up, I indicated the abstract size and shapes of the objects with a dark mixture on a toned board or canvas.
- Satisfied with the placement, I moved into color, painting the foreground flowers that might wilt or change soon first.
- With the flowers complete, I began to work all around the canvas. I used heavier paint and

harder edges to make some elements come forward, and thinner paint and softer edges to make other elements recede.
- After letting this first "alla prima" session dry, I went back over anything that needed adjusting.

my advice to you

- Take as much time as you need to set up a composition you really love and are excited to paint. Even when painting flowers from life, take time to play with the paint and color.
- When painting multi-petaled flowers, making just the suggestion of petals with beautiful brush strokes is best. Let the viewer's eye fill in the rest.

what the artist used

support
Oil-primed linen

mediums
Maroger medium

oil colors

Flake White	Cadmium Red Light	Burnt Umber
Naples Yellow	Madder Lake Deep	Viridian
Cadmium Yellow Light	Transparent Red Oxide	Phthalo Blue
Cadmium Yellow Medium	Pyrrol Red	Ultramarine Blue
Yellow Ochre	Raw Umber	Ivory Black

Raenell Doyle lives in Yelm, Washington, USA → raenell55@earthlink.net

Impeccable drawing and a simple, but dynamic triangular design make this painting work.

Bouquet of Pears, oil, 14 x 12" (36 x 31cm)

my inspiration

This antique amber dish has been waiting for a while to be put into a painting. I finally visualized it combined with a "bouquet" of pears. I love doing pears because they are similar in shape but infinite in variety.

my artistic philosophy

I see myself as a "Classical Realist". In today's world of noise and ugliness, I try to create paintings that are beautiful and quiet so that the viewer can relax. Therefore, my compositions are usually of simple design — in this case, a triangle to make it exciting. I use dramatic lighting and the tension of warm and cool colors, coupled with impeccable drawing.

my working process

- After setting up my live arrangement, I did a quick compositional sketch directly on the canvas. However, I remained open to possible changes in the design until I found a composition that "talked to me".

- I then began blocking in color over the entire canvas in a very loose, impressionistic style. I built up several layers to achieve the color, temperature and lighting that I wanted, allowing each layer to dry before I continued. Along the way, I continuously refined my drawing so I wouldn't lose the accuracy of the subject.

- Finally, when I was satisfied with the painting, I completed the highlights.

my advice to you

Whether beginner or experienced, abstract or realist, I urge all artists to make at least 10 sketches or drawings every day. Draw everything. If you can draw well, any and all forms of artistic expression are open to you, but if you cannot draw, you will always be limited in what you can do.

55

what the artist used

support

Double-primed Belgian linen canvas, portrait grade

brushes

A full range of bristle brushes for the main work, then smaller sables for the final layers

oil colors

FLAKE WHITE | CADMIUM YELLOW PALE | NAPLES YELLOW | PERMANENT ROSE

CADMIUM RED | ALIZARIN CRIMSON | BURNT UMBER | CADMIUM GREEN LIGHT

ULTRAMARINE BLUE

Joseph John Dudding lives and works in Shiremanstown, Pennsylvania, USA → jdud306491@aol.com

I never forget how important the design tools are.

my inspiration

The first light of day brings crispness to the shadows created by the early morning sun. It is this special relationship of light on any subject that I embrace and try to recreate. So when I was out for an early morning stroll and came upon these common petunias, they spoke a language of beauty. I knew I had to capture this fleeting moment and share it with others.

my design strategy

For this painting's design, I used repetition in color, size and shape; variation and contrast in light (chiaroscuro); gradation in creating the shadows; harmony in the use of color and shape; dominance of color, shape and size; and unity in the composition through the related elements.

a personal challenge

The flowers in this painting were done with only three colors. I wanted to challenge myself to see if I could accomplish the depth, variety and realism I demand in my art with such an extremely limited palette. I was excited as the glowing image came to life.

my working process

- Taking a flower from one of my photos, another from an on-site sketch and so on, I created my design in the form of a thumbnail sketch. Visualizing flowers in their natural environment this way is more challenging than simply arranging them in a vase and immediately seeing the results. I then drew the image in pencil directly on my paper.

- The first color I applied was Raw Sienna. Adding Manganese Blue and Cobalt Violet to my palette, I then painted in all of the shadows, plus some details. I tried to keep in mind the use of warmer and cooler versions of this mixture to make some petals recede and others come forward. Since I was dealing with white flowers, it was the shadows that would tell the tale.

- A few glazes of darker colors enhanced the depth and varied the tones and colors.

- Once the flowers were completed, I tackled the background, using my signature dark mix of Phthalo Blue (green shade), Permanent Alizarin Crimson and Violet. I always save the background for last so my dark colors don't bleed into my pale flowers.

Les Fleurs de Blanc, watercolor, 30 x 22" (76 x 56cm)

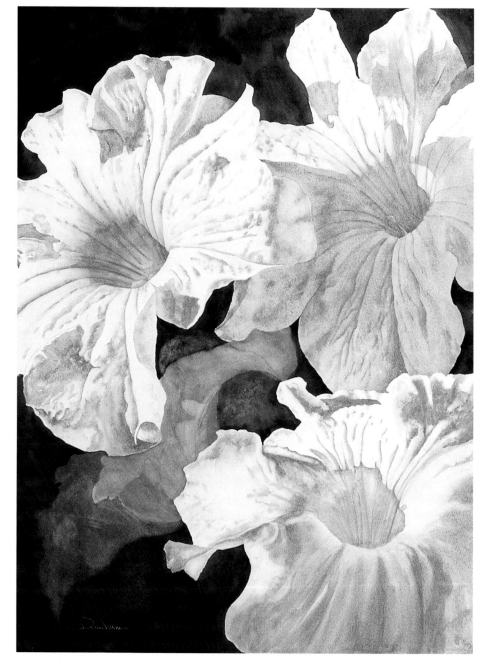

HOT TIP!

Never stretch your watercolor paper, as it removes sizing that aids in lifting pigment should you need to.

what the artist used

support
140lb cold pressed bright white watercolor paper

brushes
Squirrel hair mops

watercolors

Raw Sienna	Manganese Blue
Alizarin Crimson	Phthalo Blue
Phthalo Green	Violet
Ultramarine Blue	Cobalt Violet

Kathy Dunham lives in La Quinta, California, USA → www.kathydunham.com

It's important to have a strong emotional connection with my subjects.

my inspiration

I generally choose one compelling object and build everything else around it. In this case, the beautiful blue pitcher with its ornate gold trim caught my eye. I visualized it surrounded by other blue objects, notes of contrasting orange and plenty of white to offset these intense colors. I soon had a vivid mental concept of a painting that was elegant, high-key and dynamic, yet with a soft ambience.

my design strategy

I spent a huge amount of time on this all-important initial design step. Although I wanted the painting to be simple and uncluttered, which I achieved with the expansive white background, I also felt the need for intriguing variations in the shapes, sizes, heights and textures that would lead the eye to the focal point, the blue pitcher. Allowing the flowers to break out of the top edge created interesting negative shapes. Finally, a spotlight positioned lower than the objects completed the striking, dramatic mood I was seeking.

my working process

- Over a thin wash, I drew my focal point in its correct position on the canvas. I then made a careful brush drawing, constantly measuring and scrutinizing to make sure it was accurate.

- Switching to bigger brushes, I began to block in my masses, wet-into-wet, always checking that the relationships of value and color were exactly what I wanted.

- Still squinting at my subject to see it as nothing more than a series of related shapes, I began to define the forms within my composition. The biggest challenge was mixing all the subtle variations and nuances throughout the white background and foreground.

- Once I had successfully established the main relationships in the overall image, I was ready to tackle the little things. I addressed the specific details and edges within each object.

please notice

Even though the overall effect is cool and high-key, this painting is full of warm color. Following the same principle, it's the contrast of the really dark darks that make these light values pop.

HOT TIP!

Don't skimp on the quality of your materials! Not having to do battle with uneven surfaces, globby paint or brushes that leave behind trails of hairs will decrease your frustration level.

Calla Lilies, oil, 36 x 24" (92 x 61cm)

what the artist used

support
Fine-textured Belgian linen mounted on Foamcore

brushes
Sable flats and rounds

oil colors

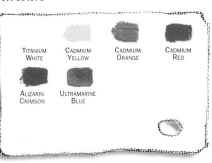

TITANIUM WHITE CADMIUM YELLOW CADMIUM ORANGE CADMIUM RED

ALIZARIN CRIMSON ULTRAMARINE BLUE

Cathy Edgar lives in Tucson, Arizona, USA → cmedgar@earthlink.net

Study this combination of drawing and painting.

Paisley Tulips, watercolor, ink & gouache, 21¼ x 29¼" (55 x 74cm)

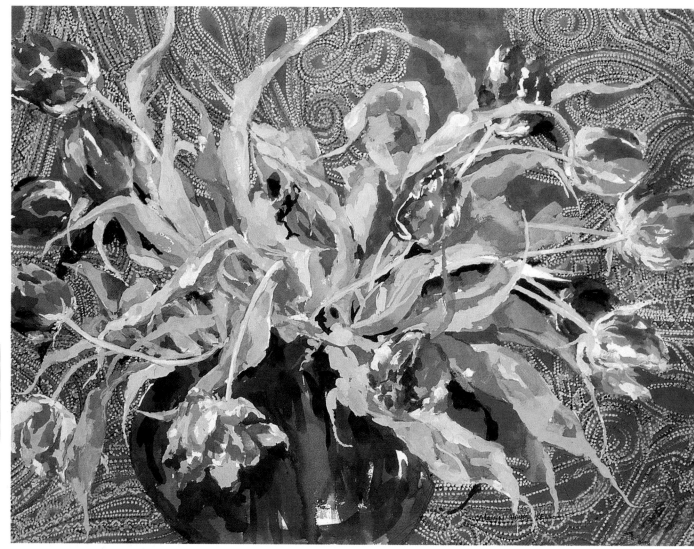

my inspiration

My mother's treasured, red paisley throw inspired me to build a still life around it. I looked for colors that would harmonize, but shapes that would contrast to add drama and depth. The gracefulness of the pink and purple tulips, the stark roundness of the blue vase and the set patterns of the paisley throw met my goals. The cool green of the leaves gave the whole painting movement.

please notice

I love to draw, but I was stuck in a hole between drawing and painting for quite a while. I love lines and was afraid of losing them under paint. To solve the problem, I simply began to use a lot of lines and dots in my work. In addition to giving my paintings a unique look, they can be used to create texture, to tone down areas and to unify paintings.

my working process

• I began by drawing from life very loosely and permanently in ink. I then continued "drawing" in watercolor.

• I painted the flowers and vase first, dropped in the Vermilion background and then used the paisley pattern to tie the painting together.

• I drew the background pattern lightly in ink and then dotted these lines in various colors (yellow, green, blue, white and black). The dots created texture, brought the background up to the two-dimensional surface and toned down the background red while blending it with the flowers.

• I played with the tulip leaves until they all worked together to create a pattern.

• Finally, I used some glazing to intensify the reds. This painting took a great deal of time — it required many layers of paint and some lifting to tone down certain areas.

something to think about

Watercolor doesn't have to be the "toughest medium to conquer" unless you limit yourself to being a purist with transparent watercolors. I much prefer to add gouache to my repertoire when needed. If using gouache was good enough for Winslow Homer and Toulouse-Lautrec, it's good enough for me.

what the artist used

support
Watercolor paper

brushes
Synthetic brushes

other materials
Ink
Watercolor
Gouache

Carolyn Hayes Kelso lives in St Augustine, Florida, USA → www.jacksonvillewatercolor.org

Take a leaf from my book, and change your viewpoint.

my inspiration

A wonderful example of one of Australia's native trees — the eucalyptus — lives in our garden. All I need to do is look up, and I can see its beauty against the sky. The richness of its color, especially when in bloom, is superb.

my color philosophy

I felt I had to stay as close as possible to the colors in this beautiful eucalyptus tree. Nature had already provided the best color harmony, variation and contrast I could find, so I tried to capture these qualities as accurately as I could in order to do the tree justice.

my viewpoint

- I wanted to find an interesting viewpoint for my subject so I imagined that the native birds saw it as a wonderful food source. I began to develop my composition by doing a rough sketch first, standing on a ladder to see the rough outlines of a small branch, some leaves and the seed heads better. The sun was mostly overhead and that gave me the idea of the clouds building up.

my working process

- To prepare the paper I soaked it first and let it dry. I then transferred my rough sketch onto my paper using an ink-pen, making some minor adjustments along the way.

- I painted the sky first, then the background blossom area, both with a wet-into-wet technique. I used the sea sponge in some parts of the sky to suggest clouds.

- Still working wet-into-wet, I painted each leaf separately and the seed heads as well. The stem was done last, then I went back to the background blossoms to apply the finishing touches. For me, layers of wet-into-wet applications work miracles for harmonizing the colors and values.

- Then hands off! The mirror test confirmed the results.

Illyarrie Bird's Eye View, watercolor/ink, 12 x 8½" (31x 21cm)

59

what the artist used

support
250lb cold pressed watercolor paper

brushes
¾" draw and wash brush; sable brushes in #8, 6, 4; ink sea-sponge

watercolors

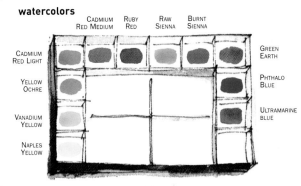

Hilde Jones lives at 2 Manxton Way, Lynwood, 6147 Western Australia

My painting is all about color and texture.

my inspiration

On a recent trip to Taos, New Mexico, I came upon this very large and long chili pepper bunch. Inspiration was born! The contrast of the light stucco background, the vivid reds and burgundies of the peppers, the yellow raffia and the colorful shadows intrigued me. I wanted the viewer to be transported to the sunny southwest, even if they were in the depths of winter.

my "red-hot" color philosophy

This image is based on color and value, so I planned to use a huge range of bright, fresh reds plus some cooler violets, greens and blues to give them three-dimensional form. Recognizing that the reds would be extremely dominant, however, I decided to use complementary colors in the raffia to attract the eye and keep it flowing up and down the ristra. I decided to make the background echo the overall color range, but more subtly and with a stronger texture from various salts.

my working process

- Combining several photographs, I developed my design on a large sheet of tracing paper. Then I transferred the drawing onto the watercolor paper, using a waxless graphite paper.

- Using liquid frisket pen, I blocked out areas to remain white or light colored.

- When dry, I started applying the first glazes of warm yellow tones on the peppers. With each glaze, I added fine salt crystals, building up the color and the texture on each pepper. I worked every other pepper to hold my hard and soft edges.

- I continued adding pigment, using every red from Raw Sienna to Violet plus a few cool tones for balance and shadow, until I had completed all of the peppers.

- Because I planned to paint the entire background area wet-on-wet, including coarse salt applications, I protected the ristra with frisket while painting.

- After removing the frisket outlining just the raffia, I painted one strand at a time with yellows, charging in soft purples for the shadows. Next, I painted the small details.

- Finally, I removed the frisket from the peppers, softened some hard edges and added final glazes to fine-tune the painting.

something you could try

On scrap pieces of watercolor paper, try out various salts with your palette colors and different water amounts. Each type of salt leaves a unique texture on the paper.

what the artist used

support
300lb cold pressed watercolor paper

Triple elephant sheet size cut in half the long way

brushes
#10 and #6 rounds; 1½" flat wash brush

watercolors
Aureolin
New Gamboge
Quinacridone Gold
Raw Sienna
Quinacridone Red
Burnt Scarlet
Cadmium Red Deep
Venetian Red

Quinacridone Rose
Maroon
Moonglow
Sap Green
Cobalt Blue
Ultramarine Blue
Manganese Violet
Paynes Gray

other materials
Masking fluid pens

Various salts

Annie L Ferder lives in Bend, Oregon, USA → annieferder@bendcable.com

Red Hots, watercolor, 60 x 18" (153 x 46cm)

This one's all about family ties!

what I wanted to say

This painting is about family — the one we're born into, the one we create, and the human family as a whole. We are all tied to one another, whether we like it or not. I wanted the composition of the painting to call to mind the moment before a family photograph is taken, when everyone is still talking and wriggling. I also wanted to suggest a circle, which often symbolizes unity. I emphasized this twice by circling the pears with the thread.

color symbolism

Family relationships provoke our strongest emotions, and I wanted to reflect the heat and ice of these passions in my colors. I painted six pears in warm yellows through to reds. I then painted the seventh pear in cooler greens. I introduced complementary colors in the shadows and background and pushed the warm colors up the "heat" scale.

my design strategy

I began by choosing the seven most outrageously shaped, personality-laden pears I could find. In my studio, I took time shifting the pears and lighting around until I got the composition just right. This process took the place of preparatory sketches, thumbnails or color studies.

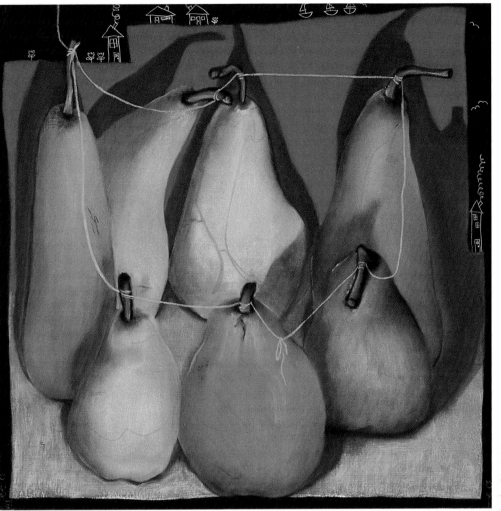

Family (Tied to Life), pastel & charcoal, 22½ x 22¼" (57 x 56cm)

61

my working process

- I prepared my paper surface by applying two coats of gritty, colored acrylic ground.
- In pastel pencil, I made a blind contour drawing to capture the bones of my painting, some wonderfully wonky shapes and knots of lines that would later disappear.
- I worked over the whole surface as one, moving freely between pears, background and shadows. I layered and blended the colors with my fingers. I began with the local colors of the pears, but then intensified and enriched

them so that each pear's appearance was unique, yet all were related (like a family). I used a kneadable eraser to pull back and reveal underlying layers, and to make adjustments and corrections.
- Once I felt the painting was nearly complete, I drew in the connecting thread using pastel pencil.
- The black area framing the painting felt incomplete, empty. I let the painting sit on my easel for a few days until the answer came. In went the line drawings, using a graphite pencil. Done!

what the artist used

support

140lb hot press watercolor paper; ground — two coats of a textured acrylic ground for pastels blended with a small amount of acrylic paint and applied with a wide foam brush

other materials

Soft pastels and pastel pencils

Soft charcoal in pressed stick form

4B graphite drawing pencil for the line drawings

Kneadable eraser to pull back layers of pastel and to make changes

Cathy Fink lives at 1747 Haultain Street, Victoria, BC, V8R 2L1 Canada

Here I achieved a balancing act between subtle value shifts and strong shadows.

Morning Shadowplay, oil, 22 x 18" (56 x 46cm)

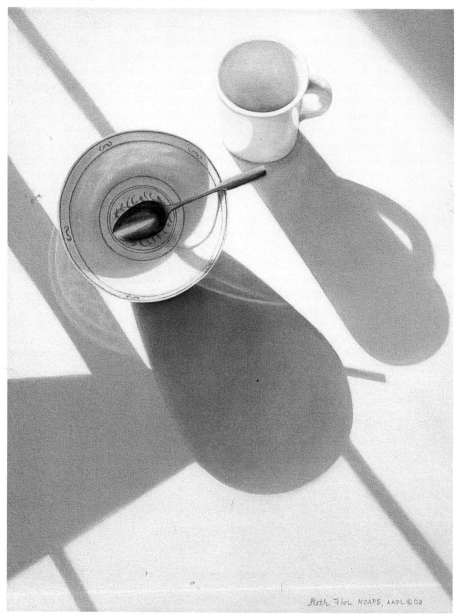

my inspiration

While working on another painting, I noticed how light and shadows changed these common objects into an interesting pattern. It was an "aha!" moment! I was amazed at the beauty that can be found in everyday, household items.

my design strategy

Shape is the dominant element of design in this painting, both the positive shapes of the objects and shadows and the negative shapes surrounding them. Once I had placed the bowl in the "sweet spot", I refined the arrangement of the other objects and their cast shadows so they would balance the design and direct your eye.

Tonal values were integral to the concept. I wanted to use subtle value shifts to portray the delicacies in the shadows and make them believable, but I had to use a wide range of values to make the shadows strong enough to carry the weight of the design.

Color was secondary to shape and value. I used a limited palette to paint the colors I saw, looking for subtleties in tone.

preparing to paint

I photographed the original shadow pattern as it happened since I knew it would change quickly and I might never see it exactly the same way again. However, I still used the set-up to paint from during morning light.

my working process

- I began by stretching a canvas in the appropriate size for the design. A careful drawing done in pencil proved that the design worked on the canvas size.

- On the white ground, I began painting the shadows first to give it some structure. I thinned this paint with a little painting medium, which allowed me to retrieve some lights with a rag.

- Next, I began to develop my mid-tones and lights. I tried to be as accurate as possible with every stroke, always striving for correct values, colors, transitions and edges.

- After painting in the shadow pattern in the bowl and the mug, I then painted in some details — the blue patterns on the bowl and the spoon.

- Only a few highlights and added darks were necessary to finish.

my advice to you

- Avoid trite subjects and compositions.

- Simplify. Don't use every detail or every design element in every painting.

Beth Flor can be contacted at PO Box 262, Petersburg, Alaska 99833 USA

what the artist used

support
Polyflax synthetic canvas (a slick surface)

brushes
Mixed sable/synthetic brights, sizes 14-20

oil colors

WHITE · NAPLES YELLOW · JAUNE NAPLES ROUGE · LIGHT BLUE VIOLET

ULTRAMARINE BLUE · BLACK · MOONGLOW

62

I wanted to go beyond realism and suggest meaning.

Persimmons, oil, 31½ x 47" (80 x 120cm)

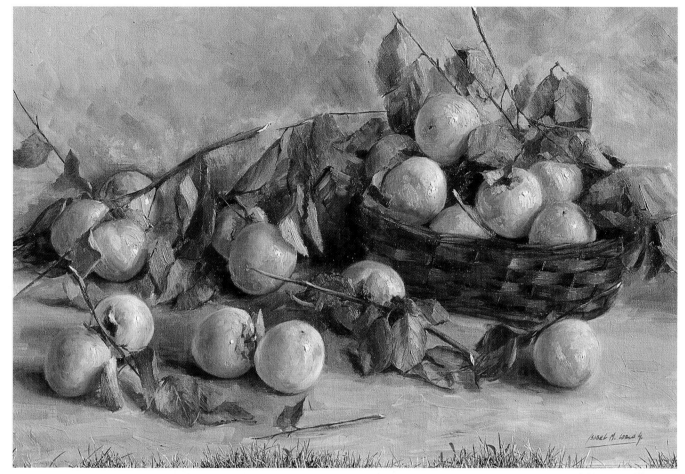

my inspiration

Expressing color and light on live or natural objects in the simplest possible way is always my pretext for painting. In this case, I was inspired by the autumn character and colors of the fruit, which generated a particular atmosphere. The persimmons, which also remind me of my childhood, possess their own energy and generate movement with the secondary elements, forming a harmonic whole.

composing on the canvas

- I painted this directly from life, with a time limit of the natural decomposition of the model.
- When I started to paint, I made a small preliminary sketch directly on the canvas, using oils and a very firm brush so that I could make rapid, definite strokes.
- Once the objects had been assembled and arranged directly on the canvas in the correct

proportions and locations, I worked on the light, through which I generate the forms. In this case, my subject received natural light from a window on the right.

- The composition of this painting was based on the fruit itself, to which I added branches and leaves, thus giving the necessary movement and integration.

my working process

- Over the sketch, I applied the colors and approximate values on the canvas to conform to the basis of the painting. Then I reproduced the projected shadows, superimposing layers with which I gave birth to the forms through light.
- I worked alternately with soft and hard brushes. The soft brushes allow me to work on the shadows, transitions and twilight zones of the shadow, while the hard brushes were

best for the light zones, where I formed the area of highest pictorial substance and consequently the volume of the subject.

please notice

My intention was to present an harmonious whole to the viewer, beginning with the logical order

of the contents of the basket and moving to the chance location of the elements outside it. In the process, I hoped to provoke emotion as the viewer contemplated my work, suggesting a reading that goes beyond the dynamic realism of the proposed forms.

what the artist used

support
Cotton canvas

brushes
Soft, flat, fine oil brushes for shadow areas; bristle brushes that left paint marks in areas with a higher pictorial substance

other materials
Oil medium

oil colors

TITANIUM WHITE · CADMIUM LEMON · CADMIUM YELLOW · CADMIUM ORANGE
VERMILION RED · CADMIUM DEEP RED · ALIZARIN CRIMSON · CERULEAN BLUE
ULTRAMARINE BLUE

Isabel M Lorca Godoy lives in Santiago, Chile → www.isabelorca.cl

For this fun painting I used the techniques of the Old Masters.

Sweet Things, oil, 9 x 12" (23 x 31cm)

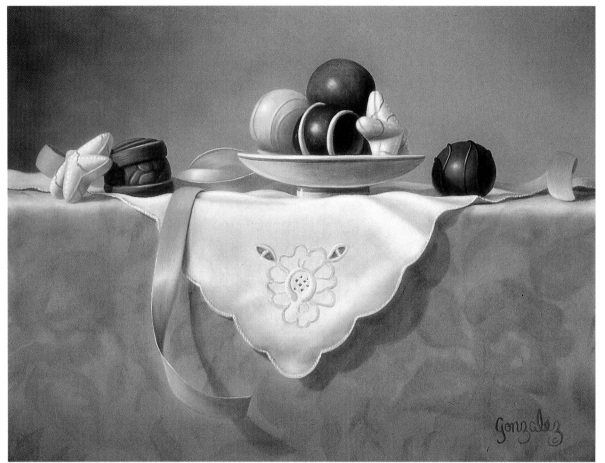

my design strategy

This painting falls under the category of "just fun." At first, I was afraid the concept might be too simple, so I spent a little time figuring out what would give it some punch and bring it all together. That's when I added the ribbon and handkerchief. The curves went together perfectly with the round truffles, and the floral design had the same shape as the starfish candy, creating repetition. Color was another challenge because the truffles were a uniformly dark color. I simply changed one of the truffles to pink.

my working process

- Once I had worked out the composition in preliminary pencil sketches, I created a small oil color sketch to maintain the true colors of the objects.
- I prepared my sturdy Masonite board with about six coats of gesso, each slightly sanded.

Next, I mixed modeling paste and water into a creamy substance and brushed it onto the slick gesso to create surface tooth.

- After transferring my design onto my board, I blocked in the masses with Raw Umber and Titanium White.
- With the underpainting complete, I blocked in the color and started to define each object, keeping my colors in the middle tones. This process was repeated until I had achieved the appropriate visual value concept.
- Once the color values were where they needed to be, I started to add details to give the objects their character.
- Lastly, I glazed in the final shadows and added the brightest highlights.

my link with tradition

Although my paintings have a contemporary flair, they also possess the beauty of the Old Masters' techniques. A lot of this has to do with my simplified palette of primaries and the mediums I use.

The first medium I use consists of stand oil, Damar varnish and beeswax, which I mix into all of my colors. The stand oil has a tendency to seek a uniform level, making it easier to blend and eliminating brushstrokes. The second medium is a mixture of painting medium and poppyseed oil, used whenever my painting gets dry and I need to rework a section wet-on-wet. The last mediums, Liquin and linseed oil, are used for glazes. Liquin is fast-drying and linseed oil is slow-drying, so the drying time of the paint can be controlled depending on which one I use.

what the artist used

support
Masonite

brushes
Hog hair bristles (flats) #2, #6, #12 to block in the masses
Sable brushes (brights) #8, #14, #20 to block in the color
Pure red sable (filbert & rounds) for detail

mediums
Slow drying medium similar to Maroger medium

Linseed oil
Painting medium
Poppyseed oil

oil colors
Titanium White
Cadmium Yellow
Yellow Ochre
Alizarin Crimson
Raw Umber
Ultramarine Blue
Cobalt Blue

George A Gonzalez lives in Friendswood, Texas, USA → www.gonzalezstudios.com

I strive for impressionistic and imaginative results using pools of color.

Sweet Pea Posy, watercolor, 16 x 16" (41 x 41cm)

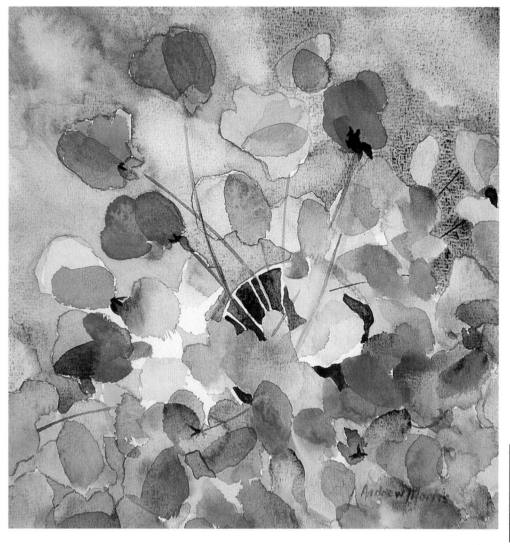

what I wanted to say

I have always felt that the joy in the world comes from nature's flowers. So when I grew an especially good crop of multi-colored sweet peas, I was determined to capture their essence in a painting. I decided an unusual top view would allow me to show the maximum number of colorful blooms in my picture, and would lend itself well to a sweeping, radial design within a square format.

As always, I wanted my painting to be colorful and decorative. I very much try to make all of them impressionistic and imaginative, rather than photographic and finely detailed. So, I chose to use bright, transparent watercolors to produce pools of color that dry slowly, leaving sharp, dark edges and a pale centre. They look just like the sweet peas.

my working process

- Near my floral arrangement, I set up my easel so that it was absolutely flat and level. Then I taped my paper to a smooth board.

- After deciding on my angle of view, I made several rough sketches in a sketchbook to establish the size, shapes, tones and scale.

- With a 2B pencil, I lightly outlined the main components on my paper.

- I applied masking fluid wherever the stems crossed the vase.

- Using very clean water, brushes and paint, I mixed up some of the first colors on the palette, tested them on a separate sheet and started to paint. I used a mop brush to pick up enough color to make several pools of paint where the flower petals were to be, leaving a space between each.

- It was essential to allow about an hour's drying time before putting down the next layer.

- I worked around the picture in this way, taking my time and finishing up with the darker colors.

try pools of color yourself

This technique is a bit challenging because it requires patience to allow the pools of paint to dry naturally. If you try it yourself, do not use a hot air drier or the hard edges of the puddles will not form. Also, make sure the puddles are dry before starting on the next layer. I recommend working alternately on two paintings at a time, although one always seems to turn out better than the other.

what the artist used

support
300lb hot pressed watercolor paper taped down to a flat, level board

brushes
Two large squirrel mop brushes, about 10 to 15 size; a number 3 rigger brush

other materials
2B drawing pencil

A ruling pen charged with masking fluid

watercolors
Light Red
Alizarin Crimson
Sepia
Viridian
Sap Green
Ultramarine Blue (Red Shade)

Andrew Morris lives in Hythe, Kent, England → Andrewmorrisart@aol.com

Glazes of transparent acrylics make this backlit floral look like stained glass.

I Got Sunshine, acrylic, 16 x 20" (41 x 51cm)

my design and color strategy

Sunlight on flowers made me want to fill a painting with several close-up flower heads. I used a flat, circular composition to grab the viewer's eye and lead it around the painting. The flowers form an engaging pattern against the negative shapes of the dark background.

why I chose this medium

The painting is backlit so the light glows through the petals, giving a rich intensity of jewel-like color, like light shining through a stained-glass window. The bold contrast of the cool, dark background against the warm yellows made the colors glow. Bright, transparent acrylics seemed the perfect medium for achieving these effects.

my working process

• Starting with a preliminary

sketch from life, I determined the initial concept, which gave me a good indication whether the painting would work. I then took a reference photograph to work from in the studio.

• After drawing out the final composition, I transferred it to the canvas.

• From there, I blocked in the shadow areas with a thin wash.

• Thanks to the speedy drying time of acrylics, I easily built up thin layers of washes. I used acrylics as if they were watercolors, creating the depth of rich colors I wanted by layering transparent washes rather than mixing solid, flat colors. Adding a glazing medium kept the layers transparent and also slowed the drying slightly, giving me time to apply the paint smoothly.

• I then used an interesting combination of darks for the background areas rather than

black, which would be too severe and flat.

• Finally, for the detail parts, I worked into the painting with a #0 watercolor brush.

the main challenge in painting this picture

Creating the cool shadow areas on the petals that were out of the sun was a challenge. These cool shadows are really quite dark in tone, and their contrast is the key to highlighting the warm, glowing colors. The trick was to make the cool shadows with color rather

than tone, otherwise they would become too heavy and spoil the illusion of light.

my advice to you

Practice sketching regularly to hone your drafting skills and color observation, but keep your quick sketches as a diary for your eyes only! Other people's criticism, whilst meant to be helpful, can inhibit your creativity and development. Instead, look back at your paintings over time and see for yourself how you have improved.

what the artist used

support
Canvas

brushes
Watercolor brushes
(round #0, 1, 2, 6) and
acrylic brushes
(flat #2, 4, and 8)
for the background

acrylic colors
Zinc White
Cadmium Yellow Light
Cadmium Yellow Medium
Quinacridone Gold
Quinacridone Crimson
Raw Umber

Raw Sienna
Phthalo Green (blue shade)
Cerulean Blue
Ultramarine Blue

Julia Hargreaves lives at 910 Stuart Road, Kelowna, BC, V1Z 1H1 Canada

My subconscious mind was at work on this one.

Sunlit Meditation, opaque watercolor, 24 x 18" (61 x 46cm)

my inspiration

Looking up from painting one late afternoon, I saw the cast shadow of a steer skull that hangs in my studio, then saw the phalaenopsis (that's an orchid) in bloom. I placed the plant in the shadow of the horned critter and moved it forward just a bit so the light could catch the blooms. My eyes/brain did an "aha!" It's hard to put my exact inspiration into words — I just saw something that pleased me (made something inside go "ahhhhhh!") and wanted to capture that impression. I loved the contrast of the light/shadow but also of the theme of life/death.

why I chose this medium

I usually choose gouache for all my work — oils are too slow, watercolors too intense and acrylics too quick. Gouache (or opaque watercolor) permits me to paint extreme detail if so desired, and its qualities seemed ideal for promoting a peaceful, meditative aura without becoming too stimulating. The only secret to working with gouache is to mix up large batches of each color so you don't have to try to match colors later — which is nearly impossible!

my working process

- After arranging the elements until they felt right, I made a sketch directly onto the watercolor paper. I also took some slides of the light because it was very fleeting (like life — oh yeah, THAT must be what I was trying to say with this subject!), plus I knew the orchids would change over time.

- Then I gently soaked the paper, stapled it to Foamcore, taped off the edges and let it dry.

- Next, I reinforced the compositional sketch with a very diluted pale ochre wash. I also focused on warm light and cool shadows.

what's so good about using gouache?

- One of the benefits of using gouache is that it is possible to build up some areas opaquely and others transparently by adding more water to the gouache.

- After defining the forms, I added details and highlights. For this, I find medium-sized brushes that hold more paint give me better control than small brushes.

- Always the hardest challenge is knowing when to stop. My dog decided this for me when he grabbed the brush I had dropped and turned it into a long, hairy toothpick. I figured, okay, my painting Muse must be working though a shih-Tzu, I'm done!

what the artist used

support
300lb hot pressed 100% cotton watercolor paper, very forgiving and durable; stretched on Foamcore board

brushes
Kolinsky sable in 1" and ½" flats; #4 and #6 rounds

materials
Gouache (opaque watercolor)

Richard William Haynes lives in Fairfield, New Jersey, USA ➔ rwhaynes@verizon.net

My painting is composed with triangles.

Gossip, oil, 12 x 24" (31 x 61cm)

what I wanted to say

I enjoy infusing inanimate objects with personality and using them in a story line. For this one, I pictured three ladies at a very proper tearoom. One lady was left to sit at the table all by herself while her two friends excused themselves to powder their noses and, of course, gossip about their waiting friend. Viewers may notice the petals falling from the geranium, leaving a sad trail as their friendship starts to unravel, but I hope you also see the humor in the painting.

follow my eye-path

The painting is composed of a series of triangles. The large triangle is formed by the teapot, geranium and makeup compact; the mid-size triangles are the upper left-hand corner and right-hand corner; and the smaller triangle is the red one made from the shape of the geraniums. The eye-path reads right to left, from the teapot up to the red geraniums down the petals over and down to the lower left and stops at the tube of lipstick.

The two still life set-ups could stand on their own but notice how I used the cast shadow and sprinkled petals to bridge the two arrangements.

my working process

- I painted this in my studio under a natural north light. A preliminary thumbnail sketch was made to determine the composition.

- I prepared a toned ground of Raw Umber and Ivory Black mixed with turpentine. Then I very carefully drew in the image with a brush, using Burnt Umber thinned with turpentine. I also began to block in some of my tonal values, lifting out some whites with turpentine.

- My painting approach was very direct, from the general to the specific. I aimed to get the gesture of the whole thing while eliminating extraneous details, following the old adage, "less is more". I used a lot of heavy paint with little medium, which can flatten the paint.

- To complete the painting, I added the blue design on the cups. For this, I used a fine script brush and paint thinned with medium.

my advice to you

In the words of Cole Porter, "It don't mean a thing if it ain't got that swing". Your paintings will have more punch if you leave out unnecessary details and get right to the heart of the matter.

what the artist used

support
Canvas

oil colors

Titanium White · Yellow Ochre · Cadmium Red · Alizarin Crimson
Burnt Sienna · Raw Umber · Burnt Umber · Phthalo Green
Ultramarine Blue · Ivory Black

brushes
Drawing brush: #12; filberts: #4, 6 and 8; script liner: #1

68

Susan Fleming Hotard lives in Metairie, Louisiana, USA → susanhotard@cox.net

This is about tight cropping and dark shadows.

Sunstruck, watercolor, 15 x 11" (38 x 28cm)

my inspiration

These hydrangea blossoms just seemed to dance in the sunlight. I wanted to capture their beautiful, sunlit shapes and leaf tips contrasted against the cool, deep shadows in the foliage.

my design strategy

On-location watercolor studies and reference photos were used to create the final painting in the studio. In designing the painting, my ambition was to zero in on the interesting, interlocking shapes to highlight contrasts in value and temperature from top to bottom, and incorporate dark hues in the foliage to emphasize the warm tones and highlights of the flowers.

my working process

- First I made a light pencil sketch to outline the major flower and shadow shapes.

- With the board tilted at an angle, I wet the entire surface and washed in the sky colors, the lightest flower blossoms and then the foliage, allowing the colors to mix and flow. I allowed some of the white of the paper to remain visible to suggest sparkling sunlight.

- After the initial wash had thoroughly dried, I worked the background flowers, keeping the brushwork relatively loose, blending colors and softening some of the edges. Treating the stems and leaves as part of the same shape, I allowed the colors of the flowers to bleed into the stems and gradually transition to the darker green hues.

- The foreground flower heads were tackled next. I glazed layers of successively deeper shading to suggest the petals and curvature of the blossoms. I allowed the darkest darks of the blossom shadows to flow into the darks of the shadowed foliage.

- I continued working down through the foliage, using the edges of the shadows to carve out the sunlit leaf tips with negative painting. I used lots of pigment and changed hues every couple of brushstrokes to add variety and interest.

- When this was completed, I re-evaluated the painting as a whole and added some accents.

the main challenge in painting this picture

In this painting, my main challenge was to capture the intricacies and detail of the flowers without painting each and every tedious detail. It was essential to maintain the freshness of these graceful flowers without overworking them. I felt that my use of an underpainting for the sunlit highlights and negative painting on the rich shadows helped to suggest the illusion of detail without losing spontaneity.

69

what the artist used

support
200lb cold pressed watercolor paper

brushes
Synthetic brushes (1" flat and #8, 10, 12, 16 rounds)

watercolors
Permanent Magenta
Permanent Rose
Rose Madder Genuine
Burnt Sienna
Viridian
Cobalt Blue
Ultramarine Blue

William Jaeger lives in Severna Park, Maryland, USA → pbjaeger@verizon.net

With a little originality, it's possible to present an uncommon perspective on a common subject.

Apples and Oranges #2, pastel, 18 x 28" (46 x 71cm)

my design strategy

For me, creating a piece of art is a challenging process of finding a new way to interpret any genre, be it landscape, figure or still life.

The idea for this painting was to view the subject from a different perspective — in this case, from above. Along with the oranges and red apples, I introduced a couple of green apples to add interest. By placing the bowl of fruit in direct, early morning sunlight, a long, deep shadow was created to form part of the design and add contrast to the final painting. The bowl of fruit was placed in the center because I knew the shadow area would draw the viewer's eye to the green apple on the right where all the contrast is. The shape of the shadow area was also more interesting when a greater part of it was visible.

why I chose this medium

Because of the warm colors in direct sunlight, I wanted the painting to have a bright appearance. I felt that pastel would allow me to easily introduce the many tones and hues of the different colors in each element.

my working process

- First, I selected a sheet of tinted pastel paper in a harmonious tone.
- Using a complementary color to the main color of each element, I drew in my image, taking care with the placement of the overall subject on the page.
- Next, I applied a foundation of dark and light local colors to establish a value pattern.

- I used scumbling and glazing to build up layers of different colors side by side and one over the other until the objects had form and depth. This loose, impressionistic style shows individual colors when viewed up close but pulls together visually when viewed from a distance.
- After putting in the reflected color patterns, highlights and dark accents, the painting seemed brighter and more exciting.

- In the background, I used lighter values of the colors of the fruit to create continuity.
- Upon completion, I left it for a period of time and then returned to make a few minor corrections.
- No fixative was used.

what the artist used

support
A sheet of pastel paper

materials
A variety of soft pastels

Bill James lives in Miami, Florida, USA → billjames@bellsouth.net

To paint realistically, I focus on planes, not details.

Intermission, oil, 30 x 30" (76 x 76cm)

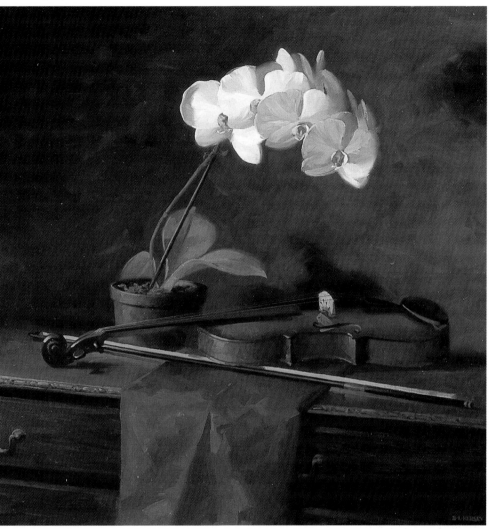

my inspiration

The primary inspiration for this piece was the graceful forms of the orchid. I was also inspired by the cool shadow sides of the white petals beneath the warm lamp light.

my design and color philosophy

I wanted to give the orchid blossoms the most impact. Since the blossoms were white, a dark background seemed the perfect thing.

I also wanted to play up their cool blue shadows, so I surrounded the plant with warm reds and browns. To highlight the beauty of the blossoms' shape, I kept the other shapes simpler. I arranged the objects so that the eye enters through the lit table edge and the fabric, then zig-zags along the bow and violin, and finally moves up the stem to the flowers.

my working process

- I began this piece by toning my canvas with a transparent wash of Burnt Umber acrylic.

- I then roughly indicated the large shapes with Burnt Umber oil thinned with a little turps.

- Next, I used thinned paint to quickly block in my shadow areas and then the light areas. This was just a general indication of the placement, proportions, value and color of the elements.

- Once I had the canvas covered and all of my elements established, I chose a mid-size brush and began to refine with thicker, more opaque paint, starting at my focal point and working out from there. I find that having the near-finished focal point as a set standard helps me limit the amount of detail I put into less important areas.

- As I refined, I looked for planes, adjustments in shape, variations in color, subtle value shifts, edge variations and reflected color.

- For finishing touches, I chose a small bristle brush and put in a few key points to catch the viewer's eye: the orchid blossoms, the twist-tie, a leaf edge, the violin head and the table edge.

my advice to you

To paint realistically, focus on planes, not details. The underlying structure of each object (sphere, cube, cylinder and so on) is far more important than any detail you may add to embellish it. So as you paint, always consider the location and angle of your light source and its effect on each plane.

what the artist used

support
Stretched canvas

brushes
Bristle filberts and flats, starting with #12 and moving down to #2

oil colors

TITANIUM WHITE · CADMIUM YELLOW DEEP · YELLOW OCHRE · CADMIUM RED LIGHT · ALIZARIN CRIMSON · TRANSPARENT OXIDE RED · BURNT UMBER · VIRIDIAN · SAP GREEN · CERULEAN BLUE · ULTRAMARINE BLUE

Laurie Kersey lives in Monterey, California, USA → www.lauriekersey.com

Zooming in gave me the wow! factor I was after.

Pomegranates, oil, 23½ x 27½" (60 x 70cm)

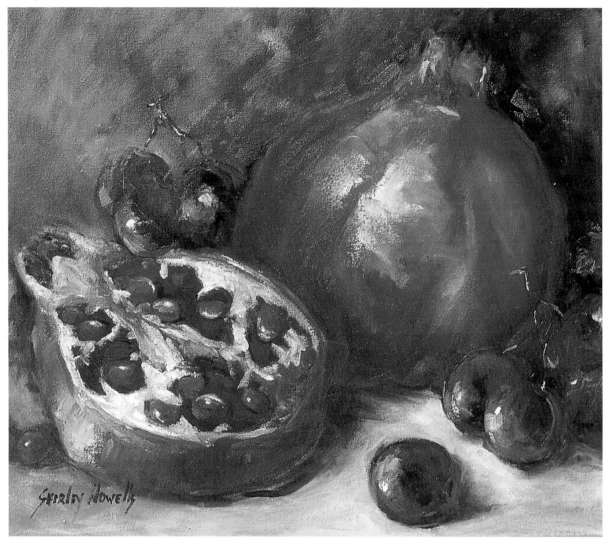

split-second inspiration

I have always been inspired by the voluptuous beauty and exciting colors of fruit and vegetables. There is a fruit and vegetable store just five minutes from my home studio, and my weekly visits for supplies always leave me aching to start a new painting. The visual excitement of, say, purple grapes stacked against piles of red plums, orange apricots and yellow peaches is breathtaking. When my gallery asked for a "large painting of fruit with the wow factor", I was immediately excited, despite only having 24 hours to deliver.

my lightening-quick working process

- I started with a carefully composed set-up, but without any preliminary sketches, color notes or studies. As I became emotionally involved, the painting seemed to take on a life of its own.

- Because of the time frame, I did a preliminary block-in with acrylic to establish color relationships and to get rid of the terrifying white canvas.

- The set-up was lit from the side, with the intention of leading the eye through from the light on the pomegranate portion to the highlight on the full fruit and then in a circular motion by the highlights on the grapes.

- I always paint with a fully loaded brush and with enough vigor to keep myself just a bit frightened. I began with the right background darks, which were deep and contained elements of the entire palette excluding white and yellow. As I worked towards the left background, I brightened the colors with a heavier amount of ochre and just a touch of the yellow so that, as the paint mixed on the canvas, it took on a greenish hue which complemented the red of the pomegranates.

- The painting was completed in one session, wet-into-wet, losing non-essential edges as I went.

what the artist used

support
Canvas

brushes
Brights in #8, 10 & 12; rounds #2; palette knife

other materials
Medium only used sparingly to maintain flow and looseness in background

oil colors
Titanium White
Cadmium Yellow Light
Yellow Ochre
Cadmium Red Light
Alizarin Crimson
Cerulean Blue
Ultramarine Blue
Cobalt Violet

Shirley Howells lives in Pinetown, Natal, South Africa → shirleyhowells@absamail.co.za

Freshness was my concept.

my inspiration

The "special day" in the title was my daughter's wedding, and the "remnants" were some leftover flowers that remained fresh for days. Freshness became the concept I wanted to convey. Taking my cue from the contrasting tones of the flowers I developed a lively pink, white and green arrangement around them.

follow my eye-path

I planned a circular eye path and provided multiple entry points by allowing the subject to break through all four edges. It's the path of light values that ultimately leads you through this painting — from the pink flowers to the fold of cloth, to the pink flower on the table, to the value contrast between the cloth and the dark background, to the pitcher handle and finally circling through the flowers. Through their rhythm and repetition, the holes in the lace complete the circle and lead your eye around again.

my watercolor technique

In this painting, I used a combination of wet-on-wet and wet-on-dry techniques, even within the same object. I began with a pencil sketch and a few flat washes to establish some color, but then I used my special techniques to develop the objects. To do the pitcher, I laid a flat wash of warm beige. When the beige wash was almost dry, I started working on the bottom left of the pitcher. By adding an additional wash of a shadow color that would gently blend with the first wash, I produced a soft-edged area that turned away from the light.
I continued this wash up the handle and around to the spout, by which time my first wash was dry and the cast shadows I needed could become hard-edged darks. Before the cast shadow wash dried completely, I used a wet-on-wet process to add more concentrated pigment in the area under the lip and under the leaf, plus some Raw Sienna to show the reflected color. I used this same process for the rest of the painting, saving whites as I went to give it some sparkle.

something you could try

Sometimes I'll have only a single flower but I'll make it into an entire bouquet by turning the flower in my hand and drawing it in different positions on my paper.

Barbara Maiser lives in East Lyme, Connecticut, USA → maiserart@yahoo.com

Remnants of a Special Day, watercolor, 10 x 7" (26 x 18cm)

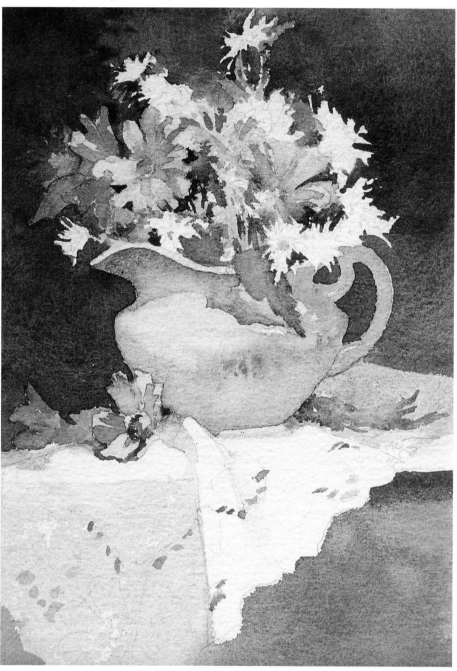

what the artist used

support
140lb cold press watercolor paper

brushes
1" flat; #10, 8 and 6 rounds

watercolors

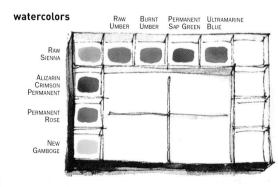

Raw Umber · Burnt Umber · Permanent Sap Green · Ultramarine Blue

Raw Sienna
Alizarin Crimson Permanent
Permanent Rose
New Gamboge

I plan with my head, and paint with my heart.

Sunlit Floral, oil, 48 x 36" (122 x 92cm)

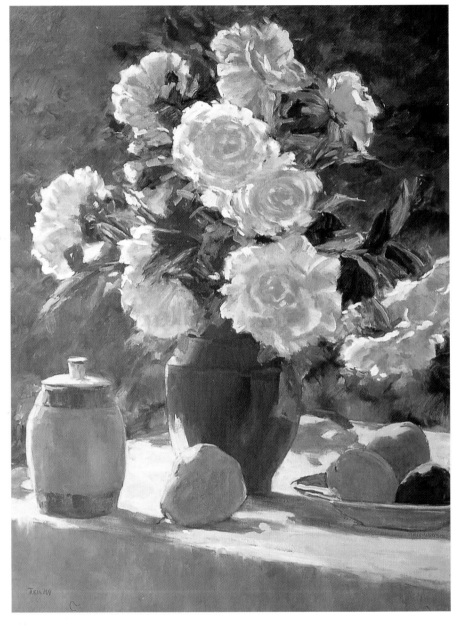

my design strategy

It's impossible to paint plein-air during an Idaho winter, so in the summer months, I arrange fresh flowers, fruit and other objects to photograph outdoors. Then, throughout the colder months, I have plenty of bright, colorful, uplifting material to work from in the warmth of my studio.

My goal for this one was to create drama through contrast and variety. I put light values against dark, cool colors next to warm, transparent paint against opaque and thin paint next to thick. Notice that the centers of the three flowers in the front of the bouquet have a series of warm, transparent glazes while the edges have cool, opaque and thicker paint.

It does not have a strong center of interest. Instead, I used rear-side lighting in order to link the shadow shapes, thus keeping the viewer's eye moving. Choosing cool light allowed me to paint the shadows — a prominent area — warm.

my working process

- I chose a five-tone color chord: blue-violet, yellow-green, yellow, orange and red-orange, keeping it dominantly warm.

- To begin, I applied a warm glaze of Cadmium Orange.

- When dry, I painted thin to thick, dark to light and transparent to opaque, saving the thickest paint until the end. For exciting variety, I used a combination of underpainting, wet-into-wet, glazing and drybrushing. I let the painting dry between stages.

- Because the dominant space is made up of the shadow shapes, the majority of activity is in this area. The challenge was to make these shapes read as one while retaining this activity. To accomplish this, I changed color temperature instead of value wherever possible.

something you could try

Most successful works of art do not just happen. Careful planning and selective decision-making ahead of time can multiply an artist's chance of success. Using a sketchbook helps me make a plan. I draw thumbnail sketches and value patterns. I also note other decisions about the painting, including what I want to say about the image, if there is a strong center of interest, and whether I want it to be dominantly warm or cool, high- or low-key, high- or low-intensity. I name the painting, choose a color chord and list the tubes colors I will use. I also attach any reference material. I find that making these decisions ahead of time allows the left side of my brain to take over when the painting begins.

what the artist used

support
Stretched canvas

brushes
Filbert and bright bristle brushes, sizes 2, 6, 8 and 10; a palette knife

mediums
Painting medium for glazing

oil colors

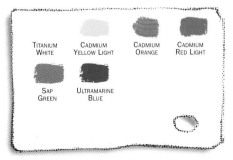

TITANIUM WHITE CADMIUM YELLOW LIGHT CADMIUM ORANGE CADMIUM RED LIGHT

SAP GREEN ULTRAMARINE BLUE

74

Tricia May lives in Boise, Idaho, USA → www.triciamay.com

No matter what I paint, my excitement for the subject always shows in the finished piece.

Drying Roses, oil, 10 x 7" (26 x 18cm)

an instant composition

I frequently travel to paint, so I have developed a great method for warming up to each new locale. I usually buy a few items from a local market and do a few alla prima paintings, just to get my creative energy going.

After arriving in San Miguel de Allende, Mexico, I purchased these charming roses and a few other items, and took them up to my room. The flowers wilted quickly, so I taped them upside down to the wall in the hope of making the petals fall back into place. Wow! I was really excited about this ready-made subject, especially the wonderful violet shadows on the warm wall. I couldn't wait to get started!

my working process

- On a linen support taped to a lightweight backing board, I did a tonal painting in complementary colors to my subject — Transparent Red Oxide under the greens and Yellow Ochre and Indian Yellow under the violets. I rubbed paint off the area where the roses would be to keep the colors clean later.

- Next, I blocked in the very darkest areas, squinting so that the shapes stayed abstract. I allowed some of the transparent underpainting to show through as accents that would punch up the colors to come.

- Adding a little medium to help the paint move across the canvas, I painted in the middle values, then the very lightest lights. I kept it very general until I had captured the color harmony and the value pattern. I then cleaned my brushes and palette so I could continue.

- Looking very carefully now, I put in a few details such as the leaf shapes, especially the light accents along their edges.

- When I felt I had put in just enough information, I stopped. Looking at the painting in a hand mirror helped me see when I'd reached that point. It took me about two hours from start to finish.

the main challenge in painting this picture

A painting doesn't have to be complicated or large to be successful, but painting simply can sometimes be a challenge. You have to paint just enough into the shapes to give the subject matter meaning and substance, yet avoid putting in too much information, which will rob the painting of life.

what the artist used

support
Double oil-primed linen

brushes
Bristle flats and filberts
#2, 4, 6, 8, 10

mediums
Alkyd-oil medium
to speed drying time

oil colors

Alkyd color White
Cadmium Yellow Light
Cadmium Yellow Deep
Yellow Ochre
Indian Yellow
Transparent Oxide Red
Cadmium Red Light

Alizarin Crimson
Viridian
Ultramarine Blue
Manganese Blue
Indigo
Ivory Black

75

Mary Ulm Mayhew lives in West Bend, Wisconsin, USA → pigmentstudio@hotmail.com

I couldn't resist the size, color and intricacy of these flowers.

Concerto for Ruffles, watercolor, 14 x 20" (36 x 51cm)

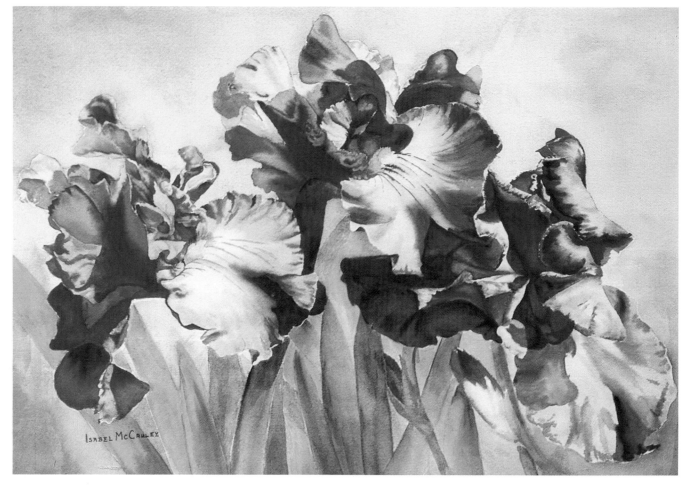

my inspiration

I was born in England and absorbed the love of flowers. Today I grow the flowers of my childhood, as well as plants native to the chaparral region where I now live. I indulge my passion for them through my paintings. I have a wonderful show of bearded iris for many weeks each year, and I couldn't resist the large size, contrasting colors and intricate ruffles of these petals.

my color philosophy

After taking many photographs of the iris from different points of view, I determined that I wanted my painting to be about the blossoms, with leaves and background only to anchor and support their display. My concept also included strong sunlight and cast shadows. To achieve this, I decided to contrast the near-white shapes against the rich purple and analogous maroon.

The bright orange center provided an extra punch of complementary color and directed the viewer's eye to the focal point.

preparing to paint

- Using about five photographs, I made thumbnail sketches to determine the best placement of the three blooms.
- Taking the sketch I liked the most, I drew a very detailed drawing onto inexpensive paper which allows me to change my drawing to my heart's content.
- My patio door makes a good light box. I taped my cartoon to it, taped my watercolor paper on top and traced off my design very lightly with a 2B pencil.

my working process

- At last, I was ready to paint. I used diluted masking fluid on the flower center to maintain the clean paper.

- Each petal was done separately by painting wet-into-wet and floating two or more colors into each small area. The dark shadowed parts were glazed to achieve the desired darkness.
- I next painted the leaves, using plenty of variety of greens in both wet-into-wet and glazing. A lot of the veins were drawn with an old-fashioned nib pen dipped in wet pigment.

- To paint the background, I wet the paper twice using a large brush filled with water and carefully painted the water around the subject matter, leaving both the flowers and leaves dry. The background colors were then dropped into the surface and allowed to mingle fairly randomly.
- Finally, I removed the masking fluid and painted the bright orange centers.

what the artist used

support
140lb cold pressed, acid free watercolor paper

brushes
Kolinsky sable #12 and 8 rounds and ⅜" flat; synthetic round #10; old style dip ink pen

watercolors
Aureolin Yellow
Rose Madder
Phthalo Green
Sap Green
Prussian Blue
Ultramarine Blue
Cobalt Blue
Quinancridone Violet

Isabel McCauley lives at 23719 Vista Ramona Rd, Ramona, CA 92065 USA

The fading beauty of the flowers is the star of this show.

Marigolds and Broken Pots, acrylic, 10 x 8" (26 x 20cm)

my inspiration

Things that are worn, old and crumbling tend to catch my eye. One late summer afternoon, I noticed that all the blowsy flowers and plants in my garden were fading and brown, yet the marigolds had come into their own. The deep oranges, yellows, soft greens and ochre edges stood out from the dark, overgrown foliage. As I sat sketching them, the late sun caught the waiting marigolds, their flowers low but full of aging beauty. It was as if a spotlight had suddenly been thrown on this leading lady among a stage full of actors. Down with the pencil — this was a job for the paints!

my on-site working process

- The sunlight was fading fast so I went straight in on the white canvas with a very dark, thin wash to capture the main areas of light and shade. I took a photograph for insurance.

- Then, using a limited selection of bright pigments, I drew in the main subject, noting the bold, honest colors seen in this particular light.

finishing in the studio

- Details had to be finished in the studio using the photograph I had taken. Looking at this reference, I was reminded of how the wilting and thin petals of the marigolds had stood out against the dark leaves and background. I recreated this by dabbing on pure color and "teasing" it out in the direction I wanted, one of my favourite techniques.

- Using the side of the brush, I dragged up some green for the impression of grass.

- I left my painting unfinished for a few days without any proper decision on the background. With acrylics, I can get away with a few trials. Finally, I found something that worked.

the main challenge in painting this picture

Speed was imperative in this little painting's success. The true test was painting in the most important parts, the ones bathed in sunlight first, and not being tempted to stray from my initial design idea later.

something to think about

There is something special about a painting or sketch made on the spot. It may not be perfect, but it has freedom and honesty about it.

what the artist used

support
Canvas board

brushes
Old bristle ½" brush for scrubbing in the background; ½" flat, #4 round, fine-point color shaper for applying paint

acrylic colors
White
Cadmium Yellow
Cadmium Orange
Cadmium Red
Burnt Umber
Sap Green
Ultramarine Blue

77

Yvonne Lucas lives at 92 Newland, Sherborne, Dorset DT9 3DT, England

It helps if I tackle the toughest parts first.

White Roses, watercolor, 20 x 20" (51 x 51cm)

my inspiration

Inspired by the still life paintings of 16th century Dutch and Flemish artists, I thought it would be a fun challenge to recreate that kind of ambience, using some of my favorite old Southern objects and watercolor paint.

the main challenge in painting this picture

Getting the silver and crystal right was difficult. While these objects appear to be rather monochromatic, they are full of many reflected colors. Seeing all those colors and rendering them to the degree that they become an enhancement and not a distraction was the real challenge.

how I did it

- After choosing my favorite digital photo of my subject, I printed it out at different degrees of contrast to bring out the details.

- Using a combination of projection and freehand drawing, I then refined my composition in a detailed 2H drawing on the watercolor paper.

- I used two techniques for masking off the white areas I wanted to preserve. For small areas, I applied dots of liquid frisket with the handle end of a brush; for larger areas, I laid down a strip of low-tack drafting tape and cut out a mask with a craft knife.

- It just made sense to start with the most difficult objects, such as the decanter. I loaded up three separate brushes, each with a different value of the same color, and went to work on painting these complex areas inch by inch, sometimes in quarter-inch squares at a time. To get the detail right, I focused on rendering the precise breakdown of each small area. I couldn't worry about how the whole would turn out until later.

- When I knew I could make the crystal transparent and substantive at the same time, I moved on to the coffee server and the other objects. To prevent any deep, dark colors from spattering, I used sheets of lightweight tracing paper to cover everything except that small part of the paper I was working on.

- After completing the main elements, I evaluated the whole. Some of the objects needed additional glazing to enrich their colors and balance the overall value pattern.

- Finally, I painted the background with a warm mixture of Mineral Violet and Alizarin Crimson to balance all of the cool Prussian Blue.

what the artist used

support
300lb hot pressed paper

watercolors
Cadmium Yellow
Quinacridone Gold
Winsor Yellow
Jaune Brilliant
Permanent Magenta
Light Red
Alizarin Crimson
Burnt Sienna

brushes
A range of sable rounds

Burnt Umber
Cerulean Blue
Ultramarine Blue
Prussian Blue
Phthalo Blue (red shade)
Mineral Violet

78

Laurin McCracken lives in Memphis, Tennessee, USA → www.lauringallery.com

I like complementary colors because they suggest a sunny, summery feeling.

my inspiration
While walking on a summer afternoon, these brightly colored flowers caught my eye. I was especially intrigued by the way the yellow-green leaves contrasted against the purple tones. I decided I could play these off against each other in a watercolor painting.

my design strategy
Although I didn't do any preliminary sketches, I did take the time to find the most appealing area within the plant. I liked the large shapes of complementary colors, the interesting negative shapes, and particularly the way the purples created a rhythmic flow that carry the eye around the overall space.

my working process
- I jumped right in without any preliminary drawings. I laid down a pale lavender wash in the background, then began to build up mid-value washes of a variety of greens, painting around the areas I knew I would like to keep light in value.
- When the washes were thoroughly dry, I put in the purple flowers and the lightest, brightest yellow-green leaves. I really pushed the contrast of these colors to give this painting some vitality.
- Still working wet-on-dry, I put in my mid-tones and then my darks. I wanted the values to create the same kind of rhythm as the colors in order to lead the eye up and down the image.
- I completed the painting by using fine brushes to put in the small details.

my advice to you
Paint without drawing — it creates a fresher, more spontaneous result.

what the artist used

support
Watercolor paper

brushes
Rounds in a range of sizes

watercolors

Cadmium Yellow	Hookers Green
Yellow Ochre	Sap Green
Cadmium Orange	Ultramarine Violet
Alizarin Crimson	Ultramarine Blue
Cadmium Red	Cobalt Blue
Phthalo Green	

Summer Woodland, watercolor, 27 x 15" (69 x 38cm)

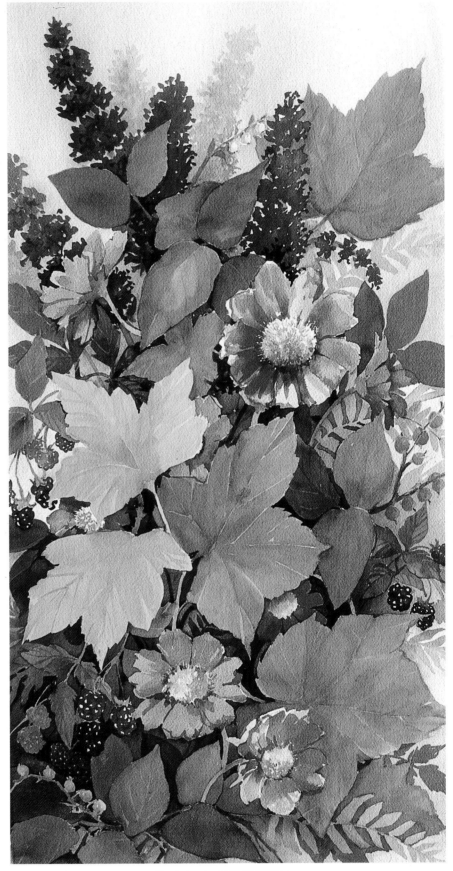

Judith McNea can be contacted through her gallery: Issaquah Gallery, 49 Front Street North, Issaquah WA 98027 USA

By carefully balancing transparent and opaque oil paint I suggested a spontaneous, painterly look.

Fragrance, oil, 16 x 20" (41 x 51cm)

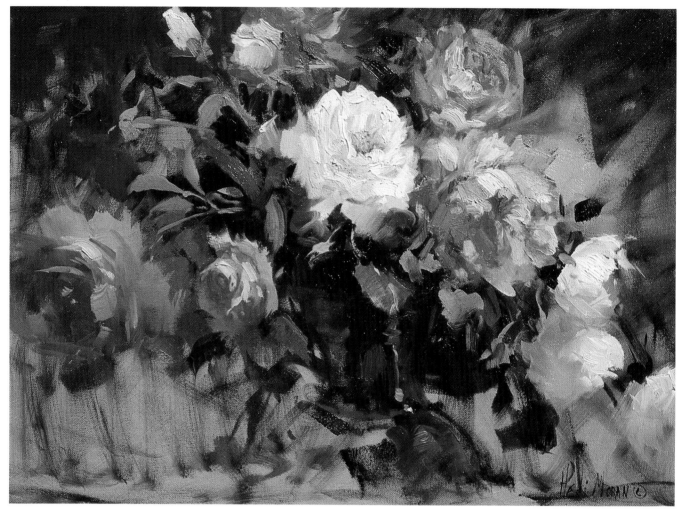

my design strategy

Originally, I put this arrangement together for my class at the Scottsdale Artists School. My plan was for the viewer's eye to start at the strong focal area — the white flower — then follow a big arc, moving left and down through the flowers and vase, then back up to the focal point.

why I chose this medium

To keep the attention on the focal area, I knew I would have to downplay and soften the edges of the positive elements on the periphery. Oil paint thus seemed the perfect medium. I could take advantage of the transparency of the darks for these outer areas, scrape off some paint to make the background interesting but subdued, and make the key flowers rich, bright and juicy with heavier, opaque pigments.

my working process

- I worked from life, without any preliminary studies. I just jumped right in while my enthusiasm for the subject was strong.
- On a toned ground, I began with transparent colors only. I looked at my subject as large shapes and indicated their location on the canvas with the dark, transparent version of the colors I saw. For example, a pale pink flower would first be Alizarin Crimson.
- When my canvas was covered with color shapes, I brushed the edges together a little. I wanted to see a rhythm developing in my composition, a pleasing flow throughout the picture. I made some changes in the composition, confident the transparent colors would stay clean. At this point, the canvas

looked a little as though I were looking through blurry glasses.

- When I was satisfied, I started in the focal area, working wet-into-wet with more opaque colors, including white. I worked all over the painting, moving from shape to shape, making sure they were correct in relation to each other in placement, size and color. My goal was to create a spontaneous, painterly look.

- Once dry, I strengthened my lights to complete the painting.

consider this

- Use clean, lively, transparent colors first; don't apply white or opaque colors too soon.
- Appreciate that the unfinished look contributes to the quality of the painting.

what the artist used

support
Cotton canvas with a coat of gray tinted gesso

oil colors
Titanium White
Cadmium Yellow Light
Indian Yellow
Cadmium Orange

brushes
Bristle brushes, usually flats or brights, and also sables in a wide range of sizes

Cadmium Red Light
Alizarin Crimson
Permanent Rose
Sap Green

mediums
Odorless turpentine to clean brushes and occasionally thin paint

Indigo
Ultramarine Blue
Winsor Violet

Hedi Moran lives at 10135 E. Larkspur Dr, Scottsdale, AZ 85260 USA

I find colored pencils are perfect for precise, transparent layers.

Matters of the Heart, colored pencil, 12½ x 16¼" (31 x 42cm)

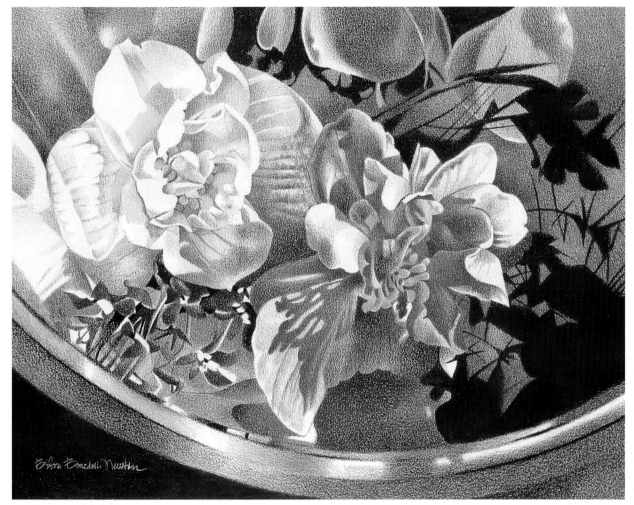

my design and color philosophy

For me, begonias are reminders of matters of the heart — loved people, happy events. What better way to preserve these flowers than in a painting?

As usual, I began by selecting a main subject (the silver bowl) and a supporting object (the begonias). It wasn't until I put the selected objects together in full sun that I understood I needed something else to complete the composition. The lobelia flowers were added for color contrast, textural variety and spatial harmony.

After carefully arranging my still life composition outdoors, I checked the composition through my camera lens, looking at both horizontal and vertical formats, and made slight adjustments to the objects.

I wanted the bowl to form a protective enclosure for these two fragile blooms, but at the same time, to be open to sky and sun for dramatic reflective light and shadows. I liked the way the strong curve of the bowl played against the irregular, delicate shapes of the petals. I shot many photos from various angles.

my working process

- Because this is an intimate, light-filled scene with fine detail, I decided to use colored pencil for its precise application, layering ability as well as transparency of color.

- I enlarged my freehand drawing done from my photos on a photocopier, and traced it onto two-ply paper, using a light French Gray.

- In the darkest areas, I used a water-soluble black pencil,

which I then liquefied with water. The dried pigment created very solid areas with no paper texture showing through. I then repeated with an Indigo Blue water-soluble pencil. Not only did this establish my value range, it also provided a tonal foundation.

- I then proceeded to build up all color in light layers, like glazes, defining forms with volume and adding details as needed. In the layering process, the sharp pencil points helped to blend the individual colors together. The lightest areas were finished last.

HOT TIPS!

- Use water-soluble colored pencils for a quick, transparent under-color.

- Practice building a specific color by using three or four different pencils instead of eight or ten. Too many layers of color results in clogged paper and a heavy look.

- Reusable adhesive is good for lifting smudges of colored pencil. If color must be erased completely, use an electric eraser.

what the artist used

support
Acid free, 100% cotton fiber, regular surface two-ply white

Drawing paper

materials
Water-soluble and traditional dry, wax-based colored pencils

An electric pencil sharpener

Reusable adhesive to lift color

81

Barbara Benedetti Newton lives in Renton, Washington, USA → www.barbaranewton.net

You may not believe it, but I actually polished these marbles to get this glossy sheen.

Shadow Lights, colored pencil, 22 x 30" (56 x 76cm)

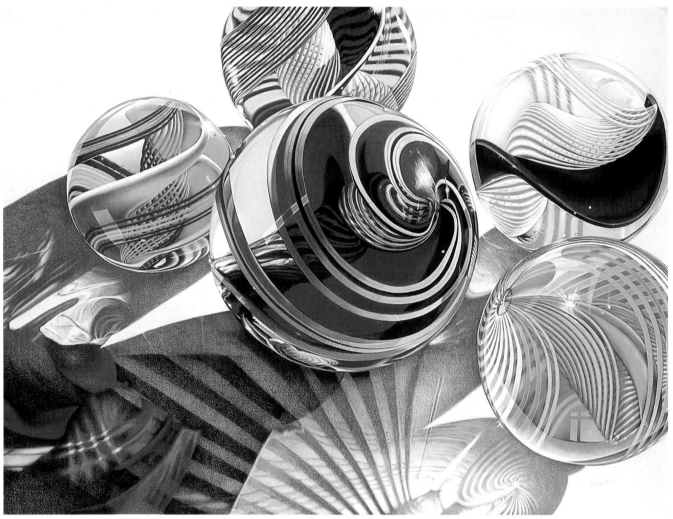

my inspiration

Here in Seattle, you see beautiful creations everywhere. I noticed these beautiful, intricate art glass marbles for sale, and I was intrigued by the reflections and shadows they produced in intense sunlight.

my design strategy

In this piece, I wanted to produce tension by tightly concentrating the marbles in the upper right. You normally think of marbles rolling, in motion, so I left the lower part of the image for your eye to "roll" into. This is the opposite direction your eye normally flows, but I wanted the shadows to gain importance and, once again, cause a little tension.

I used very direct afternoon sunlight to get the intense and intricate shadows in the

foreground. Nothing I've found can imitate the sun for this effect. Light dances through glass to produce an unending array of intricacies and subtleties.

Working the marbles in a higher contrast, color-rich technique while capturing the subtleties of the shadows was quite a challenge.

my working process

- I worked from about six different photos, each having some element that I needed for reference.
- After doing a basic pencil sketch of the final composition, I transferred it to the drawing surface with a very soft graphite pencil. Soft graphite is completely erasable and won't impress a line into the surface.

- I then proceeded to render the piece in colored pencil because of the many different ways I can work with them. For the marbles, I used a "burnishing" technique involving extremely heavy, saturated applications of the pencil worked up in many layers until the surface appears polished.
- After removing any pencil "dust" from the surrounding areas, I took a lint-free cloth and actually buffed the surface to produce a glossy sheen.

- I then rendered the shadows in a more ethereal, transparent method, allowing much of the paper to show through.
- Once completed, I sprayed the piece with several coats of archival matte fixative to stop any wax "bloom" from rising to the surface of the drawing.

my advice to you

Stand back to see the "bigger picture". Keep looking at the overall composition, mood, color scheme and so on as you work, and don't get bogged down on a particular object or area.

what the artist used

support
Heavy, museum-grade paper

materials
Wax-based colored pencils

Laura Ospanik lives in Seattle, Washington, USA → lospanik@cablespeed.com

This still life commission had to be both traditional and tropical.

Tropical Lilies, oil, 30 x 36" (76 x 92cm)

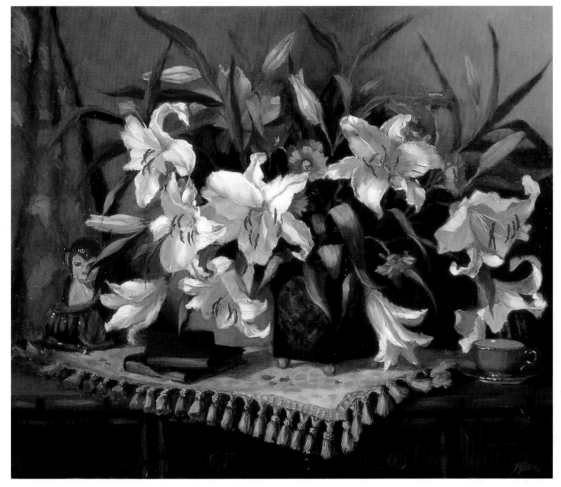

the commission story

Hired to do a commission, I was told this painting was to be both tropical and traditional to fit either an island or urban décor. Lilies were to be the principle flower. I was also asked to incorporate the leopard-print fabric, if possible, and find a compatible color scheme. Everything in this still life was thus chosen to reflect this feeling of being both tropical and traditional.

my design strategy

I spent nearly a full day borrowing and gathering objects and deciding on the tropical coral color that would lead your eye around the painting and tie everything together. I then worked at arranging and overlapping my objects to bring depth and interest to every portion of the horizontal format. I lit my subject from the upper left with a spotlight to highlight the grouping of lily blossoms slightly left of center.

my working process

- Using a thin wash of Raw Umber, I covered the canvas. Then using a rag, I wiped out the places for the lily blossoms and leaves in the center of interest, being careful to not leave any sharp edges. I indicated where the other elements would be, including the fabric in the background. Still using turps in my paint, I began expressing the values I saw.

- Because I paint from life, I always try to paint the flowers first as fully as I can. So, on the first day of actual painting, I went immediately for the center of interest flowers. They were painted wet-into-wet, rather thinly. Later I went back and punched up the lights and further described the shadows, always striving to get the "feel" of the flowers and how they related to one another.

- With the main flowers in place or at least under construction, I set about describing the other lilies in their various stages of opening. At this time, I also began painting the leaves.

- When I was happy with the principle flowers, I put in the coral flowers, the vase and the background objects. I adjusted values, colors and edges as needed to keep the emphasis on the lilies.

- When I thought I was finished, I brought it into my house where I could live with it for a while under different lighting conditions to see what else, if anything, needed to be done.

what the artist used

brushes
Soft and bristle filberts, rounds and flats #4 to 8

mediums
Turpentine

Painting medium

Maroger medium

oil colors

White · Yellow Ochre · Indian Yellow · Cadmium Orange

Cadmium Red Light · Transparent Oxide Red · Viridian · Ultramarine Blue

83

Hope Reis lives in West Palm Beach, Florida, USA → bocamuseumartistguild.org/reis

Here's how movement can be achieved with dynamic curves and diagonals.

Melons, watercolor, 14 x 19½" (36 x 50cm)

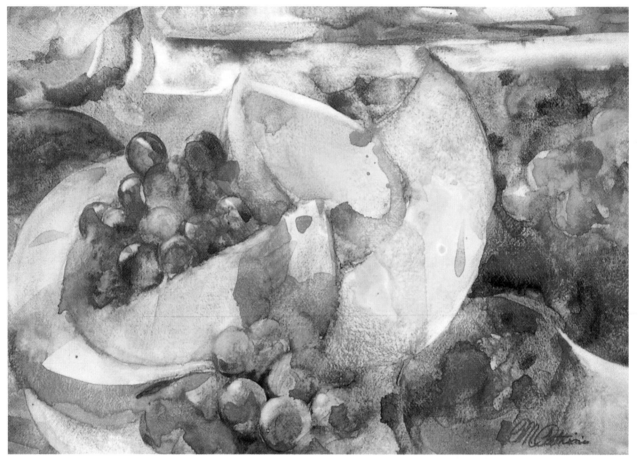

my design strategy

I absolutely love to paint so when I don't have a live model available, I set up a still life. I always pull out far more objects than I can use so that I'm free to pick and choose. For this one, I decided to cut the melons, adding the grapes, apples and bananas on the side and front, making an interesting arrangement of shapes and colors in which dynamic curves play against angular and straight lines.

my working process

- Working directly from my set-up, I made a contour drawing, going from one shape to another, on my watercolor paper.
- Then I used masking fluid to reserve some whites.
- Starting with a nice, juicy wet-into-wet technique, I floated colors throughout the background and tossed salt on different areas. When that was dry I brushed off the excess salt before continuing.

- Next, I worked on the melons and grapes, again painting wet-on-wet with some salt. I took great care wherever two shapes met.
- To bring out the melons and grapes, I painted stronger values of negative shapes around them, spraying with water for more texture.
- Further glazes enhanced the color balance, depth and textures.
- Last, I removed the masking with a toothpick, wet the edges of the white spots and dabbed or scrubbed with a bristle brush to soften their edges.

something you could try

Try different watercolor papers, such as rough 300lb paper. Have fun experimenting with the way pigment runs, mingles and dries on different surfaces.

thoughts to keep you going

- Remember, all paintings go through an ugly stage. So keep going and you will pull the painting into a work of art.
- It's your attitude — not your aptitude — that determines your altitude!

what the artist used

support
300lb rough watercolor paper

brushes
#14 ,10 and 8 rounds; #8 bristle flat

watercolors

other materials
Masking fluid
Salt
Spray bottle for water
Paper towels
5 x 7" cardboard viewfinder

BURNT SIENNA
ALIZARIN CRIMSON
CADMIUM ORANGE
CADMIUM YELLOW PALE

ROSE MADDER
CADMIUM GREEN PALE
MANGANESE BLUE
ULTRAMARINE BLUE

Marietta Petrini lives in Encino, California, USA → hearts8@pacbell.net

My goal was to create rigid, structural forms.

Peaches, oil, 16 x 20" (41 x 51cm)

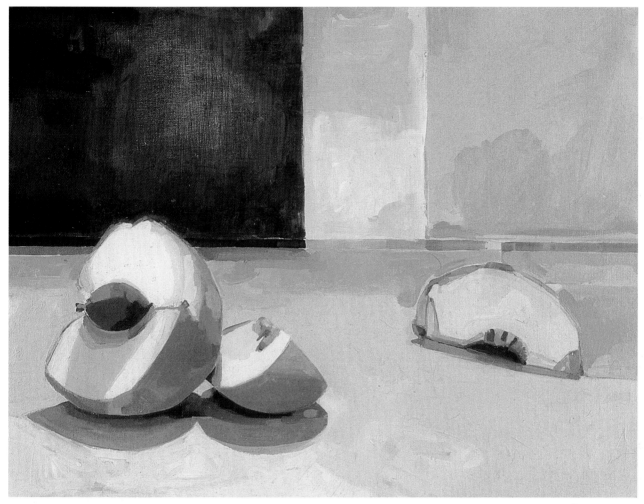

my inspiration

There's a painter named Evan Uglow, whose work I admire. I challenged myself to combine his sculptural, measured-out technique with my own loose, painterly one.

my design strategy

I cut the peaches and arranged them to create perfect balance through an asymmetrical, harmonic composition. The main focal point is the pit inside the peach on the left. The slice of peach on the right was placed there to counteract that dominance and move the viewer's eye around the whole painting.

I was trying to create very rigid, structural forms by using the elements of value, depth, space, shape and color. An overhead spotlight supported interest by creating sharp shadows and dramatic contrast.

my color philosophy

My color scheme is basically warm and monochromatic, made richer by the use of oil paint. I felt that a monochromatic color scheme would keep the painting simple and harmonic.

my working process

- The peaches were painted from a photograph and from life. I used my photo to create the composition, and the still life for reference with colors.
- I began with a very simple line drawing on the canvas, measuring out all of the important points to keep the proportions correct. I then put an orange acrylic wash over it.
- After that dried, I laid in the general colors, focusing on creating flat, simplified planes of color. I varied my paint applications by using thick

impasto in some areas and wiping down to the underpainting in other areas.

- As I painted, I looked at color swatches to determine the best colors for the background based on the colors in the peaches. This was my greatest challenge.

- Then I added the smaller, tighter details and highlights.
- Last, I used a warm yellow glaze over the entire thing to create additional depth and richness of color.

what the artist used

support
Stretched linen

brushes
#4 flat; palette knife

medium
Painting medium

oil colors

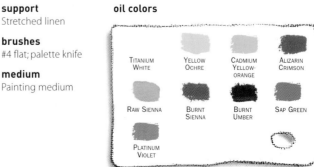

TITANIUM WHITE · YELLOW OCHRE · CADMIUM YELLOW-ORANGE · ALIZARIN CRIMSON

RAW SIENNA · BURNT SIENNA · BURNT UMBER · SAP GREEN

PLATINUM VIOLET

85

Kelly Reaves lives in Chicago, Illinois, USA → KReave@artic.edu

Staging a "dress rehearsal" with fake flowers helped me plan the best composition and color scheme.

Orange Poppies, oil, 12 x 20" (31 x 51cm)

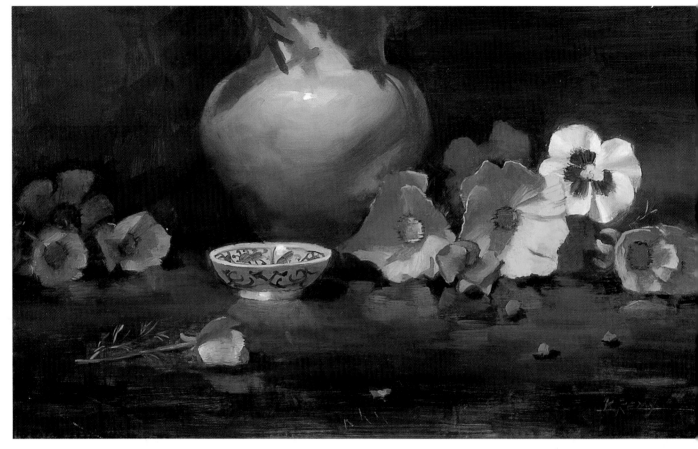

staging a dress rehearsal

When I saw these orange poppies growing in a field in New Mexico, I was struck by how startlingly bright and intense they were. Right from the moment of inspiration, however, I knew my concept for this painting would require a lot of restraint. Painting each poppy brightly and colorfully would destroy the impact of just a little color in the right place.

To get it right, I felt it would be best to do a "dress rehearsal". Using artificial flowers similar in size, shape and color to the poppies, I arranged my objects several different ways under various lighting conditions. I tried out different vases, eventually settling on the aqua vase as a delightful complement to the oranges. When I thought I had the perfect combination of colors and raking light, I made a small, abstract, color-note sketch. When I was ready to paint the real thing, I replaced the "stand-in" flowers with real poppies.

my working process

I'm very definite about identifying and working in separate stages, making sure each stage is successfully concluded in preparation for the next stage.

- On a toned ground, I laid in all of the darks, creating a transparent foundation for the color and light to come.

- The next stage meant introducing color in the form of the darker lights and slightly heavier paint. I adjusted shapes and value relationships as needed.

- Using even heavier, more opaque paint, I continued to build towards the final lights and infuse more color, mostly in my center of interest. I considered the best use of all my painting tools, such as paint texture, edges and brushstrokes.

- Then I was on to the finishing stage. I added the highlights and gave a final check to the dark accents as well. When I considered my painting finished and thoroughly dry, I gave it two coats of varnish.

think first

- Establish a concept before you begin. Is it about color? Light? Movement?

- Define the stages of your painting and what to expect from them. Do not go on to the next stage unless you know that the last stage has been successful.

- Work from "parent piles" of paint on your palette so that all the colors in your painting are ultimately related.

what the artist used

support
Double lead-primed linen glued to a birch plywood board

brushes
Filberts of sizes #3, 4, 6, 8, 12; palette knives

mediums
Maroger medium

oil colors

Titanium White
Cadmium Lemon Yellow
Naples Yellow
Cadmium Yellow Deep
Yellow Ochre
Venetian Red
Cadmium Red Light
Alizarin Crimson
Burnt Umber
Cobalt Blue
Ultramarine Blue
Phthalo Blue
Ivory Black

Roberta Remy lives in Santa Fe, New Mexico, USA → Roberta@rt66.com

My painting is all about repeated color relationships.

Frances' Flowers, oil, 14 x 16" (36 x 41cm)

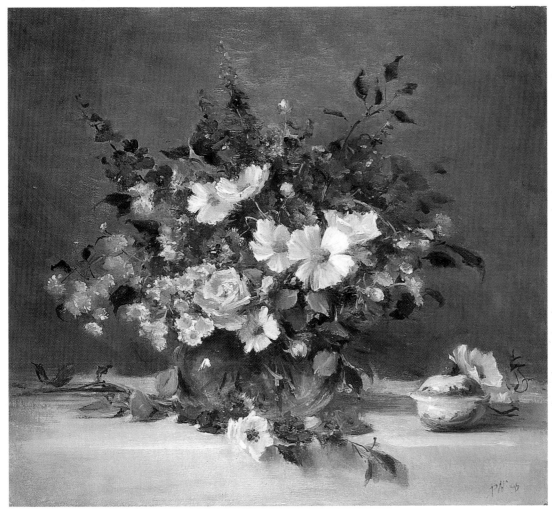

my inspiration

Having spent three summers visiting a friend in Quebec, I was very impressed with the many formal gardens there. After a day of painting in her garden, I cut a few flowers to paint later in the studio.

follow my eye-path

The white cosmos were my primary focus. I hoped the viewer's eye would go there first, then travel through the delphiniums and the rose, down to the bouquet and the battersea box, and finally back to the main focus.

why I chose this medium

I chose oils because I felt I could achieve the rich, vibrant color I was seeking. Color relationships are what my paintings are all about. I often repeat the background color in the flowers, or some flower color in the background or tablecloth. This creates a more unified consistency throughout the painting.

my working process

- Working from life under natural north light, I began the painting with a size and placement drawing. I used a small round brush and Raw Umber thinned with mineral spirits to draw directly on a toned canvas.

- I then proceeded to mass in the shadows, keeping the paint thin.

- Switching to slightly heavier paint, I worked all over the canvas, massing the colors as I saw them throughout the flowers. I then moved into the background, using my brush to "cut" or define the shapes of the flowers and leaves. Developing everything at the same time creates atmosphere.

- With my heaviest paint, I applied the lightest areas and highlights.

- Stepping back to observe, I decided the shadows weren't rich enough and required a scumbling of dry color in a few areas.

the main challenges in painting this picture

In any still life or floral, some objects must recede and others must come forward. In each case, it's essential to determine how best to do this because it affects the rhythm and flow of the painting. I feel it is also important to clarify the primary focal point while keeping the secondary points of interest more subdued.

what the artist used

support
Double oil-primed, toned linen canvas

oil colors

Cadmium Yellow	Cadmium Red	Cobalt Blue
Naples Yellow	Terra Rosa	Ultramarine Violet
Yellow Ochre	Raw Umber	Mars Black
Cadmium Orange	Cinnabar Green	
Alizarin Crimson	Ultramarine Blue	

brushes
A variety of bristle and soft brushes in an array of sizes and types

mediums
Stand oil and odorless mineral spirits

87

Patricia A Rohrbacher lives at 4132 Mohawk Drive, Copley, OH 44321 USA

The concept for this one was quiet grace.

Endless Love, oil, 21 x 18" (54 x 46cm)

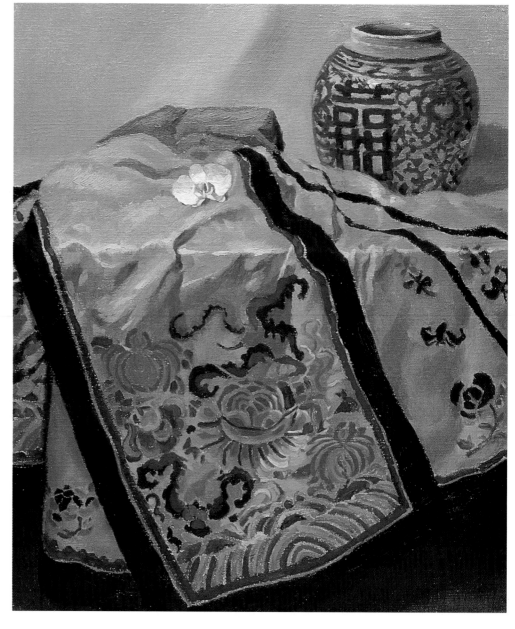

what I wanted to say

I have always been fascinated with the tranquility of traditional Chinese women. While visiting a friend's house in Taipei one day, I came across a piece of clothing and this antique pottery. I felt the combination of these items could present the impression of women's elegance and delight I had in mind so I borrowed the pieces. With the addition of a fresh orchid, I was able to present my feeling and ideas in the painting.

my design and color philosophy

Harmonious color was the key to capturing the quiet grace of my concept, which was something of a challenge. I used many types of color contrast to achieve my goal. For instance, the warm yellow robe and similar yellow in the background challenge the blue-violet pottery in terms of the size of the colored areas, the color tones and the temperatures.

I made other decisions to bring even more eye-catching appeal and interest to my subject as well, such as placing the small white flowers against the black lines, varying the spacing between the black lines and emphasizing a number of different textures.

my working process

- First, I used Burnt Umber and retouching varnish as the foundation.
- Working directly from life so I could see the true color variations in my subject, I used a #8 flat brush to block in my low-intensity colors.
- I gradually overlapped these with higher ones, developing the forms, textures and details of my objects. I used many different techniques with the Chinese brush, such as rolling, compressing, picking, pressing, checking, dragging, patting and swinging.
- Finally, I ended with heavy painting on the highlight spots.

what the artist used

support
Linen

brushes
#8 and #6 flat brushes; smallest size Chinese brush pen

oil colors

Titanium White · Cadmium Yellow · Light Oxide Red · Madder Lake Deep · Raw Sienna · Burnt Umber · Viridian · Sky Blue · Cobalt Blue · Permanent Blue Violet

Wu Ting-Hsuan lives in Taipei, Taiwan → wthsuan@yahoo.com.tw

Subdued color harmony, subtle tonal contrast and simplified detail carried off my strong Z-shaped design.

Peonies, Cool Light, oil, 16 x 20" (41 x 51cm)

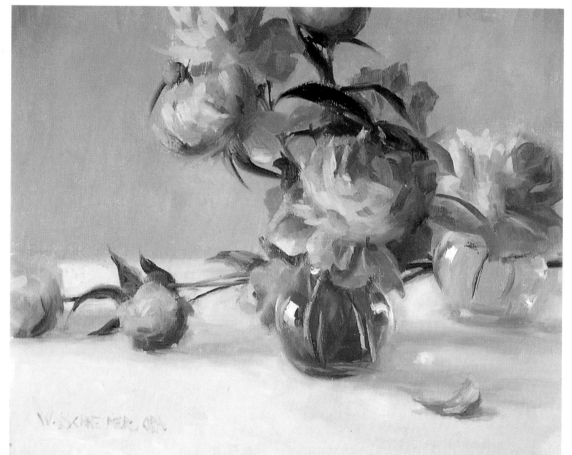

my design strategy

I painted this simple portrait of flowers from life in about three hours. First, I set up the floral arrangement in an interesting design, checking the results through a rectangular cardboard viewfinder. A few thumbnail sketches further refined the design based on a "Z" shape.

My center of interest is comprised of the center peonies, the darker vase and the lighter blossom at the far right. The smaller flowers at the top left and on the table are subordinate to the main mass but also act as variations on the theme. Extending some blossoms beyond the picture plane keeps the eye from exiting the painting.

North light enhanced the cool pink of the flowers, which I wanted to contrast with a warm, grayed version of their complement, green, in the shadows. I also used small amounts of yellow and blue near the center of interest.

my working process

- I began by washing the linen with a warm gray tone and sketching in the main elements with charcoal. Then I used a paper towel to wipe out the lightest areas to confirm the value pattern of the finished painting.

- Then I applied my lightest light (the highlight on the vase), darkest dark (the leaf above the main flower) and sharpest edge (the dark petal silhouetted against the light peony on the right). Squinting at my subject helped me make these comparisons.

- I applied thicker paint to the background so I could vary the edges of the subject from razor sharp to soft. Working wet-on-wet allowed me greater control of my edges.

- Then I established the shadows, midtones and lights as broad, flat areas.

- The finishing touches were the details and highlights on the flowers (subtle) and on the vases (wham!).

- Just when I thought I was done, my wife pointed out that it seemed top-heavy. I took her advice and added the petal at the lower right. I think it saved the day.

the main challenges in painting this picture

As usual, the greatest challenge was to simplify. In fact, I originally had painted the main flower with way too much detail. I scraped out that area and started over, squinting to eliminate the details I saw and painting the big shapes rather than each petal. Sargent, Zorn and Sorolla all used this technique to create remarkably truthful paintings.

what the artist used

support
Double-primed linen

brushes
Fairly large bristle filberts (8-14); a #6 sable flat for some of the sharper edges

oil colors

White · Cadmium Yellow Light · Transparent Oxide Red · Permanent Red Light · Alizarin Crimson · Ultramarine Blue

89

William A Schneider lives in Crystal Lake, Illinois, USA → www.schneiderart.com

Pastels helped me achieve this powerful, monumental work.

Bolero, pastel, 20 x 20" (51 x 51cm)

my inspiration

This beautiful living sculpture was more than enough inspiration for me to make the painting. The same spirit that guided Mozart and Beethoven created this incredible flower. I can only try to do it justice.

my design strategy

I cropped in very close, allowing the tulip to fill and even break out of the space. Baroque and monumental, it felt right to do this. My goal was to capture the flower's richness and power but at the same time keep it fresh.

my working process

- I work from life and from photographs. Life provides feeling and color, while the photos keep the light and breezes from changing my view. I used side lighting to bring out the form and structure.

- When I'd decided on my composition by drawing thumbnail sketches, I made a very light, full-size drawing on my paper in the colors to be used.

- By this time, I knew exactly where I was going with the painting, so I could have started just about anywhere on the surface. I stroked in the colors, overlapping several, then began to smooth and blend them with my fingers. I'm blessed with dry skin and seldom use anything but my fingers, all 10 of them. I am ambidextrous so I use whichever hand is more convenient.

- I then sat back to evaluate my work and to listen to the painting about what it needed. In some places, I removed some of the pigment with transparent tape, a kneadable eraser or an electric eraser. Finally, to sharpen a few final edges, I laid some thin paper where I wanted the edge and working against the paper.

why pastels?

When painting flowers, I can never have enough brilliant and intense colors. That's why I chose pastels for this one. Another reason is that I knew I would be wanting both hard and soft edges. I use broken pieces of small, square pastels for sharp corners and for fine detail, and the larger soft pastels for broad strokes.

what the artist used

support
Smooth paper with just enough tooth to hold the pastels

pastel colors

pale yellow ochre	permanent rose light
yellow ochre	raw sienna
deep yellow	burnt sienna
gold ochre	ultramarine blue light
permanent red deep	mars violet
permanent red	ivory black
permanent red light	
madder lake deep	
light oxide red	
permanent rose	

other materials
Spray fixative used sparingly in the early stages

Donald Sinclair lives in Shelburne, Ontario, Canada → www.levelgallery.ca/artists/dsinclair.htm

If you ask me the secret to painting white objects, I'll tell you it's subtle shifts of tonal value and temperature.

White On White, oil, 12 x 24" (31 x 61cm)

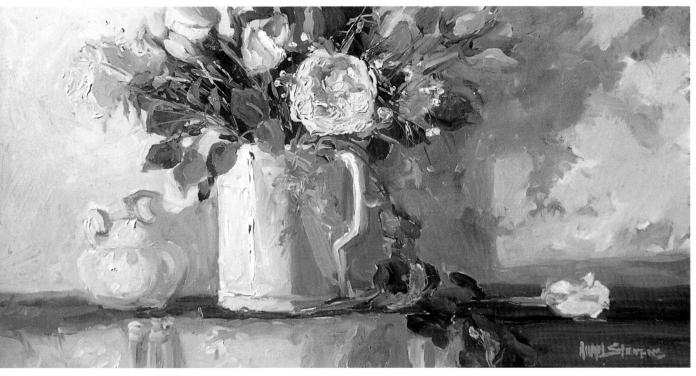

my inspiration

I love to see the effect light has on objects in a still life and in the landscape. Light can change the ordinary into the extraordinary, especially with a timeless subject such as this. I felt inspired to work with these white objects and to reveal their subtle nuances.

my design strategy

The elongated shape of this canvas helped make my design look interesting before I had even begun to paint. The shadows hold this painting together, while a few of the flowers in the pitcher act as the star, or center of interest.

my approach

- First, I need to create the right environment for painting. I usually paint in the morning when I have the most energy, and I turn the music up loud while I work.

- Working quickly and loosely directly from my set-up, I blocked in the various color/value masses.

- I then began to define the flowers and cast shadow in the background more carefully. Because of their lack of obvious color, I had to carefully observe and play up the shifts of warms against cools and darker values against lighter values. I took a lot of care with what colors I mixed to create these grays.

- I left some flowers in a more unfinished state, and completed just the few in my center of interest to attract the eye there.

- I do most of my paintings start-to-finish in one day. I painted most of the painting in about two hours, then went away for awhile before coming back for a fresh look. I finished it in less than an hour.

the main challenge in painting this picture

Because there was so much white in this painting, avoiding a chalky look was a challenge. Controlling my tonal values and color temperatures were essential.

my advice to you

- Leave some of your canvas showing to give freshness and dimension to your painting.

- Don't finish all of the flowers to the same degree. Make a few flowers special.

what the artist used

oil colors

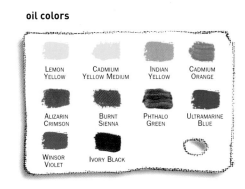

LEMON YELLOW · CADMIUM YELLOW MEDIUM · INDIAN YELLOW · CADMIUM ORANGE

ALIZARIN CRIMSON · BURNT SIENNA · PHTHALO GREEN · ULTRAMARINE BLUE

WINSOR VIOLET · IVORY BLACK

Allayn Stevens lives in Laguna Beach, California, USA → www.allaynstevens.com

91

For this complex gouache painting I called on my computer.

Silver & Iris, gouache, 14 x 26½" (36 x 67cm)

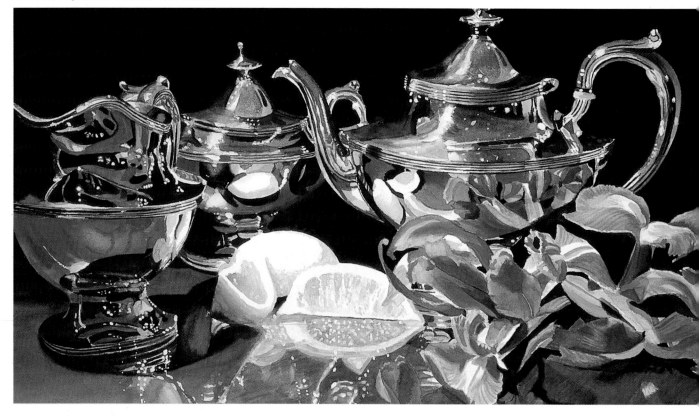

my inspiration

I have reflective surfaces throughout my home, and every once in a while I'll walk into a room and the light hitting one of those surfaces will simply stop me in my tracks. It was this mesmerizing sensory experience that I was attempting to recreate here.

In setting up a busy still life such as this one, with so many surfaces reflecting the same items and such a high contrast of light and shadow, it would have been easy for the piece to become fragmented and overwhelming. To prevent the chaos from getting out of hand, I used large vistas of complementary colors and repetitive shapes to tie the piece together and create a harmonious composition.

computer-aided creating

In order to capture the dramatic, low-angle lighting, I took photos of the set-up with my digital camera, which I then downloaded into my computer. When I settled on the best image, I cropped it and made some color and contrast adjustments. I then used the pencil tool to draw a grid on the computer image, and lightly drew a matching grid on my stretched watercolor paper to transfer the image. Later, I used the image on the computer as a reference to paint from as well. This enabled me to zoom in on a particular area and enlarge it, which works really well with a confusing subject like this.

my working process

- I set a warm tone with an underpainting on the bottom half of the silver pieces and the table top with Gamboge.
- Once that was thoroughly dry, I used a wet-on-wet technique for many of the objects, allowing the colors to intermingle for a soft effect. At this point, I was thinning my gouache with lots of water, like watercolors.
- After the major objects were completed, I laid in the black background with a mixture of Alizarin Crimson and Phthalo Green, drybrushing up to the objects to create soft edges.
- Switching to heavier paint almost straight from the tube, I completed the final stages of the painting by adding all of the white highlights and making a few color adjustments.

my advice to you

Try painting with lots of concentrated color, dark darks and value contrast — you'll be amazed at the difference they can make.

what the artist used

support
260lb cold pressed watercolor paper stretched on a board

brushes
Mostly synthetic brushes because the firmer bristles are more effective with gouache; flats #10, 12 and 1" and rounds #2, 4, 7, 8 and 10

Note: I used one watercolor — Quinacradone Burnt Scarlet — because I haven't found a good substitute for this color in gouache.

gouache colors

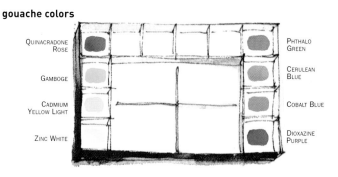

QUINACRADONE ROSE
GAMBOGE
CADMIUM YELLOW LIGHT
ZINC WHITE
PHTHALO GREEN
CERULEAN BLUE
COBALT BLUE
DIOXAZINE PURPLE

92

Michele Suchland lives in Anchorage, Alaska, USA → www.michelesuchland.com

Here's a case of "putting the cart before the horse" — I had the frame first and made the subject fit.

Table Grapes, watercolor, 13 x 13" (33 x 33cm)

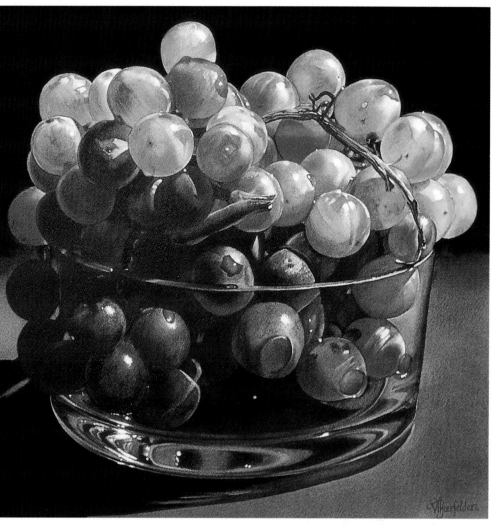

finding my subject

In this case, the "cart came before the horse" in that I'd acquired a wonderful frame — square, plain and completely gold-leafed. I thought about the "perfect" subject matter for more than a year before I settled on the dark California table grapes in a simple glass dish. I wanted a marriage of subject and frame, beautifully fitting the classic combination of gold and black. Yet, I also felt this would be a unique expression of my own voice, a powerfully personal statement that would evoke a sense of wonder.

my design strategy

Having a strong impression in my mind of what I was after, I began to arrange my chosen objects. As I explored each possible arrangement of main subject and accessories under various lighting situations, I shot pictures with my camera. I chose one that captured the golden afternoon sunlight illuminating the grapes and bowl and the simple, dark stand behind them for contrast.

Using cut-out viewfinders, I decided on the composition. The viewer's eye goes directly to the center of the composition and is held there, taking in the bowl and its contents. Then the eye circles, following the stem on the sunlit side, going up and over the grapes into the shadows. Finally, the eye comes back around, tracing the edge of the bowl and/or its base.

my working process

- Over a careful, intricate drawing on watercolor paper, I used a thin masking liquid to preserve the whitest whites — the tiny highlights and refractions in the glass base.
- I then laid in a kind of "grisaille" to model the subject.
- Using variegated washes and blending to describe the round shapes, I proceeded to layer in color, dark to light. The layering ability of transparent watercolor was ideal for achieving the translucent effects I desired.

- Some drybrush work was added to give a bit of a "sparkle" where needed, for example, on the dried stems.

please notice

I managed to maintain interest and detail in the shadowed sections of the grape cluster and not let them be overpowered by the bright highlighted areas. My aim was to keep the viewer's eye fully engaged.

what the artist used

support
140lb hot pressed watercolor paper

brushes
Pure sable rounds #000-5; a couple of flats, ½" and ¼"

watercolors

Quinacridone Gold	Brown Pink
New Gamboge	Quinacridone Pink
Aureolin	Quinacridone Coral
Quinacridone Burnt Orange	Neutral Tint
Quinacridone Burnt Scarlet	Warm Sepia
Quinacridone Red	Indigo

93

Vivian Thierfelder lives in Spruce Grove, Alberta, Canada → www.vivianthierfelder.com

An abstract foundation enhanced the flow of light over these pomegranates and key limes.

Key Lime, oil, 14 x 22" (36 x 56cm)

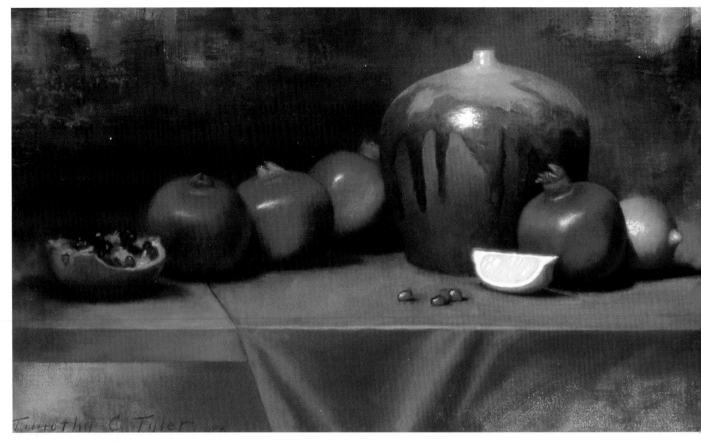

my design strategy

With all subjects, the moment I consider something as a possible painting I'm thinking about design — the placement of shapes, color and edges. Here, I wanted to paint a bright, wet slice of key lime. I did everything I could to make that little slice of lime the resounding star of the show. After placing it in the golden mean, I positioned the tip of the pot directly above the slice to reinforce this. The creases in the cloth below the lime point to it.

The supporting cast was slowly and thoughtfully arranged for effect. To the right and the left of the bright green lime is rich red — one red small, the other large. No two pomegranates are the same. These are used to create a visual cadence approaching the lime. If you squint at the area around the Raku vase and fruit (the negative shapes), you'll find none of these are the same size. Finally, the rich green of a whole lime is used to arrest the eye.

my working process

- I normally draw in the basic shapes first with thin turps and brown paint.
- I'll quickly start painting the items with the most intense and therefore the easiest colors to read. I can better judge the trickier colors after I get the easy ones onto the canvas.
- The illusion of light and form is captured by nailing the colors, values and edges precisely. I paint each passage as thickly and accurately as I can. I trust nature and paint what I see very faithfully. Painting from life provides me with so many answers.
- The next time I work on the piece I may revise these colors slightly. I never compare my work to the set-up.

something to think about

I think viewers find artwork appealing sometimes without being able to precisely identify why. One possible reason is good, thoughtful composition and color. I like it when people appreciate "the light" or "depth" or "verisimilitude" in my work, but I know as a painter, these things are children of method and technique.

HOT TIP!

When you make a mental observation, put that knowledge down onto your canvas in the form of a brushstroke. Otherwise, your eye may get ahead of your hand.

what the artist used

support
Linen

brushes and tools
Rounds, filberts, flats, brights in red sable, badger hair and hog bristle; Italian trowel-type painting knives with round shoulders; rags; my fingers

oil colors
Unbleached Titanium
Zinc White
Titanium White
Cadmium Yellow Light
Yellow Ochre
Cadmium Red Light
Quinacridone Magenta
Alizarin Crimson Permanent
Quinacridone Rose
Phthalo Green
Transparent Brown Oxide
Ivory Black

Tim Tyler lives in Siloam Springs, Arkansas, USA → www.timothyctyler.com

I didn't want feminine. I wanted conflicting, powerful, moody and intense.

Cadmium Flowers, oil, 14 x 11" (36 x 28cm)

something different

My intention was to create a still life based on mood. Without meaning to generalize or conjure up negative stereotypes, I wanted to create an overall image that was more masculine than many florals, which tend to be delicate representations.

The whole painting was thus based on conflict, not harmony. I used cool against hot, light against dark, soft edges against hard edges, and round shapes against linear shapes with skewed, abstract perspectives.

my working process

- Using nothing but my imagination, I produced a thumbnail sketch, using only three colors of oil pastels on black paper.

- With this in mind, I decided to mirror the process, using a limited palette of oils on canvas. The first step was to add texture to the support with an acrylic impasto gel, which I then sealed with a black gesso.

- I then coated the support with a light, clear glaze of alkyd-based medium to form a sticky film to help with the scumbled effects to come.

- From this point on, I established the overall form and composition loosely. I started at the center of visual interest and worked outwards, allowing the focal point to develop. I added impasto alkyd gels to speed the drying time of the pigments. Not only did this help keep the paint mixtures as clean and pure as possible, it also allowed for some interesting effects.

- Satisfied with the general development of the image, I tightened some areas and softened a few edges. One important refinement was to enhance the warm edges at the top of the flowers.

- When the painting was in its final stages, I had to constantly remind myself not to overwork it with too much detail.

please notice

Most of the mixing was done on the support (as opposed to pre-mixing) to create shards of color, as opposed to soft blends. The dark ground makes these oil colors even more luminous.

something you could try

Don't be afraid to use black or represent black objects. Black can be a strong ally in creating high contrast and moody paintings, plus it accentuates the richness of colors.

what the artist used

support

Masonite board with light applications of sculpting gel applied with a course nylon brush to accentuate the brushstrokes; finished with black gesso to create a highly textured surface

brushes

Flat, fine hog-hair brushes #6 to 18

medium

An alkyd gel to accelerate drying speed and to help with a coarser blend

oil colors

Titanium White
Cadmium Yellow Light
Cadmium Red Deep
Transparent Red Oxide
Chromium Oxide Green
Ivory Black

95

Renato Muccillo lives in Vancouver, British Columbia, Canada → www.renatomuccillo.com

I made a light plan — and stuck to it.

try these tactics yourself

I wanted my subject to say, "Look at me! Look at my great color." In order to do this, I made several strategic decisions meant to grab the eye:

- I pushed the limits of my blue/purple and yellow/orange complementary colors to the max.
- I set the vase smack in the middle of my paper to challenge the theory of never putting your subject in the center.
- I set my still life arrangement in front of a window so I could take advantage of the backlighting, thus giving interesting shadows.
- I repeated yellow so that the eye would travel from the large sunflower on the left of the paper, down and around to the lemon, back up to the window panel and to the upper blossom.

my working process

- I went directly to my paper with pencil, indicating the negative spaces as well as the positive.
- I chose to load up my brush with watercolor paints because they allow me to keep the painting wet and juicy. I worked as quickly as I could.
- When I felt the piece was completed, I then took out my trusty old twig, dipped it into indian ink and made my marks with gusto.

the main challenge in painting this picture

The biggest challenge was to avoid getting caught up with the light changes. I had to stick to the first image I had at the start of the painting.

my advice to you

- Paint what you love, not what you think will sell. Use objects that have a special meaning to you and your emotions will project in your finished piece.
- Step out of your comfort zone. Try something different and challenging.

Burst of Yellow, watercolor & ink, 14 x 10" (36 x 26cm)

what the artist used

support
140lb cold pressed paper

brushes and tools
#12 round sable brush;
a twig

Indian ink

watercolors

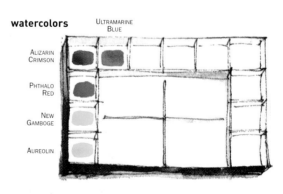

Grace Haverty lives in Scottsdale, Arizona, USA → www.havertystudios.com

My yin-yang interplay of contrasting shapes, patterns and colors gives this painting lots of punch.

Anemone in Blue, watercolor, 26 x 29" (66 x 72cm)

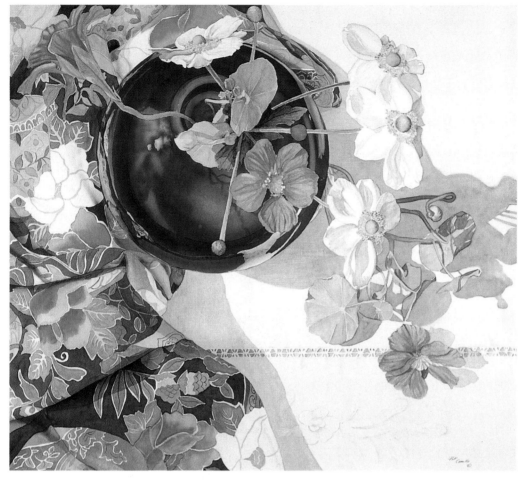

my design and color strategy

I was inspired by the gorgeous color and reflective qualities of this blue vase. The nasturtium and Japanese anemone provided wonderful complementary colors to the striking blue. The colorful material coordinated with the objects, while the white provided a resting place for the eye.

I loved the yin/yang of the color scheme, so I felt I needed to balance the design in an interesting way, too. The painting was composed in a circular pattern to mimic the round vase, which was set off-center for interest. I also added a small horizontal line and a subtle flower embroidery to the white material to anchor the painting.

After playing with some conceptual sketches and thumbnail color studies, I set up the still life outside to maximize the effect of the light and shadow. Once the design was established,

I shot several photos to capture the exact lighting I wanted. Both the photos and the actual still life were used as reference.

my working process

- After a detailed drawing, I laid on several thin layers of a mixture of Cobalt Blue, Aureolin and Opera to make the white background recess. I then detailed the cutwork and embroidered flower on the white cloth.

- Next, I painted the flowers, reserving some whites.

- To put in the shadowed areas of the colored material, I wet the entire area with water and, after the shine had disappeared, I painted shadows with Phthalo Blue.

- Once this area had completely dried, I then started to develop the material. I worked all like colors at the same time so that I would maintain similar tones,

using some drybrushing. Additional layers of paint were added to the darkest areas, with each successive layer drying completely before another was added.

- The shadowed area on the white cloth and its reflected colors came next.

- Once this was complete, I then started to paint the blue vase. Glazed layers of Ultramarine Blue, Cobalt Blue and Phthalo Blue built up the vibrant color.

- Highlights were then lifted out by re-wetting the area and using a paper towel to lift off the color.

my advice to you

Paint what you know and love, whether painting a still life, floral or any other subject. When you have a special affinity for your subject, that feeling comes through to your viewer.

what the artist used

support
300lb cold press watercolor paper

watercolors
New Gamboge
Aureolin
Quinacridone Gold
Opera
Permanent Red

brushes
Sizes #2, 6, 8, 10 and 12 round sable brushes

Sap Green
Ultramarine Blue
Cobalt Blue
Phthalo Blue

Pat Camillo lives in Saugatuck, Michigan, USA → www.patsartstudio.com

A bird's eye view makes a clear pattern and a bold image.

Oranges & Pears, acrylic, 24½ x 14½" (62 x 36cm)

the main challenge in painting this picture

I wanted to paint something in a short time frame so I looked for a subject with simple shapes in varying colors. At a market stall, I found some amazing oranges and pears. My concept was then to balance the colors and shapes of the oranges and the various green pears within the composition.

my design strategy

I wanted to fill the canvas board as much as possible, to crop into the visual space and split the area into quarters. I tried various combinations until I was satisfied with the "bird's eye" view. It caused the objects to flatten out to some extent, creating a clearer pattern. Cutting into the composition of the picture also stops the viewer's eye from wandering out.

The group of oranges are linked together by overlapping. The pears are on their own in another group but linked by the angle of the green cloth running across the table top, pulling the ham stand and bowl together. Placing the two still lifes from corner to corner visually makes the eye pass from one group to the other.

my working process

- I wanted to complete this still life within a limited time frame so I set up all of my equipment at the ready: paint on the palette, brushes, jars of clean water, roll of kitchen towels.

- The techniques used were wet-on-wet, wet-on-dry, variegated washes and a little blending. My goal was to put down the color, tones and shades with bold strokes as quickly as possible, allowing the energy of the colors to show through.

- I left much of the bold, loose brush work visible, which led to a strong, colorful image.

try this yourself

Set yourself the challenge of painting within a time scale shorter than you would usually work in, rather like a five-minute life drawing exercise. You may be surprised at the spontaneity in your resulting work.

what the artist used

Support
Canvas board

Brushes
Flats in #6, 8, 10; round #4

acrylic colors

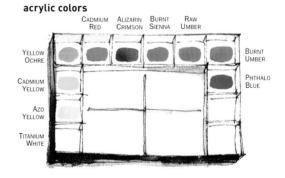

98

John Atkinson lives in Norfolk, England → crown.studio@virgin.net

I wanted to show the enormity of the sky and the fragility of the flower.

Iris, oil on canvas, 39 x 15 ½" (99 x 40cm)

my inspiration

This painting was inspired by an ink and watercolor study I completed of irises in a vase. I wanted to replicate the strong color of the flowers in their natural environment, unaffected by man-made lighting or implements. What I am saying is that nature is affected by man's interference in many guises, yet we have the opportunity to escape from it when we choose. The painting also signifies the enormity and fragility of life.

my design strategy

I used strong color to attract initial attention. However, I also positioned the flowers at the bottom of the canvas with a single stem reaching upwards to direct focus away from the iris and towards the sky, thereby showing the enormity of the Earth and the fragility of the flower. I lit the work from above, because it felt natural for the flowers to be reaching upwards towards the sunlight.

my working process

- I sketched the outline of the flowers directly onto the canvas in pencil.
- I used color straight from the tube rather than mix colors on the palette. To me, this philosophy fits in with the theme of man's interference with nature.
- I then painted the skyline, using a little painting medium mixed with Cerulean Blue, Titanium White, Cadmium Red and Cadmium Yellow. I used paper kitchen towels to spread the paint onto the canvas.
- I then concentrated on the petals, using Cadmium Yellow, Titanium White and Cobalt Violet Hue. I used a palette knife and shapers to complete the veins on the petals.
- I finally completed the stems in Permanent Green Light and outlined the flowers in Lamp Black.

consider this

- Make your composition unusual or different. Change perspectives and angles to give a fresh approach to your work.
- If an approach isn't working, abandon it and start afresh in a different way.
- Once you have finished your piece, never be tempted to go back and alter it. Finished means finished.

what the artist used

brushes
Flat #8; rounds #2, 6 and 8
Palette knife
Paper kitchen towels

mediums
painting medium

oil colors
Titanium White
Cadmium Yellow
Cadmium Red
Permanent Green Light
Cerulean Blue
Cobalt Violet Hue
Lamp Black

Frank Radcliffe lives in Ware, Hertfordshire, UK → www.frankradcliffe.com

Mood can be driven by one strong color in different values.

my inspiration

During a recent visit to my mother's spectacular garden, I took photographs at various times and made small color drawings in my sketchbook. The glorious colors, exaggerated shapes and velvety texture of these purple irises gave me all the incentive I needed.

my design strategy

For all their delicacy and softness, I wanted the design to reflect the real power of the iris against the hard, sword-shaped leaves. I decided that the mood of the painting would be driven by the dominance of one strong color in various values. To enrich the quality of the subject, I chose a contrasting soft-textured background as a foil to push the powerful, dark purple flowers forward. By using intersecting, mostly vertical shapes and lines, I hoped to convey the feeling of strength, drama and movement.

my working process

- I began the piece by putting a thin coat of clear acrylic gesso on the watercolor paper for an interesting texture. Then I let it dry.

- Using sketches and a value study, I drew the large flower shapes, stems and a few leaves onto the paper.

- Since I paint mostly wet-on-wet, I kept my support flat and mounted to a board. I wet the surface with clear water but tried to avoid at least part of the flower shapes. Using my 2" flat brush, I painted on a watered-down wash of Phthalo Blue, Raw Sienna and Hookers Green, letting them blend on the paper. The finished surface was about a value of 4 when it dried.

- I began painting the flowers one petal at a time. I wet each petal and, using my #10 round brush, I laid in the violets and golds, again letting them blend on the paper. I highlighted the parts of the flowers facing the sky and darkened the areas that were shaded to ensure every petal had dimension.

- Using my 1" flat brush, I worked on the stems and leaves incorporating various greens, golds and blues.

- Before finishing, I refined some darks, put in more leaves to enhance the composition and softened some edges.

- Last, I added some white gouache to small areas to "pop" the transparent colors nearby.

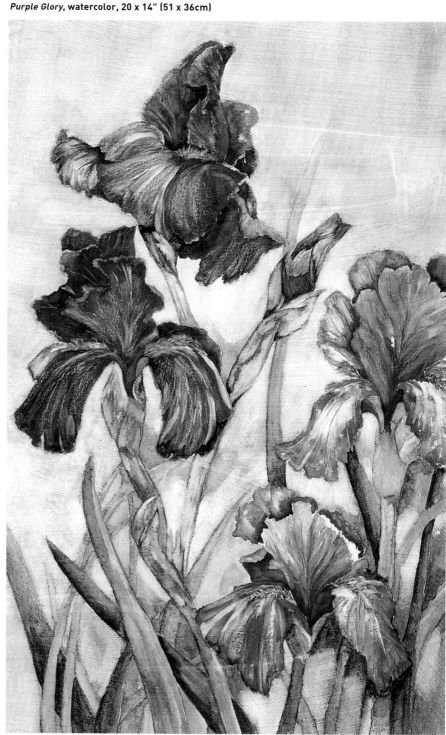

Purple Glory, watercolor, 20 x 14" (51 x 36cm)

try this idea

Apply one or more light coats of gesso to the surface of your watercolor paper, allowing each coat to dry. The result will be an interesting textured surface on which you can work.

what the artist used

support
300lb cold pressed watercolor paper

brushes
Flats 2" and 1"; rounds #4, 6, 10

other materials
White gouache
Clear acrylic gesso

Anita J Nugent lives in Murrieta, California, USA → nugentfp@aol.com

Terms you should know

abstracting Taking from reality, usually simplifying, to suggest a general idea. Not necessarily related to real forms or objects.

acid free For greater permanance, use an acid free paper with a pH content of less than 7.

acrylic Viewed historically, this is a fairly recent member of the color family. Waterbased, so can be diluted to create thin washes, or mixed with various mediums to make the paint thicker or textured.

aerial perspective Dust, water droplets and impurities in the atmosphere gray off color the further away it is from us. These impurities block light, filter reds and allow blues to dominate, so that in the distance we see objects as less distinct and bluer. This is an important point for landscape painters to grasp. Objects in the foreground will be sharp, more in focus and will have more color.

bleeding Applies mainly to watercolor where the pigment tends to crawl along the surface outside the area in which it was intended. Can be a good or a bad thing, depending on your intention.

blending Juxtaposing colors so that they intermix, with no sharp edges. Applies to pastel, where you blend colors by rubbing them with fingers or paper stumps, and to oil, where you would use a broad soft brush to blend colors.

body color Mainly gouache or opaque paint, as opposed to transparent paint. Can be used to create richness of color or to cover up errors. Chinese White (a zinc opaque watercolor) is often used to restore or create highlights. Many watercolor purists insist that a watercolor painting should only be created using transparent pigments, but countless leading artists use opaque paint in moderation. That is the key — only use opaque color on transparent watercolor paintings very sparingly.

brushes
Wash A wide, flat brush used for applying washes over large areas, or varnishing.

Bright A flat paintbrush with short filaments, often called a short flat.

Filbert Similar to a flat brush, with rounded edges.

Round A pointed brush used in all mediums.

Spotter A brush with a tiny, pointed head which is used for fine details.

Liner/Rigger A brush with a long brush head used for fine detailing.

Fan A crescent-shaped brush head for blending and texturing.

brush sizes The size of flat brushes is expressed in inches and fractions of an inch measured across the width of the ferrule. For instance, No.12 = 1 inch and No. 6 = ½ inch.

The size of a round brush is the diameter in millimetres of the brush head where it emerges from the ferrule. For instance No. 5 measures 5mm (¼ inch) in diameter.

Be aware that sometimes brush sizes may vary slightly between brands, even though they may both be labelled say, No. 10 round. Instead of choosing numbers, choose a quality brush in the size you prefer.

canvas Mainly for oil painting. Canvas can be bought in rolls, prestretched or already stretched with support strips or mounted on a still backing.

Canvas is fabric which comes in cotton, linen and synthetic blends.

Linen is considered better than cotton because of its strength and appealing textured surface. Newer synthetics do not rot and do not sag. You can buy canvas raw, (with no coating), or primed, (coated with gesso), which is flexible with obvious canvas texture. You can also buy canvas that has been coated twice — double primed canvas — that is stiffer with less texture.

Canvas board is canvas glued to a rigid backing such as cardboard, hardboard or wood. Note that cardboard is not suitable for serious work because cardboard is not acid free, and will not last.

Wood and hardboard must be prepared properly.

cast shadow A cast shadow is one thrown onto a surface by an object blocking the light. It is important to remember that the edges of a cast shadow are not sharp.

center of interest (focal point) This is the area in your painting that you want to emphasize. It is the main point. You can create a center of interest with color, light, tone, shape, contrast, edges, texture, or any of the major design elements. Any center of interest must by supported and balanced by other objects. And do not simply place your center of interest smack in the center of your painting! Make it your mission to learn something about the elements of design.

chiaroscuro This is an Italian word meaning light and dark. In art is means using a range of light and dark shading to give the illusion of form.

collage A work that has other materials glued on, including rice paper, paper, card, cloth, wire, shells, leaves.

color temperature This term refers to the warmness or coolness of a paint. Warm colors are those in the red, orange, yellow, brown group. Cool colors are those in the blue and green group. However, there are warm yellows and there are yellows with a cooler feel to them.

composition and design Composition refers to the whole work, while design refers to the arrangement of the elements.

counterchange When you place contrasting elements — dark against light.

drybrush Mainly for watercolor. If you use stiff paint with very little water you can drag this across the paper and produce interesting textured effects.

frisket Frisket fluid (masking fluid) can be painted over an area to protect it from subsequent washes. When dry the frisket can be rubbed off. You can also use paper frisket that you cut to fit the area to be covered.

gesso A textured, porous, absorbent acrylic paint that is used mainly as a preparatory ground for other mediums such as oil or acrylic.

glaze A thin, transparent layer of darker paint applied over the top of a lighter wash. This richens, darkens, balances, covers up or adds luminosity.

high key/low key The overall lightness (high key) or darkness (low key) of a painting.

impasto Applying paint thickly for effect.

lifting Removing pigment with a brush, sponge or tissue.

Collect all these titles in the 2004 Annual Series

100 ways to paint
STILL LIFE & FLORALS

ISBN: 1-929834-39-X
ON SALE: February 04

100 ways to paint
PEOPLE & FIGURES

ISBN: 1-929834-40-3
Publication date: April 04

100 ways to paint
LANDSCAPES

ISBN: 1-929834-41-1
Publication date: June 04

100 ways to paint
FLOWERS & GARDENS

Publication date: August 04

100 ways to paint
SEASCAPES, RIVERS
& LAKES

Publication date: October 04

100 ways to paint
FAVORITE SUBJECTS

Publication date: December 04

- -

How to order these books

Available through major art stores and leading bookstores.

Distributed to the trade and art markets in North America by

F&W Publications, Inc.,
4700 East Galbraith Road
Cincinnati, Ohio, 45236
(800) 289-0963

Or visit: www.artinthemaking.com

international
artist